D0386859

The Ongoing Moment

The Ongoing Moment

GEOFF DYER

PANTHEON BOOKS

NEW YORK

Library of Congress Cataloging-in-Publication Data
Dyer, Geoff.
The ongoing moment / Geoff Dyer.
p. cm.
Includes bibliographical references and index.
ISBN 0-375-42215-3
1. Photography—Popular works. 2. Photography—
United States—History. I. Title.
TR149.D92 2005 770—dc22 2005047586

www.pantheonbooks.com
Printed in the United States of America
First American Edition
2 4 6 8 9 7 5 3 1

For Rebecca

Contents

List of Illustrations

Black-and-white Photographs

Colour Plates

the only thing in which I have been actually thorough
has been in being thoroughly unprepared.
Alfred Stieglitz

The capacity of photographs to evoke rather than tell, to suggest rather
than explain, makes them alluring material for the historian or
anthropologist or art historian who would pluck a single picture from a
large collection and use it to narrate his or her own stories. But such
stories may or may not have anything to do with the original narrative
context of the photograph, the intent of its creator, or the ways in
which it was used by its original audience.
Martha Sandweiss

I am not the first researcher to draw inspiration from a 'certain Chinese encyclopaedia' described by Borges. According to this arcane work 'animals are divided into: (a) those that belong to the Emperor; (b) embalmed ones; (c) those that are trained; (d) suckling pigs; (e) mermaids; (f) fabulous ones; (g) stray dogs; (h) those that are included in this classification; (i) those that tremble as if they were mad; (j) innumerable ones; (k) those drawn with a very fine camel's-hair brush; (l) et cetera; (m) those that have just broken the flower vase; (n) those that at distance resemble flies.'

While the survey of photography undertaken in these pages can claim neither this degree of rigour nor eccentricity, it takes heart from earlier, well-intended attempts to marshal the infinite variety of photographic possibilities into some kind of haphazard order. Walker Evans said it was 'a pet subject' of his – how writers like James Joyce and Henry James were 'unconscious photographers'. In the case of Walt Whitman there was nothing *un*conscious about it. 'In these *Leaves* [*of Grass*] every thing is literally photographed,' he insisted. 'Nothing is poeticized.' Keen to emulate the 'Priests of the Sun', Whitman created

poems that, at times, read like extended captions in a huge, constantly evolving catalogue of photographs:

> See, in my poems, cities, solid, vast, inland, with paved streets, with iron and stone edifices, ceaseless vehicles, and commerce,
> See, the many-cylinder'd steam-printing-press – see, the electric telegraph stretching across the continent, [. . .]
> See, the strong and quick locomotive as it departs, panting, blowing the steam-whistle,
> See ploughmen ploughing farms – see, miners digging mines – see, the numberless factories,
> See mechanics busy at their benches with tools [. . .]

For his part Evans, in 1934, compiled a list of picture categories as a way of clarifying his own ideas about what he was trying to do in his work:

> People, all classes, surrounded by bunches of the new down-and-out.
> Automobiles and the automobile landscape.
> Architecture, American urban taste, commerce, small scale, large scale, clubs, the city atmosphere, the street smell, the hateful stuff, women's clubs, fake culture, bad education, religion in decay.
> The movies.
> Evidence of what people of the city read, eat, see for amusement, do for relaxation and not get it.
> Sex.
> Advertising.
> A lot else, you see what I mean.

The cultural historian Alan Trachtenberg has pointed out that this list calls to mind Lewis Hine's earlier *Catalogue of Social and Industrial Photographs*, 'only seasoned with Evans's irony'. But it's more than

irony that sets the two endeavours apart. Hine's is an entirely logical and rigorous listing – 'Immigrants', 'Women Workers at Work', 'Men Workers at Work', 'Incidents of a Worker's Life' and so on – comprising over a hundred topics and more than eight hundred sub-topics.* A model of orderly arrangement and organization, it is entirely lacking in the provisional, highly contingent and ultimately unsustainable ('a lot else') quality of Evans's catalogue of his own intentions.

Some of Evans's best-known work was done under the auspices of the Farm Security Administration between 1935–37. Known first as the Resettlement Administration, this was one of Roosevelt's New Deal agencies aimed at improving the lot of poor farmers and sharecroppers brought to the brink of starvation by the Depression. The FSA was headed by the economist Rexford Tugwell who, in 1935, appointed his old teaching assistant Roy Stryker to run the Historical Section. Both men were convinced of the power of photographs to give a human reality to economic arguments but it was not until the fall of that year, when Stryker was granted sole responsibility for making a photographic record of the agency's policy and work, that he got a clearer sense of his task – and of his power. This was brought into still sharper focus when he saw some photographs that had already been commissioned. They'd been done by Evans and were sufficiently impressive to secure the photographer the post as Stryker's Senior Information Specialist. Evans viewed this appointment as a kind of 'subsidized freedom', but, like many of the other photographers

* Hine's list is also reminiscent of another of Whitman's, the celebratory 'A Song for Occupations':

> House-building, measuring, sawing the boards,
> Blacksmithing, glass-blowing, nail-making, coopering, tin-roofing, shingle-
> dressing,
> Ship-joining, dock-building, fish-curing, flagging of sidewalks by flaggers,
> The pump, the pile-driver, the great derrick, the coal-kiln and brick-kiln,
> Coal-mines and all that is down there, the lamps in the darkness, echoes,
> songs, what meditations, what vast native thoughts looking through
> smutch'd faces,
> Iron-works, forge fires in the mountains or by river-banks [...]

working for Stryker (Ben Shahn, Dorothea Lange, Russell Lee, Arthur Rothstein, among others), he found his freedom compromised by the patron who had bestowed it. As Stryker's sense of his mission grew he issued more and more exacting 'shooting scripts', broken down by season, often sub-divided by location, itemizing in extraordinary detail what he wanted photographing. Here is an excerpt from a script for 'Summer':

> Crowded cars going out on the open road. Gas station attendant filling tank of open touring and convertible cars.
>
> Rock gardens: sun parasols; beach umbrellas; sandy shores with gently swelling waves; whitecaps showering spray over sailboat in distant horizon.
>
> People standing in shade of trees and awnings. Open windows on street cars and buses; drinking water from spring or old well; shady spot along bank – sun on water beyond; swimming in pools, rivers, and creeks.

Under 'American Habit', photographers of 'Small Town' life were instructed to look out for: 'R.R. station – watching the train "go through"; sitting on the front porch; women visiting from porch to street; cutting the lawn; watering the lawn; eating ice-cream cones; waiting for the bus . . .' In the 'City' they were pointed towards 'park bench-sitting; waiting for street car; walking the dog; women with youngsters in park or sidewalk; kids' games . . .' All of this was to be supplemented by 'General' shots: '"fill 'er up" – gas in car; "flats fixed"; traffic jam; detour sign; "Men Working" . . . Orange drink. Bill posters; sign painters – crowd watching a window sign being painted. Sky writing . . . Parade watching: ticker tape; sitting on curb . . .'

There is a particular poetry – the poetry of comprehensive contingency – about these scripts, and the fact that they now read as captions shows how diligently, if begrudgingly, Stryker's photographers did his bidding. Stryker supplemented his scripts with still more precise orders to make good any omissions. 'Where are the elm-shaded streets?' he asked Russell Lee, in Amarillo, Texas, in 1939. On another

occasion Lee was asked to look out for 'a small town barber shop where they still have the individual [shaving cream] cups with Mr Citizen's name on each cup'. Having told Arthur Rothstein, in Denver, to look out for '*Raking and burning leaves. Clearing up the garden. Getting ready for winter*', Stryker added, as an afterthought: 'Don't forget *people on front porches* either.' While fulfilling Stryker's orders photographers such as Evans and Lange brought their own private agendas to bear so that, at times, the resulting pictures represent a hybrid or merging of distinct categorical requirements.

In the 1950s Evans became friendly with the young Swiss photographer Robert Frank whom he encouraged to apply for a Guggenheim fellowship. In support of his application Frank came up with his own, highly individualized list of things he might photograph:

> a town at night, a parking lot, a supermarket, a highway, the man who owns three cars and the man who owns none, the farmer and his children, a new house and a warped clapboard house, the dictation of taste, the dream of grandeur, advertising, neon lights, the faces of the leaders, and the faces of the followers, gas tanks and post offices and backyards . . .

When the fellowship was awarded in 1955 Frank set out on a road trip across America, in the course of which he exposed nearly seven hundred rolls of film. After printing three hundred negatives Frank arranged the pictures into categories such as 'symbols, cars, cities, people, signs, cemeteries . . .' By the time the resulting book, *The Americans*, was published (in France in 1958; in the States the following year) only traces of this preliminary order could be seen. There were still pictures of cars and cemeteries but the book was no longer arranged around the intended categories.

In the full knowledge that there are other, more sensible ways to organize a book I take my cue from these highly contingent, provisional, often abandoned attempts rather than the methodical approach of Hine. As Robert Frank put it in his Guggenheim application, 'the project I have in mind is one that will shape itself as it proceeds, and is

essentially elastic.' Dorothea Lange also believed that 'to know ahead of time what you're looking for means you're then only photographing your own preconceptions, which is very limiting.' As far as she was concerned it was fine for a photographer to work 'completely without plan' and just photograph 'that to which he instinctively responds'. Taking Lange at her word I tried as far as possible to be open to anything, 'like a piece of unexposed, sensitized material'. Certain pictures caught my eye, just as certain things happened to catch the eye of the photographers who took them in the first place. Initially chance played a key part in both processes. After a point, though, I began to see that a number of these photos had something in common – a hat, say – and once I became aware of this I started to look out for pictures of hats. I wanted my take on photography to be arbitrary, incidental, but at some point things necessarily coalesced under particular areas of interest. As soon as I realized I was drawn to hats the *idea* of the hat became an organizing principle or node.

It is inherent in the idea of a taxonomy that the categories are distinct, that there is no overlap between, say, cats and dogs. Whether because the taxonomy has decreed this to be the case or because it reflects an inbuilt distinction is a moot point; either way there is no such thing as a dat or cog or a dog-cat. (Foucault blahs on about this in the preface to *The Order of Things* that's why the Borges encyclopedia provoked a 'laughter that shattered all the familiar landmarks of [his] thought'.) One of the features of this photographic taxonomy is that there is a great deal of seepage or traffic between categories. No sooner had I established hats and steps as organizing principles than I saw that some of the pictures that had engaged my attention had both hats *and* steps in them.* (These, not surprisingly, were some of the most

* Edward Weston also had some difficulties on this score. Charis Wilson, in her memoir of her years with the photographer, records how Weston's ledger 'identified negatives alphabetically – N for nudes, T for trees, R for rocks, S for shells, Cl for clouds (C had already been used for cactus) – and gave no clue as to the contents of particular negatives other than a date. There were ambiguous groups; for example, A for architecture overlapped with M for mechanical.'

interesting photographs to me.) Once this started happening the static grid of the taxonomy began to melt into the looser, more fluid form of narratives or stories. And while a taxonomy is expected to be comprehensive and disinterested, I knew right away that my own interests were best served by being – in both senses of the word – partial.

I suspect, then, that this book will be a source of irritation to many people, especially those who know more about photography than I do. I'm sympathetic but, if we're to make any progress at all, there's one kind of criticism I'd like to rule out of court straightaway. This is the 'But what about X?' or 'Why didn't he mention Y?' charge of inadmissible omission. Can we agree, in Whitman's words, 'that much unseen is also here', that it's not necessary to discuss – or even mention – every picture ever taken of a hat in order to learn something interesting about pictures of hats? I hope so, because the person doing the learning is the person writing the book as much as the person reading it. The driver is along for the ride too. For Henri Cartier-Bresson photography was 'a way of comprehending'. This book is the story of my attempt at comprehending the medium that he mastered.

John Szarkowski thought Garry Winogrand's best pictures 'were not illustrations of what he had known, but were new knowledge.' I wanted, among other things, to look at photographs to see what new knowledge I could derive from them – though I couldn't do this without bringing a certain amount of old knowledge to bear *on* them. I also wanted to learn more about – or at least become more sensitive to – the differences between certain photographers, to get more of an idea of their styles. To see if *style* could be identified in and by – if it inhered in – content. The only way to do this was to see how different people photographed *the same thing*.

In the process this book has ended up being mainly – but not exclusively – about American photographs, or at least photographs *of* America. This was not my intention. At the outset I didn't have any particular photographers – or photographs for that matter – in mind. Everyone and anything was eligible. There were photographers I'd not heard of and pictures I'd not seen (I make no claim to being an expert in this or any other field). There were important photographers I

happened not to be interested in (Irving Penn, for one); there were photographers I'd written about before or couldn't find anything new to say about (Cartier-Bresson and Robert Capa, for two); there were photographers I thought I'd write about at length (Eugène Atget, and we'll stop the counting right there) but ended up writing about only briefly; there were photographers I didn't intend writing about but ended up writing about quite a bit. One of these was Michael Ormerod in whose work several of the book's themes culminate. This was a lucky and entirely unintended break. He's the author's embedded representative: an Englishman undertaking a survey of American photography.

Ormerod had the advantage of doing this *within* the medium, through photographs themselves, but I'm not a photographer. I don't just mean that I'm not a professional or serious photographer; I mean I don't even *own* a camera. The only time I take a picture is when tourists ask me to take one of them, with their camera. (These rare works are now dispersed around the world, in private collections, mostly in Japan.) It's a handicap, sure, but it does mean that I come to the medium from a position of some kind of purity. I also have a hunch that not taking photographs is a condition of writing about them in the same way that my not playing a musical instrument was a precondition for writing about jazz in the late 1980s. Back then there were few books around to satisfy my curiosity about the music and the people who created it. The situation with regard to photography could hardly be more different. There are great books on the idea of photography – or, as Stieglitz put it, 'the *idea* photography' – by Susan Sontag, John Berger and Roland Barthes.* There are excellent book-length surveys of the history of photography or various genres and movements within that history. There are numerous books and essays of the highest

* One of the challenges of writing this book was to avoid quoting Berger, Sontag, Barthes and Walter Benjamin every five pages. Even so, there are plenty of quotes in the text, not all of them acknowledged. To find out who said what the curious reader is directed to the notes – the equivalent, in this context, of captions to the text or (since the text itself is an extended series of captions) sub-captions.

standard about particular photographers by curators and scholars. Photographers themselves have also proved extremely eloquent about their medium. This made things a lot easier. With the bar set so high I was free to walk right under it. But I still hope, as Diane Arbus put it, that 'I have some slight corner on something about the quality of things.'

Dorothea Lange said that 'the camera is an instrument that teaches people how to see without a camera.' I might not be a photographer but I now see the kind of photographs I might have taken if I were one.

1. Paul Strand: *Blind Woman, New York*, 1916

the inevitable familiar inventive blind man . . .
Walker Evans

In 1928 Walker Evans, then aged 24, went to the New York Public Library to consult back numbers of Alfred Stieglitz's influential journal *Camera Work*. He flicked quickly through them, looking at the pictures and reading, but mainly just looking, until he came to the last issue, June/July 1917, devoted solely to the work of Stieglitz's protégé, Paul Strand. Evans was smitten by one picture in particular. 'I remember going out of there over-stimulated,' he told an interviewer forty years later. '"That's the stuff," he said to himself. "That's the thing to do." It charged me up.'

The photograph was *Blind Woman* of 1916 [1]. One of her eyes is squinted shut, dead; the other glares off to the left. Behind her is a brick wall. Around her neck is a badge, Licensed Peddler 2622, and a sign, BLIND. It's a powerful picture. It charges me up, even now.

At some level I was conscious of this photograph before I actually saw it. I first glimpsed it, aged seventeen, in book VII of *The Prelude*. Wordsworth is remembering an incident in London (a little earlier he was 'striking right across the crowded Strand') when he was

> . . . smitten with the view
> Of a blind Beggar, who, with upright face,
> Stood, propped against a wall, upon his chest
> Wearing a written paper, to explain
> The story of the man, and who he was.

Wordsworth is utterly stunned by this 'spectacle'. As the poet's mind races it seems to him

. . . that in this label was a type,
Or emblem, of the utmost that we know,
Both of ourselves and of the universe;
And, on the shape of the unmoving man,
His fixed face and sightless eyes, I looked,
As if admonished from another world.

The congruity between these two encounters – separated by more than a century, one captured in poetry, the other in a photograph – proves that Wordsworth got it right: the man *is* a type or emblem. Change 'he' to 'she' and the words double as a description of the photograph. By dwelling on the way that he 'looked' on these 'sightless eyes' Wordsworth even anticipates and articulates something of Strand's relationship with his subject.

At the time Strand was preoccupied with the difficulty of how to use his bulky Ensign camera to take pictures of 'people in the streets without their being aware of it'. How do you make your subjects blind to your presence? This is another reason why the photograph is emblematic: it provides a graphic illustration of the photographer's ideal relationship to his subject. This was the aspect of the picture Strand stressed in an interview in 1971 (the same year that Evans reminisced about seeing it): 'Although *Blind Woman* has enormous social meaning and impact, it grew out of a very clear desire to solve a problem.' Strand's solution was to take the lens from his uncle's old view camera and fix it to one side of his own camera. He then held the camera in such a way that this false lens stuck straight ahead while the real lens, partly hidden by his sleeve, was focused at a right angle to the ostensible object of his attention. It may have been a clumsy solution – 'Do you know anyone who did it before? I don't' – but this clumsiness was in keeping with everything about the cumbersome enterprise of photography at the time. And it worked – usually. 'There were two toughs watching me when I made one of the first photographs: "Aw, he was photographing out of the side of the camera," one of them said.' Strand also recalled that the woman in the picture that so affected Evans 'was blind, not half-blind'; however, the left eye *looks* as

if it is surveying the street acquisitively so that the picture slyly hints at its maker's method — *his* sleight of hand and eye.

Strand had no qualms about pioneering this kind of subterfuge; it was only by deceiving his subjects that he could be faithful to them. 'I felt that one could get *a quality of being* through the fact that the person did not know he was being photographed,' he recalled. The blind woman is the most extreme extrapolation of this argument. The photographer sees his subject as she is unable to see herself. An unconscious embodiment or representative of the process whereby the photographer becomes unheeded, invisible, she is in turn a projection of his ultimate ambition: to become her — and the world's — eyes. The photographer's desire for invisibility is also dramatically previsioned by Wordsworth in the streets of London:

> . . . Lo!
> He dons his coat of darkness; on the stage
> Walks, and achieves his wonders, from the eye
> Of living Mortal covert [. . .]
> . . . and how can it be wrought?
> The garb he wears is black as death, the word
> 'Invisible' flames forth upon his chest.

The blind subject is the objective corollary of the photographer's longed-for invisibility. It comes as no surprise therefore — the logic of the medium seems almost to demand it — that so many photographers have made pictures of the blind.

In 1911 Lewis Hine, who had instructed Strand in photography at the Ethical Culture School in New York, took a picture of *A Blind Beggar in Italian Market District* [2]. Hine believed that 'in the last analysis, good photography is a question of art' but, unlike Stieglitz (for whom art was an end in itself), he believed that the medium should serve the larger project of social reform. In keeping with this, Hine's focus is not solely on the face of the beggar; his interest is not in the human condition but the conditions in which the beggar works. Compared with the fluidity of

2. Lewis Hine: *A Blind Beggar in Italian Market District*, 1911
© George Eastman House

everything around him – the curves of the shrouded figures, the barrels
of produce full of well-rounded fruit – there is a rigidity and stiffness, a
fixity of purpose about the blind man. He is playing some kind of barrel
organ or hurdy-gurdy, wearing the picture's caption around his neck:
HELP A BLIND MAN (with subtitles in a language I can't decipher). In the
background is the blurred business of the market and the surrounding
buildings. There's a lot going on, plenty to look at. The blind musician is
the object not just of the photographer's gaze but of most of the people
who surround him. A mother and her two children gaze at him; so does
a woman clutching a basket of shopping. To his left a woman tidies up her
stall. It's a cold day and both she and the young mother are swathed in
scarves which are reminiscent of the dark cloth – 'the coat of darkness' –
beneath which the photographer stoops. To the right of the beggar a man
stands, hands in pockets, eyes shadowed by the brim of his hat, staring
squarely at the photographer. We will encounter him again. Everybody
is looking at someone else (there is even the hint – too blurred to make
it out clearly – of a face in the window directly above the beggar's head,
peering through the curtains), thereby emphasizing the blindness of the
man at the centre of this web of seeing.

A more extreme case, as one would expect, is presented by a man

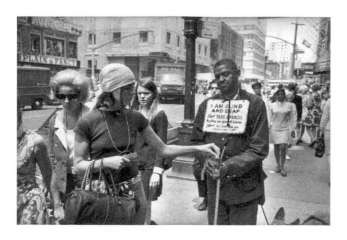

3. Garry Winogrand: *New York*, c.1968

© the Estate of Garry Winogrand, courtesy the Fraenkel Gallery, San Francisco

photographed by Garry Winogrand in New York in about 1968 [3]. Winogrand said he liked 'to work in that area where content almost overwhelms form' and there are often several potential photographs contending for attention within a single image. People are always looking elsewhere, hinting at other incidents – other photos – going on just beyond the frame. Like the street musician in John Ashbery's poem, Winogrand was someone 'who, walking the streets / Wrapped in an identity like a coat, sees on and on . . .' (We will come back to that coat.)

The patient working methods of certain photographers are evident in the calmness of their images. Winogrand had a specifically Manhattan variant of patience, one compatible with being in a hurry. The kinetic force of the city met his own '1200 ASA jitteriness' head on. The photos are jostled by what they depict. A kind of horizontal vertigo holds sway. The pictures are tilted, skewed, unsteady. There is often nowhere for our gaze to rest because, in these pictures, nothing is at rest – least of all Winogrand himself. He was a still photographer only in the strictly technical sense of the word.

In this instance, though, the photographer who is always on the move, who 'sees on and on', is confronted with his opposite: someone unmoving and unseeing. The caption hanging from the guy's neck

explains that he is BLIND AND DEAF, so that he is, simultaneously, doubly afflicted by the world and doubly insulated from its slings and arrows. He is also black, so the caption seems cruelly slung round his neck, as if he has been lynched by fate.

Strand wished to make it clear that his blind woman was not a beggar but someone plying a trade. Winogrand's blind man also just about manages to operate at the level of some kind of commercial exchange: he offers pencils in return for which 'Anything you give will help me'. The caption further informs us that his 'Dog's name is Lady' (the twin triangles of her ears peak above the bottom of the frame). It's a typical Winogrand street scene: busy, swarming, throwing into relief (as in Hine) the blind man's profound immobility. He looks like he's been there since the 1930s at least. This is so striking that everything about him – the texture not just of his clothes but of his hair – suggests that he is from a different time; a vagrant from the days of the FSA in the 1930s or of Hine and Strand. He looks as if he has been cut out of an earlier photograph and pasted on to this one. This is heightened by the way that the woman dropping coins into his cup is so conspicuously hip in a late 1960s, Women's Lib way. As is often the case with Winogrand he catches a moment of interaction which is also a moment of alienation and separation. She is keeping him at arm's length. This is one of any number of possible transactions going on, one of which also happens to be the taking of this photograph.

While most photographers like to wear what Dorothea Lange called a 'cloak of invisibility', Winogrand was a dominant, even intrusive presence. 'He was a bull of a man,' his friend Lee Friedlander recalled fondly, 'and the world his china shop.' His belligerent style of approach results in hostile glares from the people he accosts. In this case a white woman stares disapprovingly over the shoulder of the woman handing over the money as if she had spotted Winogrand taking a pencil without offering anything in return – and in a sense she is right.*

*William Henry Fox Talbot's first book of photographs was called *The Pencil Of Nature* and in the century and a half since it was published the question of whether you can take someone's likeness without their permission or knowledge – to many photographers it has become second-nature, an ethical blind-spot – has been constantly debated.

Less clearly, a black woman (I think it's a woman but it *could* be a man) looks over the shoulder of her blind brother with impending disdain. It would be interesting to see the next couple of shots on the roll of film; by then, she would have been upgraded from this incidental background role to a central part in the ongoing drama of Winogrand's Manhattan. By then, though, the photographer would have lost another integral part of the moment: the older woman to the left of the frame who hurries by, unseeing and indifferent, hidden behind the traditional signifier of blindness: her sunglasses.

Winogrand is the apotheosis of a certain kind of street photographer: darting round the city with a small, hand-held camera, mingling with the crowds and clicking away so quickly that even if people notice they do not have the chance to do anything about it. Reading accounts of photography in New York in the mid-1960s you get the impression that the city was so busy with photographers that, on 5th Avenue, they must have been bumping into each other the whole time. Joel Meyerowitz recalls that he 'kept running into Garry Winogrand'; another time he and two other photographers spotted Cartier-Bresson himself photographing the St Patrick's Day Parade.

In the wake of this plethora of activity it was inevitable that some photographers began looking at ways of bringing back an element of contrivance or artifice into their work. Rather than seeking to disguise what they were doing they chose to highlight the fact that a photograph was being made. The style of candid photography that Strand went to such lengths to achieve gave way to its opposite. Was it possible that the photographer could get *a quality of being* through the fact that a person *knew* he was being photographed – not just in the enforced conditions of a formal studio sitting but out in the street?

A heightened sense of the ordinary, of the miscellaneous deliberate, was taken to an extreme by Philip-Lorca diCorcia who, in 1978, photographed his brother Mario looking into a refrigerator. Nothing could be less remarkable, but this colour photograph was actually the result of hours of painstaking calibration, rehearsal and preparation. In the early 1990s diCorcia photographed hustlers and hookers he'd met

around Santa Monica Boulevard, but instead of discreetly taking a photo and making off with it he formalized the transaction by paying them – whatever it was they normally charged – to pose in settings of his choosing.

The street photographs diCorcia made in the mid-1990s introduce a degree of serendipity and chance – not in order to disrupt this ongoing fascination with contrivance but in order, literally, to illuminate it. Like many street photographers before him he chose what seemed a propitious spot and waited to see who would come by. At the right moment, rather than simply pressing the shutter, he simultaneously activated an elaborate, pre-coordinated system of flash lights. In 1993, in New York, diCorcia stage-managed a version of the typical busy Winogrand street scene in this way. To the left a man is lounging at a pay phone; to the right a bald guy is preaching into a microphone. In the middle of it all, swathed in coats and scarves, is the hulking figure of a blind beggar [Pl. 1]. The whole scene is brightly lit, the passers-by suspended in the midst of their lives, but the blind man is enshrined in a sudden aura of radiant illumination. In Winogrand the blind man looked as if he had been cut out of an earlier image. In diCorcia the flood of light makes it seem as if he has been digitally stitched into the scene, as if the world has been reconfigured by the act of the picture's being made.

We are used to photographs snatching a moment out of the busy flow of time and freezing it; in this picture it is as if time has been not momentarily but permanently arrested. Winogrand's picture of the blind beggar hints at the way the scene will have changed – and its photographic potential dissipated – moments after it was taken. The moment depicted achieves its force partly by virtue of a tacit sense of what has just happened or is about to happen. Isolating people both from each other and their past and future lives, diCorcia's picture *seals* the world in the instant it was made. The cinematic quality of this phase of diCorcia's work has often been noted, but the pictures, actually, are not like film stills – they are still films.

Given its impact on him it is inevitable that Evans would one day attempt an equivalent of Strand's picture of the *Blind Woman*. Equivalent

not simply in the sense that Evans photographed a blind accordion player in New York, but that he did so in pursuit of a similar procedural goal: to take pictures of people while they were oblivious to his presence.

Between 1938 and 1941 Evans made a series of portraits of passengers on the New York subway. By this time the cumbersome problems of candid street photography had been overcome and it was relatively easy to shoot, unnoticed, in daylight. In the low light and swaying cars of the subway (where photographing without a police permit was illegal) Evans faced considerable technical difficulties that became – in retrospect at least – integral to the project's purpose. With a 35mm Contax camera (set at a wide aperture and a fiftieth of a second, the chrome parts painted black) hidden beneath his coat Evans – sometimes accompanied by the young photographer Helen Levitt – rode the subway and waited until, he guessed, the person opposite him was appropriately framed. Then, using a shutter release cable running down his sleeve, he would steady himself and take a picture. Until he developed the film Evans could not be sure exactly what he had. In terms of precisely ordered composition, he was shooting blind. This was part of the attraction of the scheme.

The idea, Evans said later, was to affirm that certain people 'had come along and, without knowing it, placed themselves in front of a fixed and impersonal apparatus for a given time, and that all these individuals, inscribed in the view-finder, were photographed without the slightest human intervention at the moment the shutter clicked'. Framing and exposure could be corrected later, at the printing stage. Some of the resulting tight crops of head and shoulders resemble the images made by that most anonymous and automatic of cameras, the Photo-Me booth. The difference is that Evans's subjects were completely oblivious to the fact that they were being photographed. 'The guard is down and the mask is off,' he observed, 'even more than when in lone bedrooms (where there is a mirror), people's faces are in naked repose down in the subway.' Some of the pictures show people staring at Evans's face, studying his appearance as frankly as the camera was recording theirs. The act of looking, it seems, can make the face as

self-conscious as when it is posing in front of a mirror. Others, which show people in pairs or reading a newspaper, capture the transitory drama, the fleeting interactions of the subway. Always, though, this frank, impersonal interrogation yields no answers about the lives being lived. Years later, in *Wings of Desire*, Wim Wenders would access the random jumble of thoughts of riders on the U-Bahn in Berlin. Evans, though, is like Wordsworth in London:

> The face of everyone
> That passes by me is a mystery!

For Wordsworth this was a source of frustration which did not pass until he happened upon the blind beggar. For Evans it represented an ideal of 'pure recording': anonymous people recorded by a machine working, as far as possible, independently of human intervention.

In some instances it is precisely this detached quality of their conception and composition that gives Evans's subway pictures their intense human appeal. The most striking is his picture of a blind accordion player making his way down a crowded subway car [4]. His eyes are clamped shut, downturned like the mouth of someone so habituated to unhappiness as to feel comfortable with it. He shuffles the length of the train, conscious, as Borges writes in 'The Blind Man', that 'every step / might be a fall'. His fingers grope for the note that will turn indifference to charity. The hanging straps and lights are blurred, the accordion struggles to make itself heard above the thunder and rattle of the train. The roof and windows of the subway car hurtle towards a vanishing point that draws nearer by the second. The journey begins and ends in New York but the accordion tints the interlude with the idea – the memory – of Paris, of Europe. The blind accordion player plies his trade as he advances towards the dapper man in the overcoat who remembers his time in Paris (keep this note of nostalgia in mind) and who, unseen, is plying *his* trade. His hand reaches discreetly into his pocket. Inaudible above the clang and lurch of the train, the shutter is released. His expression does not change.

4. Walker Evans: *New York*, 25 February 1938

© The Walker Evans Archive, The Metropolitan Museum of Art,
New York, 1994 (1994.253.510.3)

Obviously we don't have any pictures of Evans at work on the subway but another photo of a blind beggar presents his situation in allegorical form. Winogrand took his picture in the midst of the busy ebb and flow of a New York street. On the subway Evans sat back waiting to see what would pass him by. In London in the early 1930s Bill Brandt took a picture of a blind beggar sitting on a fold-up chair outside a bakery in Whitechapel. Protected by the awning of the store he is set back from the flow of pedestrians, from the blurred figure of the woman who has just passed him by. He is wearing dark glasses, staring straight ahead. His hand is reaching into the pocket of his jacket as if secreting something away, the value and nature of which only he knows. Brandt slyly catches him doing this but the man who is ostensibly blind to everything going on around him effectively mimes this strategy. Ironically, as Colin Westerbeck points out in *Bystander*, the blind man, 'like the photographer', is tucked into a corner, hidden, waiting, 'taking it all in, trying not to miss a thing'. His hand reaches discreetly into his pocket. His expression does not change.

*

In 1980 Bruce Davidson began devoting more and more of his time to taking colour photographs of the New York subway. Riding the graffiti-mottled trains was 'dangerous at any time of the day or night', and Davidson prepared for his stint underground by following a programme of military fitness exercises. Feeling certain that he would get mugged at some point – as he duly was – Davidson carried, in addition to his camera equipment, a whistle for summoning help and a Swiss Army knife. The photographs he took are littered with the everyday edginess and threat that would climax with the shooting of four young black men on the Number 2 Downtown Express by Bernhard Goetz in 1984.

Like Evans, Davidson was struck by the way people travelling on the subway 'seemed weighed down by their fate'. Unlike Evans he did not try to camouflage what he was doing, preferring – usually – to ask people's permission before taking a photograph. Whereas Evans had described himself as 'a penitent spy and apologetic voyeur', Davidson explained to one of his curious subjects that he was 'a pervert, voyeur, and flasher all rolled into one photographic monster'. Even when he did not have time to ask permission to take a picture the flash gave him away instantly. While Strand felt that he could capture a quality of being through photographing people unawares, Davidson, anticipating diCorcia, found that the flash – the very thing that made people aware that they were being photographed – and the way that it reflected off the metallic surfaces of the subway cars created a unique 'iridescence'. This discovery enabled him to 'uncover a beauty that goes unnoticed by passengers, who are themselves trapped underground, hide behind protective masks, closed off and unseeing'. On a couple of occasions this turned out to be quite literally the case. Seeing a businessman 'with wrinkled bags under tightly closed eyes', Davidson took his picture very quickly, without asking. When he apologized about the flash the man told him it didn't matter because he was totally blind and couldn't see the light.

Davidson, presumably, was as conscious of the precedent of Evans's subway work as Evans was of Strand. He must have known, also, that it was only a matter of time before a blind busker came shuffling down the swaying corridors of the train and into view of his lens. The result

is a fortuitous fusion of – and an implicit commentary on – the photographs made by Davidson's illustrious predecessors. A woman in a green coat stands with her back to a carriage-door covered in the swirl and loops of graffiti [Pl. 2]. To her right another passenger is slumped in his seat, exhausted or drunk, head in hands. The busker's head is swathed in an olive scarf that frames her lined, cavernous face. She looks like she boarded the train at Hades. One of her eyes is squinted shut, dead; the other glares directly ahead. She is playing an accordion.* Unlike Strand's – or Hine's, or Winogrand's – blind beggar, Evans's and Davidson's have no notes around their necks labelling them as blind. Or rather their notes are unwieldy and musical – for what is the accordion if not the musical expression of blindness?

Walker Evans met the artist Ben Shahn in Brooklyn in 1930. A few years later he taught his friend the basics of photography: 'Look, Ben, there's nothing to it. F9 on the shady side of the street, F4.5 on the sunny side, twentieth of a second, hold your camera steady!' Shahn would subsequently join Evans on the FSA photographic project being organized by Roy Stryker; in the meantime, the two of them strolled around the Lower East Side, photographing life on the streets. According to Evans's biographer, Belinda Rathbone, they used 'a periscope on their Leicas (not unlike the one Strand had used on the Lower East Side twenty years earlier), so that they appeared to be aiming at each other rather than disturbing the natural flow of events in the street'. The resemblance to each other ends there, both in terms of manner and work. Where Evans was discreet, detached, reserved, genteel, Shahn (five years his senior) looked 'more like a labourer than an artist' and was, in Evans's opinion, 'a bit too forward' – exactly the qualities that can be seen in the picture he took of a blind accordion

* As the title of this book suggests, a tradition is never completed, but is always being incrementally advanced. Just as the manuscript had been sent for copy-editing the Czechoslovakian-born photographer Peter Peter published a book of *Subway Pictures* (Random House, 2004). Inevitably, one of these photographs is of a blind accordion player.

player on 14th Street in about 1932–4 [5]. The man is burly, powerful, a delegate of the photographer's own political sympathies. As one would expect from someone of Shahn's leftist allegiances the accordionist is not relying on charity; he is more stubbornly committed to the larger struggle of earning a living and getting a place for himself in the world.

Shahn took at least three pictures of the accordionist (all more effective than the rather childish painting he derived from them more than twenty years later), the frame expanding and contracting like the instrument itself. In one tightly framed version he dominates the picture completely; in another he looks like he is playing 'The Internationale', leading a parade of trade unionists. In the most expansive version, people make way for him as he barges down the wide-angled street, heading towards the photographer as if on his way – it will take him forty years to get there – to an encounter with Garry Winogrand. Perhaps this is why it seems like he is coming out of the past, emerging not only as a political force but as an acknowledged archetype of photography. Set in a face as pock-marked and earthy as an old potato, his eyes are impenetrably dark shadows. Is this why the picture is so strangely silent? His world is as absolutely musical as ours is

5. Ben Shahn: *Untitled [14th St, New York City]*, 1932–34
© Harvard University Art Museums

absolutely visual. If the music evoked what he could no longer see, the picture depicts what we can no longer hear.

The blind accordionist turns up in photographs by August Sander and others, but there is one photographer I particularly associate with this subject: André Kertész. According to George Szirtes in his sequence of poems 'For André Kertész',

> The accordionist is a blind intellectual
> carrying an enormous typewriter whose keys
> grow wings as the instrument expands into a tall
> horizontal hat that collapses with a tubercular wheeze.

The photograph Szirtes has in mind was taken in Esztergom, Hungary and the person in it is not blind (he's wearing spectacles rather than sunglasses). The accordion, it seems, is such a potent symbol of sightlessness as to blind us — I too had assumed he was blind to the real condition of the person playing it [6]. Kertész took this picture in 1916 when he was twenty-two. In 1959 he photographed another accordionist, this time in New York, and this time unambiguously blind [7]. It's the kind of scene that would have caught Diane Arbus's eye. The accordionist is accompanied by a seeing-eye dog and a woman, also blind, who is holding the cup into which a passing midget drops some coins. The background in the earlier picture is a whitewashed wall, smudged and cracked; in the later one it is the bustle of 6th Avenue. cars, a passing priest and another pedestrian, smoking, who glances across at the spectacle. Effectively these two pictures book-end a central strand of Kertész's long and varied career. Between these dates he made several photographs of people playing the accordion (including, in 1926, the sculptor Ossip Zadkine) and a number of others of blind musicians, most famously the *Wandering Violinist* in Arbony, 1921. A trio of associations — a kind of visual harmony — is established between accordion, violin and blindness. Music evokes a sense of sightlessness or loss — a loss for which it is both lament and compensation.

6. André Kertész: *Esztergom, Hungary*, 1916
© Estate of André Kertész, 2005

Kertész claimed that he was born a photographer. At the age of six he rummaged through his uncle's attic and came across a stash of old magazines with photographs in them. As precocious, almost, as his exact contemporary Jacques Henri Lartigue (who was taking and developing photographs by the time he was eight), Kertész began to look forward to making similar pictures himself, instinctively composing imaginary photographs he would one day preserve with a camera. Soon he was doing exactly that. His career embraced many different phases, subjects and styles but this variegation makes its underlying consistency more striking. Many of the pictures he made in Hungary before 1920 are just as mature as the ones he made later in Paris and New York.

Kertész left Hungary in 1925 and moved to Paris where he was part of the leading edge of photographic practice for the best part of a decade. By 1933 his pictures were felt to be out of tune with the mood of gathering political crisis and his career stalled. In 1936, lured by a

7. André Kertész: *Sixth Avenue, New York*, 1959
© Estate of André Kertész, 2005

contract with the Keystone picture agency, he uprooted himself a
second time and went to New York to work as a fashion photographer.
The move was intended to be temporary; it became permanent, but
not because Kertész felt at home in New York. Quite the opposite.
Though he continued to do outstanding work, the next quarter of a
century was marked by deepening frustration and disenchantment.

Things began to go wrong soon after Kertész arrived. The
Keystone agency was bankrupt and Kertész, unable to afford the return
trip to France, was forced to grub around for money. The outbreak of
war made his return impossible. It also made his staying unviable.
Classed as an enemy alien, he was prohibited from working outdoors
and from publishing his work. That was remedied by adopting
American citizenship in 1944 but he remained stubbornly resentful of
the demands made on him by the picture editors of magazines unsym-
pathetic to his more personal work. Rebuffed by an editor who told

him that his pictures were 'saying too much', Kertész – who never became fluent in English – continued to speak in his own private, lyric style. In 1947 Kertész signed an exclusive contract with *House & Garden* that guaranteed his economic well-being while curtailing his creative freedom for the next fifteen years. His sense of being ill-used and under-appreciated was compounded by the fact that between 1946 (when he exhibited thirty-six prints at the Art Institute of Chicago) and 1962 (when his work was shown at the University of Long Island) there was not a single public exhibition of his work. Even more gallingly, his place in the history of photography was in danger of being overlooked: his was not among the sixty-three names included in the genealogical tree of photographers published by *Harper's Bazaar* in 1944. Hostile to all 'tricks & "effects"', Stieglitz reacted unfavourably to Kertész's series of nudes warped and distorted by a mirror. He was not included in Edward Steichen's epochal 'The Family of Man' show of 1955. Beaumont Newhall mentioned him only briefly in his influential *Photography 1839–1937* and not at all in the *History of Photography from 1839 to the Present* (1949).

For Kertész, life in America consisted overwhelmingly of slights and disappointments. His time there, he repeatedly insisted, was 'an absolute tragedy'. One door closed; another slammed in his face. In 1963 Brassaï recalled how, when he had arrived in New York a few years earlier, his former mentor had greeted him with the words 'I am dead. It is a dead person you are seeing again.' The opinion, it seems, was shared by others. One day an old man with two shopping bags full of photos dropped them off at the Museum of Modern Art. The curator of photography, John Szarkowski, stuck his head out of his office and asked who it was. 'My secretary looked down at the sign-in book and said, "André Kertész." Everybody thought he'd been dead for thirty years.'

Kertész exaggerated and exacerbated his woes but the snubs dished out to him are, in retrospect, hard to credit. One of the masters of photography, he had to content himself, like a busker, with the merest crumbs of recognition, with coins dropped into his cup by passers-by indifferent to and ignorant of his talents. His vision was sharp, melodic, subtle, humane, but he was treated as though he were blind. Inevitably,

this neglect made him look back nostalgically on his earlier, happier days in Hungary.

The feeling was intensified by the way that many of the pictures of and from this past were themselves missing. He had left a suitcase full of negatives in the care of a woman in Paris; with the onset of war she and they had disappeared without trace. Miraculously, they would turn up later and be restored to him in 1963, part of the fairy-tale final act – international acclaim and belated recognition in the form of solo shows at the Bibliothèque Nationale in Paris and the Museum of Modern Art in New York – of Kertész's life. Until then his past seemed comprehensively lost to him. When the pictures were finally published in 1982, Kertész's biographer Pierre Borhan recalls seeing him 'with tears in his eyes, leafing through and commenting on *Hungarian Memories*'.

That is the strange thing about those early pictures of *The Wandering Violinist* and *The Blind Accordionist*: it is not just that they have retrospectively acquired the idyllic sureties of the lost homeland.* What is striking is that from the start – before long-ago *became* long-ago – when he was at home in his twenties, Kertész's vision was touched by the loss that was to come. Just as he had, aged six, looked forward to the pictures he would take when he had a camera, as soon as he began using one he took pictures that would express his feelings at the way that camera was undervalued, unwanted and underused. They became pictures of memories but they had started out as prophecies, objective representations of his own fate. Even as a high-spirited young man, part of him saw things from the point of view of an older, sadder self. Perhaps that is why these early pictures appear so mature. When he saw the blind accordionist on 6th Avenue in 1959 it must have seemed as if he were glimpsing not simply – or not *only* – another version of something he'd seen years earlier. No, time expanded (to embrace the two

* Though there *is* an element of that, of course: the feeling of nostalgia, of time and places past was so palpable that, looking at *The Wandering Violinist*, Barthes recognized 'with my whole body, the straggling villages I passed through on my long-ago travels in Hungary and Rumania'.

separate occasions) and contracted (to make the two moments adjacent). In these circumstances it is not fanciful to wonder if the tune Kertész heard in 1959 was the same one he had heard in 1922. What have they – the photographer and his surrogate, the blind accordionist – been doing in the meantime? The point is that there *is* no meantime. There was just that moment and now there is this moment with nothing in between, just the accordion collapsing and expanding, the tune unchanging:

> We are the poppies sprinkled along the field.
> We are simple crosses dotted with blood.
> Beware the sentiments concealed
> in this short rhyme. Be wise. Be good.

Franklin D. Roosevelt died on 12 April 1945. The following day, as people waited for the body of the dead president to be moved to the railroad station where it would begin the journey north, Ed Clark photographed Naval Officer Graham Jackson playing 'Going Home' on the accordion [8]. Jackson's vision is blurred by the tears streaming down his face. Behind him and to his left a group of whites, mainly women, wait for the coffin to pass. They glance across, whether at Jackson or the man photographing him is hard to say. Because of the way the picture is composed Jackson's right hand is a paw, as if he is a *mutilé de guerre*. It would be more eloquent if we could see his fingers but this possibility – the visual equivalent of subtle musical expression – is cut off, amputated, accentuating the feeling of pain: the wail, the cry, the call.

'Going Home' is the largo from Dvorak's *New World Symphony*. (It's the kind of thing which, a few years after Clark took his picture, John Coltrane could have turned into a tumultuous epic of hope, struggle and loss. In the late 1960s or early 1970s Archie Shepp would have rendered it militant, revolutionary; later still, in his sixties, he would have returned it safely to its origins.) The uncontainable overflow of emotion in Jackson is restrained and counter-balanced by his uniform and proud bearing. Because Jackson is black Clark's picture dips into

8. Ed Clark: *Going Home*, 1945
© Time & Life Pictures/Getty Images

the deep wells of emotion of Negro spirituals which Dvorak believed contained all that was needed for 'a great and noble' school of American music. At every level, therefore, the picture is about sorrow and dignity, dignity in sorrow.

Clark had only been working for *Life* magazine for a few months when he took this photo but as soon as he saw Jackson he knew, 'My God! What a picture!' Everything about it – the music, Jackson's race, his uniform – make it a classic, even definitive *Life*-like image. What we have, in other words, is a vivid example of the camera's unique capability: not the creation of a myth but its depiction. Looking at the picture, we respond every bit as quickly as Clark – and everything about it means that we do not dwell on it, that as soon as we are moved *by* it we are ready to move *on*. All the elements that came together to make the picture possible end up converging on a single level of meaning, one that makes itself felt immediately and unambiguously, irrespective of how casually or carefully we look at it. It does not require our attention or participation. Its meaning, as Barthes said of a

photo of 'a young Negro in a French uniform . . . saluting, with his eyes uplifted, probably fixed on a fold of the tricolour' on the cover of *Paris-Match* 'is *already* complete'. It is a visual anthem – and the defining quality of an anthem is that once you know it (though even that begs the question: who can remember a time when they did *not* know it?) it's never improved by being heard.

The sense that Clark's *Going Home* is an 'official' photograph is enhanced by the way that the photographer's point of view approximates that of the dead president, or at least that of the cortège as it passes by. A more subtle series of photos sharing this posthumous point of view was made by Paul Fusco, a staff photographer for *Look* magazine at the time, in June 1968. Robert F. Kennedy was assassinated in Los Angeles on 5 June. On 8 June, after a funeral in New York, Kennedy's body was carried by train to Washington. The coffin was in the last carriage, placed on chairs so that it would be visible through the large observation windows to the crowds lining the track. Fusco recorded the view from the train, his view of the people looking at the train as it headed slowly south. People stand to attention; smoke; smile; hold hands, flowers, babies or flags; wave, wave flags; kneel; point; pray; salute; remove their hats; hold signs . . . It's a true democracy – at once arbitrary and representative – of mourning. The crowds build up and thin out. In one quiet stretch there is just a girl in a pink bikini. In another, a guy with a broken leg waves his crutch. The background is sometimes a blur and sometimes the people are blurred as well, as if at certain points the train moved more quickly than at others. It's a hot day; an old woman shades herself with an umbrella. People are wearing sunglasses. Some are in uniform and some are in T-shirts (themselves a kind of uniform). They are here to look but a few look away. We watch them looking, watching as the momentous moment of the train passing passes by.

I suggested that the camera shared the point of view of the dead senator. But, as we continue looking at these pictures, that point of view seems subtly to change. The faces of the people gazing at the train are caught in attitudes of grief and loss. All are conscious – as those

glimpsed in the course of another 'travelling coincidence' were not –
of 'how their lives would all contain this hour'. For Philip Larkin in
'The Whitsun Weddings', 'each face seemed to define / Just what it
saw departing'. Here too the faces are watching something pass, and
with it a part of their own lives seems also to be passing; the part,
that is, when they stood here watching the RFK funeral train clank
by. This is why the pictures are, to put it as plainly as possible, *moving.*

Years hence when Fusco's pictures were exhibited and published a
few of the people featured in them must have recognized these passing
glimpses of their earlier selves. And *this* is the point of view that we –
who were not there – come to share. We look at these pictures as if we
are the people in them, looking back at that day when history, instead
of passing them by, passed by them.

So what one has is the observer travelling on a train.

John Cheever

As Larkin's train made its way to London on that 'sunlit Saturday', the
poet preserved the view from the window in a series of photographic
glimpses:

> Wide farms went by, short-shadowed cattle, and
> Canals with floatings of industrial froth;
> A hothouse flashed uniquely: hedges dipped
> And rose [. . .]

> – An Odeon went past, a cooling tower,
> And someone running up to bowl [. . .]

That was in 1958. More than forty years later Paul Farley raises a
glass, tacitly, to Larkin (whose journey he is, in some ways, replicating)
and, more immediately,

> to this view where everything seems to turn
> on the middle distance. Crematoria, multiplex
> way stations in the form of big sheds
> that house their promises of goods and sex;
>
> to the promise of a university town,
> its spires and playing fields.

In both cases it is as if England is narrow enough to be viewed in its entirety from either side of a moving train. In the vastness of the United States, unless the train happens to be carrying the body of a dead president, there is no possibility of a definitive national narrative unfolding from a train window. That requires the flexibility of the automobile. From a train window the best that can be hoped for is the self-contained shot, apparently taken at random. For Walker Evans this was part of its attraction. In September 1950 seven of the pictures he took from train windows were published in *Fortune* where, since 1948, he had enjoyed the privileged position of 'special photographic editor'. The pictures, including four in colour, were accompanied by a text in which Evans commended 'the rich pastime of window-gazing'.

The view from the train window is like a cross between the view from a window at home and the view from a car. It is like being at home in that you are not obliged to look out of the window as you are when driving or being driven. On a train you are not *confronted* with the view; it is an option. You can, if you prefer, spend the journey reading, looking up from time to time (though eventually you end up like Fernando Pessoa, 'torn, in a futile anguished fashion between disinterest in the landscape and disinterest in the book which could conceivably serve as a distraction').

In several ways Evans's disinterested views from the train window are a direct extension of the work he had done on the subways of New York and of the photos he'd taken from the window of his car in Louisiana in the 1930s. As in the subway pictures the view was predetermined, in this case, by the route. For someone interested by 'the artistic element in the automatic and the repetitive' the double restriction

of route and window was liberating and enabling. At least one of his pictures, of a house in the New Jersey area, was like one of Fusco's — on a day when nothing special was happening, when no one was paying any attention to the train or what it was passing through.

In 1953, also in the pages of *Fortune*, Evans wrote that 'He who travels by rail over the lesser lines of the USA clangs and shunts straight into his own childhood.' Strangely, Evans's photos from the train window seem to be travelling in the *opposite* direction. As he clanged and shunted through the eastern and mid-Atlantic states, he observed an America that was in the process of superseding the one he grew up in. This is suggested most clearly in a picture of a winter scene where a modern factory rises through settled snow like the conning tower of a huge submarine bursting through the Polar ice. These train window pictures also point to Evans's own future as a photographer, anticipating the colour images from the final phase of his career when he would eagerly embrace the limitations imposed on him by the Polaroid camera.

this world dense with writing that surrounds us on all sides
Italo Calvino

If we are being strictly literal it is the 'label' rather than the blind man himself that seems, to Wordsworth, 'the utmost that we know, / Both of ourselves and of the universe'. He is struck, also, by the *word* 'Invisible' as it flames forth on the chest of the circus performer. Many of the 'spots of time' in *The Prelude* are labelled or pre-inscribed in this way. Immediately following the passage in which the poet proclaims the importance of such moments in his life he recalls how, when only six years old, he came to a place where years earlier a murderer had been hung in chains. An 'unknown hand' had 'carved the murderer's name' there:

The monumental writing was engraven
In times long past; and still, from year to year,

35

By superstition of the neighbourhood,
The grass is cleared away, and to this hour
The letters are all fresh and visible.

Many photographers have shared Wordsworth's fondness for scenes, incidents and places that are self-labelling. Strand's *Blind Woman* is an obvious example, but no one relished the self-captioning image more than the person on whom that picture had such an impact when he came across it in the New York Public Library in 1928.

One of Evans's first published photographs (in the December 1930 issue of *Creative Art*) was of a large electric sign, DAMAGED, being loaded on to the back of a truck. It was accompanied by a multiple exposure of blazing neon words – THE BIG HOUSE, METRO GOLDWYN MAYER'S, LOEWS – on Broadway. In the years to come the jumble of truncated meanings and ironic juxtapositions in the haphazard language of signs, billboards and advertisements became one of Evans's distinctive vicarious signatures. The most famous example of this kind of self-labelling is probably the opening image in the book *American Photographs*.

Published to coincide with his exhibition at the Museum of Modern Art in New York in 1938, *American Photographs* has an autonomous aesthetic, predicated on the belief that seeing pictures in a gallery is fundamentally different to looking at them in a book. Forty-seven of the one hundred pictures in the exhibition do not appear in the book. Thirty-three of the eighty-seven pictures in the book do not appear in the exhibition. Evans took control of every aspect of the book's presentation and design. He was insistent that it be divided into two parts, that the pictures appear only on the recto page, that they should be uncaptioned (with an index at the end of each part). He was also adamant, as Lincoln Kirstein explained (possibly quoting Evans himself) in an essay at the back of the book, that 'the photographs are arranged to be seen in their given sequence'.

The effects of this sequence have been exhaustively examined by Alan Trachtenberg and others. Here I'll mention just the first three images. The very first is of a *License Photo Studio, New York*, 1934 [9], a precursor of the automated Photo-Me booths found in subway stations

9. Walker Evans: *License Photo Studio, New York*, 1934

© Walker Evans Archive, The Metropolitan Museum of Art, New York, 1994 (1994.256.650)

and supermarkets. The studio is plastered with signs advertising the fact that this is a place where photos are made and, in the context of the book in which this image appears, displayed. Painted fingers indicate the door, the way in, urging the reader to proceed, to turn the page, to see more photos. Evans's point is that the book will be as much *about* photography specifically what constitutes an *American* photograph – as it is *of* photographs. The photographed words serve, in Wordsworth's words, 'like a title page / With letters huge inscribed from top to toe'. The theme is continued in the next picture: a close-up, dominated by the single word STUDIO, of a window showing hundreds of examples of the kind of photographs produced in places like the one on the previous page. The third image is of two actual 'faces' – as opposed to a picture of pictures of faces – in Pennsylvania, isolated against a background blur of other faces. The traffic between these different, often intermingled levels of representation continues throughout the book.

The history of the photographic book is the history of photographers and editors trying to lure and coax us into *reading* them sequentially, to persuade us that a visual narrative is at work, that the arrangement of material is deliberate, that the pictures' effectiveness

will be diminished if they are looked at in isolation or randomly, haphazardly. *American Photographs* (1938) is a benchmark achievement in this ongoing history.

This book proceeds in the opposite direction, aims to reverse the process, to echo the possibilities of simultaneity and random juxtaposition afforded by a pile of photographs. You rummage in the box. You pick a photograph and then another one and the way they are combined makes you view each of them in a different way. I briefly entertained the thought of emulating B. S. Johnson's novel *The Unfortunates*, which consists of a pile of cards in a box to be reshuffled as the reader sees fit – but only briefly. For it is not the case that any combination of pictures works as well as any other. Placing a Stieglitz cloud study between a Weston nude and a view from Kertész's window does not display any of the pictures to particular advantage. But I wish that each picture – or the verbal equivalent of a picture: each section of text – was not forced to be surrounded by just *two* others. Ideally some sections would be adjacent to four or eight or even ten others. As Strand wrote in the introduction to the portfolio of photographs in *On my Doorstep*, 'rather than a linear record, [it] should be seen as a composite whole of interdependencies'. To qualify that earlier claim, then, this book aims to emulate the aleatory experience of dipping into a pile of photographs as far as is compatible with the constraints of binding, of its *being* a book. One order is proposed by the material as it is arranged here. But you could – in fact are *urged* to – go from the section ending '. . . draining it of what little meaning it had' on page 39 to the paragraph commencing 'Evans highlighted this by photographing arrows . . .' on page 244. Or from the section ending with Cartier-Bresson's remark about coincidences on page 115 to the one beginning 'DeCarava's own link to the European avant-garde . . .' on page 119. That way, some of the numerous alternative permutations get their chance to be seen and the considerable opportunity cost of having arranged things in *this particular sequence* is reduced. I've refrained from giving possible directions at the end of each section but bear in mind that the arrangement offered here is not definitive. A number of different routes can be taken through these pages. This book, if you like,

is the negative from which a variety of prints – similar and subtly different to each other – can be made.

In July 1973 Evans acquired a Polaroid SX-70 camera. He began experimenting and playing with something he at first regarded as a 'toy'. Such was his fascination and satisfaction with the results that he felt 'quite rejuvenated' and ended up devoting the last fourteen months of his life almost exclusively to this new gadget.

None of his previous pictures expresses his love of the self-labelling image as simply as the Polaroid of a faded red and green mailbox on which the word LETTERS is printed in white letters. This picture would have worked perfectly on the cover of a book he had in mind: a Polaroid alphabet made up of letters from various signs that had caught his eye (ARK from PARK, AI from PAID). Naturally enough, he was particularly fond of W and E. He was drawn, also, to the random admonitions of signs and warnings detached from their context: DO NOT ENTER, DO NOT HUMP, ENJOY. E. M. Forster was so taken by his own phrase 'Only connect' that he used it as an epigraph to signpost the message of *Howard's End*. Evans disconnected the first word – ONLY – from the streets on which it was written and photographed it over and over. Just that one word – only – from any number of different angles, isolating it and, by dint of obsessive duplication, draining it of what little meaning it had.

Evans died in April 1975 before his photographic lexicon could be completed, but his ambitions were spectacularly realized by Lee Friedlander in *Letters from the People*, a book whose sequencing is inherent in its conception.

Taking his cue from Evans, Friedlander crops a letter at a time from signs (the K of CAR PARK, the B of BAR), window displays, notices and advertisements, breaking the alphabet down into its constituent characters. Once the alphabet has been itemized in individual photographs he moves on to numbers.

The lexical reservoir at his disposal is immense. In no time at all the vast anagram of the city provides all the components necessary to

replicate the entire written culture of the English-speaking world. What emerges is culture in the bacteriological rather than literary sense of the word. Signs breed a fungus of graffiti, what Norman Mailer calls a 'plant growth' of scrawl. Consciously treading in Evans's footsteps when isolating letters from signs, Friedlander was aware, also, of those who had already photographed graffiti. Between 1938 and 1948, for example, Helen Levitt had photographed chalk drawings and messages on the buildings and streets of New York. In 1933 Brassaï commented that the 'succinct signs' preserved in his photographs of the graffiti on Paris walls 'represent none other than the origins of writing'.* The writing discovered by Friedlander has evolved beyond these origins but even when words are formed – CASH, GOD, EYE, SIN, STEAM (in wet concrete) – the suggestion is of a world packed with primitive meaning. Messages appear but the sense leaks from even the simplest announcements. WHILE U is excluded from the frame; now a shop window commands: WAIT.

Not that there is anyone around to take notice. Except in one instance there are no photos of people reading or writing (and even in that one picture, of the Vietnam Memorial in Washington, they might more accurately be said to be pointing out and looking at names rather than reading them). In all but half a dozen of the 200-plus images in the book there are no people to be seen. The only human presence is Friedlander's spectral shadow – his signature, one might say – stalking the empty city, recording rather than reading. The language seems to have spawned – to have written – itself. Often the quantity of scrawled additions renders language not simply unreadable but illegible.

Yet this photographic lexicon becomes more intensely human with every page. Names begin to appear. Then dripping expressionist shrieks: TERRIBLE, PAIN, ACID. A few pages later, almost imperceptibly, the word 'ART' makes its first discreet appearance. Dialogue emerges. Below a lavishly aerosoled HURT'N an abandoned municipal sign advises

* Bruce Davidson thought that the graffitied signatures surrounding passengers on the New York subway were 'ancient Egyptian hieroglyphics'.

CARE. Soon there are brief, frenzied essays on politics and philosophy — COMMUNISM IS NOT EXISTENTAL — and pieces of frazzled, enigmatic advice: RING IT 100 TIMES IF NECESSARY (needless to say, there is not a bell in sight, just an abstract expanse of white wall).

The observed narrative trajectory — from clumps of letters to pieces of writing — obliges us to *read* the photographs. It is too narrowly literary to suggest that *Letters from the People* stands or falls, ultimately, by the quality of the writing it depicts, but the act of reading quickly arouses the instinct for critical evaluation. And so, in the midst of all the semi-literate exhortation, we seize on a daubed declaration of love and jealousy as a species of almost-poetry, at once intimate and public:

> She's my friend
> And I'll tell you
> She Ain't no good
> She don't love you
> Like I do.

The book closes with an expression of scrawled beauty and tender lyricism:

> Everyday I calls a phone to her
> Every night I dreams for her.

It's a poignant and lovely message with which to end the book — though not as poignant as the ones that we will come across at the end of *this* book.

Friedlander was one of three photographers exhibited in the Museum of Modern Art's seminal 1967 show 'New Documents'. The others were Garry Winogrand and Diane Arbus who, in 1968, was asked if she wished she were in Chicago to photograph the hippies, radicals and anarchists involved in events there. No, what she wanted, according to biographer Patricia Bosworth, was 'to photograph blind people again.

James Thurber. Helen Keller maybe. Borges. And she wished she could photograph Homer, if only he were still around.' The following year Arbus fulfilled part of this desire when she photographed Borges for the March issue of *Harper's* magazine. He stands in Central Park, in a suit and tie, framed by leafless trees.

Arbus has often been charged with exploiting her subjects. For Eudora Welty (that rare thing, a major writer who was also a fine photographer), Arbus's work 'totally violates human privacy, and by intention'. It could be argued, to the contrary, that the stark frontality and frankness of her method was less exploitative than the surreptitious strategies pioneered by Strand and Evans. Consistent with this, her usual practice, Borges is placed in the exact centre of the frame and stares directly at the camera, fully conscious of the process of which he is a part. His wrinkled hands rest on a walking stick in a way that is almost identical to the blind man photographed the previous year by Winogrand. While the writer is in sharp focus, the trees behind him are blurred, isolating him from the visible world that frames – and defines our view of – him.

This is partly what intrigued Arbus about photographing the blind. In the early 1960s she had become fascinated by a blind street performer named Moondog. 'He lives in an atmosphere as dense and separate as an island with its own sea so he is more autonomous and vulnerable than anyone, and the world is rendered into shadows and smells and sounds as though it was being remembered even as it acts,' she wrote to Marvin Israel in 1960. 'Moondog's faith is other than ours. We believe in the invisible and what he believes in is the visible.' In 'The Aleph' Borges would have us believe that there is a place where it is possible to see everything in the world simultaneously. Having glimpsed this the narrator weeps because his eyes 'had seen that secret, hypothetical object whose name has been usurped by men but which no man has ever truly looked upon: the inconceivable universe'. Setting down this vision in words brought with it a sense of 'hopelessness' for the simple reason that what he saw was 'simultaneous' while what he writes 'is successive, because language is successive'.

To reconcile the simultaneous and the successive: that is one of the ambitions of these pages.

Arbus's friend Richard Avedon also wanted to photograph Borges ('I photograph what I'm most afraid of, and Borges was blind') and, in 1975, he flew to Buenos Aires to do exactly that. En route, Avedon learned that Borges's mother – with whom the writer had lived almost his entire life – had died that very day. Avedon assumed the session would be cancelled but the great writer received him as arranged, at four o'clock, sitting on a sofa in 'gray light'. Borges told Avedon that he admired Kipling and gave him precise instructions as to where a particular volume of his verse was to be found on the shelves. Avedon read a poem aloud and then Borges recited an Anglo-Saxon elegy. All the while the dead mother lay in an adjoining room. Later Avedon took some photographs. He was 'overwhelmed with feeling' but the photographs turned out to be 'emptier' than he had hoped. 'I thought I had somehow been so overwhelmed that I brought nothing of myself to the portrait.'

Four years later Avedon read an account by Paul Theroux of an identical visit – the dim lighting, Kipling, the Anglo-Saxon elegy – and saw his failure in a new light: Borges's 'performance permitted no interchange. He had taken his own portrait long before, and I could only photograph that.' Is it an exaggeration to say that the photographer was left with nothing to see, that he was, effectively, *blinded* by the writer?

This is not the end of the story, however, for Avedon photographed Borges again the following year, in New York. As in almost all Avedon's portraits the subject is framed by a sheer expanse of white. This one shows an old man in a pin-stripe suit with messed-up eyes and white eyebrows looking, in Adam Gopnik's unforgiving phrase, 'not sage but vaguely comical in his complacent blindness'. The key word here is 'vaguely'; not a word one associates with Avedon who is normally the most *exacting* of photographers. Unusually for an Avedon picture it lacks psychological focus, as if Borges's blindness impairs the reciprocity of intention on which the photographer depends. Or perhaps

the opposite is true: it brings sharply into focus a shortcoming in the photographer, suggesting that there was a potential for complacency not just in Borges but in Avedon's unyielding adherence to his own method. This possibility became more pronounced over time. Avedon's portrait – made in 2001 – of Harold Bloom, shows the eminent critic, eyes closed, bundled up like a snowman beneath a blizzard of white hair. The impression is of a man so swaddled in self-regard that he can read books – and possibly even write about them as well – with his eyes shut. Given that Avedon's method depends, or so he has claimed, on a reciprocity between subject and photographer, doesn't this image imply something similar – that he could make portraits with his eyes closed – about the man who made it?

Arbus liked photographing the blind 'because they can't fake their expressions. They don't know what their expressions are, so there is no mask.' In terms of Arbus's work as a whole this is accurate and misleading in equal measure. Her late pictures of inmates at various mental homes represent an extreme extrapolation of this idea, into the realm of mental sightlessness. These people have no idea of who they are or how they are perceived. In such circumstances it makes no difference if they are dressed up in masks (for a Halloween parade); they are powerless to control the way they are regarded. Elsewhere the power of Arbus's work often depends on the tension between the mask – the way people want to be seen – and the way that the camera tugs away at it. Sometimes Arbus pulls the mask completely away and we see people naked (several of her best-known pictures were done in a nudist colony), as if they are blind or mentally ill. But some of her most revealing photographs show the struggle to remove the mask and her subjects' efforts to keep it in place; the mask, in these circumstances, is still there but it's been pulled out of shape. It's ripped, no longer fits properly and, as a consequence, appears both as a ghastly contrivance and as an authentic expression of near-universal aspirations: the wish 'to be king or queen for the day, to look like Elizabeth Taylor or Marilyn Monroe or Mickey Spillane'.

Arbus herself was aware of how her work depended as much on

people's self-perceptions as it did on the lack of self-perception that drew her to the blind.

> Everybody has that thing where they need to look one way but they come out looking another way and that's what people observe. You see someone on the street and essentially what you notice about them is the flaw. It's just extraordinary that we should have been given these peculiarities. And, not content with what we were given, we create a whole other set. Our whole guise is like giving a sign to the world to think of us in a certain way but there's a point between what you want people to know about you and what you can't help people knowing about you.

Consistent with this – and in keeping with the precedent established by Strand – the blind were the external embodiment of Arbus's own desire for invisibility. In her case this was not contrived through the subterfuge of a false lens. One of the people who knew her when she first became interested in photographing the blind, in the late 1950s, remembered her as being small, but then began to wonder if she really was that small. It was more that she gave the impression of being small because of the unobtrusive way 'she'd creep into a room or on to the street with her cameras and you almost couldn't see her.' Arbus herself said that she had a knack of being able 'to figure myself into any situation'. 'Awkwardness' rather than the 'grace' she associated with Avedon was her starting point. In this way Arbus's approach to photography was similar to Joan Didion's to journalism. 'My only advantage as a reporter,' Didion explained in *Slouching Towards Bethlehem*, 'is that I am so physically small, so temperamentally unobtrusive, and so neurotically inarticulate that people tend to forget that my presence runs counter to their best interests. And it always does.'

It so happens that Arbus's version of this way of working was preserved on film by William Gedney in 1969 [10]. Forty-six at the time, Arbus is photographing some beauty queens; Gedney catches them in the process of being turned, willingly and unwittingly, into an Arbus photograph. Arbus had first photographed beauty queens in 1960 and

10. William Gedney: *Diane Arbus, New York*, 1969

© Special Collections Library, Duke University

was struck by how 'the poor girls looked so exhausted by the effort to be themselves that they continually made the fatal mistakes which were in fact themselves.' In a remarkable piece of refracted telescoping Gedney shows them as they appear to Arbus *as she appears to him*.*

After Arbus's death, Gedney remembered her, as though he were describing his own photo, as a 'rare species of bird loaded down with that bulky green canvas bag hung over one shoulder, pulling her body to one side and a 2¼ camera with attached flash strung around her neck, constantly persistent in pursuit. A small being physically, always weighted down by her equipment, the necessary burden.' A burden on which she depended but which finally became intolerable.

In 1968, while convalescing from a period in hospital, Arbus found it hard being as 'faceless' as she felt. Dreading work, Arbus wrote to a

* Gedney's picture is complemented by one taken in 1967 by Winogrand which shows Arbus as she appeared to her subjects. Winogrand is looking over the shoulder of the person she is photographing at a peace march in Central Park's Sheep Meadow. As a form of symbolic camouflage and a spindly tribute to flower power, Arbus is holding a single daffodil between her pursed lips.

friend and explained how 'I put the camera around my neck although I didn't use it and I was grateful just to wear it'. The camera here serves the same identity-confirming function as the label BLIND hung round the neck of the woman photographed by Strand. By October 1970, in a way that is completely consistent with the unflinching logic of Arbus's work, the possibility arose that perhaps the 'fake' camera had become the true expression of her condition, that she had become vocationally blind: 'What if I am no longer a photographer?'

Within nine months – two years after Gedney took his photo – Arbus had taken her own life. Since then Arbus's subjects have come to seem vicarious representations of her own fate, as if her pictures of 'freaks' were a way of externalizing the concealed eruptions of her own psyche. 'What I'm trying to describe is that it's impossible to get out of your skin and into somebody else's. And that's what all this is a little bit about. That somebody else's tragedy is not the same as your own.' And yet, at the same time, 'Every Difference is a Likeness too . . .' If, as Welty claimed, Arbus violated the privacy of others, in doing so she exposed her own private agonies and dreads. Speaking in 1961 of the 'freaks' in her photographs Arbus described them as 'people who appear like metaphors somewhere further out than we do, beckoned, not driven, invented by belief, each the author and hero of a real dream by which our own courage and cunning are tested and tried; so that we may wonder all over again what is veritable and inevitable and possible and what it is to become whoever we may be.' In 1968 she felt that she was 'undergoing some subterranean revolution in which the surface hardly stirs'. Far from being gratuitous or sensationalist her photographs became metaphors of her own traumatic journey.

At the same time that she spoke of wanting to photograph blind people, Arbus said that she wished she could have photographed 'the suicides on the faces of Marilyn Monroe and Hemingway. "It was *there*. Suicide was *there*,"' she claimed. Arbus's belief in the prophetic power of photography was derived in part from Bill Brandt who, in turn, derived it from André Breton. Commenting on the 'sadness' in the eyes of the actress Josephine Smart (whom he photographed in 1948) Brandt felt that 'the photographer's aim should be a profound likeness,

which physically and morally predicts the subject's entire future.' But while Arbus believed that there were 'things which no one else would see unless I photographed them', Brandt put the emphasis not on what *he* could see but on what his wooden Kodak *camera* could see; 'instead of photographing what I saw, I photographed what the camera was seeing'.* Something similar is perhaps going on in Strand's famous 1944 portrait of a weather-hardened Vermont farmer, *Mr. Bennett.* 'He died six months later,' Strand recalled. 'That's one of the things in his face, although I didn't know it then.'

All of which brings us back to what Arbus said of Hemingway and Monroe. Can we see Arbus's suicide in Gedney's picture of her? (In Brandt's terms, did Gedney's camera see the suicide in Arbus's face?) Or does its power derive, in fact, from what *can't* be seen?

Arbus's interest in blindness was part of a more general fascination with what could not be seen in photographs. Shortly before her death Arbus explained to students that, having been 'hipped on clarity', she had come to realize 'how I really love what you can't see in a photograph. An actual physical darkness and it's very thrilling for me to see darkness again'. Arbus attributed this awakening interest in 'obscurity' to Brandt and, even more importantly, to Brassaï.

> *And to think it would not exist*
> *but for those tenuous instruments, the eyes.*
> Borges, 'History of the Night'

It has been variously reported that Brassaï bought his first camera the day after watching his friend Kertész make a prolonged night exposure on the Pont Neuf; that Kertész lent him his first camera; that Brassaï

* Brandt came across this camera in a second-hand shop in Covent Garden. He learned that 'the camera had been used at the beginning of the century by auctioneers for photographic inventories, and by Scotland Yard for police records.'

effectively stole Kertész's approach and style. 'I gave him a crash course on night photography: what to do, how to do it, and how long the exposures had to be. Later he started to copy my style in night photography and that, more or less, was the type of work he did for the rest of his life.' Kertész was in his seventies and had endured decades of neglect when he made this ungenerous assessment of their relationship. Certainly, Kertész had mastered the techniques of night photography before arriving in Paris where he met Brassaï in 1925. Certainly, he passed on some of these skills to his fellow Hungarian. Equally certainly, Brassaï used them to develop a style and content that were uniquely his own (as Brandt, in turn, would use Brassaï to develop *his* own style). Besides, Kertész could hardly claim the city at night as his exclusive preserve.

After reading Paul Martin's two-part article 'Around London by Gaslight' in *The Amateur Photographer* in 1896 Stieglitz became absorbed in the technical and aesthetic intricacies of photographing New York at night. The results were sharp, clearly defined and softened slightly by 'halation' round the street lamps. In *The Glow of Night* (1897) the street offers its own rain-slick reflection of the scene of which it is a part. Crucial to the effect was a relatively short exposure time – of less than a minute – which, Stieglitz explained the following year, 'makes it possible to include life in night photographs of this character, thus increasing the possibilities of picture-making'. Stieglitz was by then opposed to the practice of manipulating negatives to give them a painterly, symbolist blur, but, as someone who had 'always loved snow, mist, fog, rain, deserted streets', he still relished an authentic meteorological blur. *Icy Night* of 1898 shows a path through a New York park, framed by winter trees, receding mysteriously into the distance. Images like this 'achieve the softness seen in manipulated prints, but without the manipulation'.

By the time Brassaï made his first pictures the misty city at night was well established as a photographic genre in its own right. Like the photographs made by Stieglitz thirty-five years earlier these images were simultaneously soft and sharp. What Brassaï did was to light his scenes in such a way that the night became bright, transforming the fog

from a filter to a source of light. In making darkness visible Brassaï made himself synonymous with his subject.

Brassaï was not his real name. Gyula Halász, the person who became Brassaï, may have been born in Brasso, Transylvania, but he was adamant that 'the only birth date which matters to me is not Brasso 1899, but Paris 1933'. That was the year after the publication of his book *Paris de Nuit*. 'Brassaï', then, refers not to a man but to a recognizable body of work made by the artist of that name. And yet this artist was, by all accounts, a strong personality and vigorous presence in the Parisian avant-garde of the 1920s and 1930s. He hung out with Picasso and the Surrealists and gained notoriety as 'the photographer' in *Tropic of Cancer* (1934) by his friend Henry Miller. Four years after it was written, Miller published 'The Eye of Paris', the article that consolidated the close identification of the artist with the nocturnal demi-monde of streetwalkers and brothels.

For his part, the photographer of the shadow-life of Paris spoke of photography bringing him 'out of the shadows'. Artist and city both display themselves in hiding. Psychoanalysis had shown the unconscious mind working in a similar fashion; Brassaï prowled the dream-time of the city exploring what Walter Benjamin, in 1931, called 'the optical unconscious'. This is made as explicit as possible in Brassaï's photographs of bridges over the Seine. Above are the boulevards of monumental Paris; beneath the arches are the dark river (with its peculiarly distorted reflections) and, lit dimly by fires, the *clochards* and the vagrants: lurking reminders of urges that were at odds with – and a byproduct of – bourgeois security. The force they exercized on artists and writers was almost gravitational. This is the signature feature of Brassaï's work: a psychological state is, to use the darkroom term, *fixed* in the arrangement of tangible forms. The cityscape is at once actual and internal, objective and surreal. 'More than a time,' writes Colin Westerbeck, 'night is a place here.' A place as intimate, disturbing and indifferent as the streets through which Sophie Jansen wanders in *Good Morning, Midnight*, Jean Rhys's novel of Paris in the 1930s: 'Walking in the night with the dark houses over you, like monsters . . . No hospitable doors, no lit windows, just frowning darkness. Frowning

and leering and sneering, the houses, one after another. Tall cubes of darkness, with two lighted eyes at the top to sneer.'

In Brassaï's pictures of the Paris arcades, the arches lead into a dark perspectival tunnel. The sense is of being taken deeper and deeper into the city. There we find the familiar crew – familiar, that is, from Brassaï's photos – of nocturnal transgressives and outlaws: hookers and homosexuals, Albert and his 'gang' of posing 'toughs'. Eventually the pictures grant you access to an interior: 'You press the button,' writes Rhys in a passage to which we shall return. 'The door opens.' Wherever they are taken Brassaï's pictures lead, ultimately, to the same place: 'Always the same stairs, always the same room.'

A personal prejudice – a dislike of cigarettes and make-up (on men or women) – made me take against Brassaï's well-known pictures of these brothels and bars. There was something ghastly about them; but that, I see now, derives in part from their subtle psychological torsion. Within these interiors the mirrors contrive to offer a leering commentary on what is happening in front of them. Sophie Jansen is continually confronted by these 'well-known mirrors' in *Good Morning, Midnight*: 'Well, well,' one of them says to her, 'last time you looked in here you were a bit different, weren't you? Would you believe me that, of all the faces I see, I remember each one, that I keep a ghost to throw back at each one – lightly, like an echo – when it looks into me again?'* Brassaï's pictures are non-judgemental, the people are convivial, but the mirror is always doing something behind their backs. Continuing the compositional path established by arches and arcades, these mirrors form a tunnel of multiple self-reflections. Often we see in the picture not what is actually there but only what is reflected within the frame of that surrogate camera, the mirror. The mirror remembers, bears witness and grudges. In every way Arbus's remark about Brassaï and the attraction of what *can't* be seen highlights what *can* be seen in his work.

*

* Oliver Wendell Holmes famously described photography as a 'mirror with a memory' in 1859.

In the 1960s Gedney worked intermittently on a series of pictures of empty streets and houses at night. Groping to discover in words exactly what he was trying to do in these pictures, Gedney said he saw them as representing man's 'lost groping in darkness to discover himself'. Asked about Gedney's night pictures John Szarkowski responded more succinctly, in terms strikingly reminiscent of Arbus's: 'Photography is about what you can see – this is what you can't see.'

Like many of Gedney's projects, the series was never completed (a few examples can be seen in the posthumously published book, *What Was True*), but he continued to be fascinated by the idea of the city at night, by the potential for revelation contained by darkness. In 1982 he copied out some remarks by a private eye who said that it was easier to identify people at night. The things you notice in broad daylight – colours, hair, clothes – can all be changed quickly and easily. But the things you are obliged to concentrate on at night – 'the slope of the shoulders, the way the clothing is worn, the gait' – 'never change'. They are as permanent and personal as the lines of your hand. From about 1860 to 1880 prison identification photographs in Britain included not simply shots of offenders' faces (full-frontal and profile) but also of their hands. From here it is a small step to trying to convey and reveal a person's identity solely by prints of their fingers and hands.

> *Hands have a history of their own, they have, indeed, their own civilization, their special beauty.*
> Rilke

Given that it is notoriously difficult to draw hands, photography's ability to depict them effortlessly is one of its great attractions. Thus the camera is both a way of showing the human hand and of evading its uncertainties and limitations. Henry Fox Talbot's frustration at the inadequacies of his own hand – his inability to make decent sketches of things that pleased him – goaded him to investigate ways of causing the images projected in the *camera obscura* 'to imprint themselves durably,

and remain fixed upon the paper'. When he succeeded in using 'the pencil of nature' to make 'photogenic drawings' in this way Michael Faraday declared, in 1839, that 'No human hand has hitherto traced such lines as these drawings display'. This was still a sufficiently novel boon in 1906 for George Bernard Shaw to eulogize the 'artist-photographer' Alvin Langdon Coburn on the grounds that he was 'free of that clumsy tool – the human hand'.

In 1840 or 1841 Fox Talbot made a calotype of a hand – a right hand, it is not known whose. Indeed, since it is the palm that contains all the information about an individual's character and fate, the fact that this is the back of the hand gives it an enhanced quality of anonymity. Especially since no symbolic meaning is being expressed: no gesture, no sign. We are confronted, in the defining way of the photograph, with the simple fact of a hand. Again, if the palm were facing us it would seem to be urging us to stop or, if we were familiar with the *mudras* of Buddhism, not to be afraid. As it stands, it is just a hand, anyone's hand. Amputated at the wrist, it could almost be a dead man's – the kind of thing you see in a corner of one of Joel-Peter Witkin's freaky pictures. There is something similarly unnerving about Wilhelm Röntgen's spectral X-ray – one of the first ever made, in 1895 – of his wife's left hand. 'Love treasures hands like nothing else,' writes John Berger, 'because of all they have taken, made, given, planted, picked, fed, stolen, caressed, arranged, let drop in sleep, offered'. The slight unease provoked by both Talbot's picture and Röntgen's X-ray derives precisely from this separation of the hand from anything it might have done and from anyone with whom it could be so intimately identified.

The most comprehensive cataloguing of the beloved's hands and all they have made and given was undertaken by Stieglitz. In 1917, shortly before they became romantically involved, he took some pictures of the artist Georgia O'Keeffe in which her hands feature prominently. In the years that followed, particularly in 1919, he photographed O'Keeffe's hands obsessively, either isolating them completely from the rest of her body or using them as a defining detail within a larger arrangement. Since Stieglitz believed that 'the quality of *touch* in its deepest living

sense' was inherent in his work it seems almost inevitable that he should have become so fixated by photographing his lover's hands. Sometimes – as when she hugs the collar of her coat more closely about her neck – O'Keeffe's gestures are ordinary, natural, incidental; sometimes they are elaborately contrived, resolutely unnatural. Whether the intention is purely aesthetic or to use hands within a private symbolic language, the expressive gain in having O'Keeffe twist her hands upside down and inside out is negligible. In some carefully constructed tableaux she is reaching for a grape or apple; more usually she – or, more accurately, Stieglitz – is clutching at an absent straw. 'Every feeling waits upon its gesture': this was Eudora Welty's admirably simple credo of descriptive psychology, one that served her equally well as writer and photographer. The problem with Stieglitz's pictures of O'Keeffe's hands is that often the gestures could not have originated in any feeling, only in response to a command from her photographer-lover.

A similar difficulty is posed by Dorothea Lange's picture – used on the poster of her 1966 retrospective at MoMA – of the raised hand of an Indonesian dancer. As a child Lange was taken to a church to hear an oratorio. She was too small to see the conductor, 'could just see his hands'. These made such an indelible impression on her that, years later, she read about the conductor Leopold Stokowski and knew immediately that it could only have been *his* hands that she had glimpsed that winter afternoon. The picture of the Indonesian hand assumes a similar ability to reconstruct the whole from a part, for the hand to serve as a distillation of the 'elegance, control and beauty' Lange had observed in the dance as a whole. Isolated from the flow of unfolding narrative and the deciphering help of myth, however, the solitary hand makes an empty gesture.* Lange took this picture in

* In the west our own myths – our versions of the Mahabharata to which Javanese dance alludes – are provided by movies such as *Casablanca*, *Psycho* or *It's a Wonderful Life*. Their influence is so pervasive that you feel you have seen these films even if you have not done so personally. This knowledge underwrites Douglas Gordon's *24 Hour Psycho*, a re-projection of the film that takes not ninety minutes but a full day to unfold. In doing so film is revealed for exactly what it is (and is not): a succession of still images. In the segment I happened to catch, Janet Leigh was driving along a freeway, her hand clutching the

1958; in her photos from the 1930s, by contrast, hands form an essential part in the visual legend of the Depression.

Hands, in these pictures, have an eloquence Lange's subjects frequently lack in speech. Again and again we see people with their hands knotted together as if in self-sufficient solidarity with themselves. A desperate attempt to hold yourself together, this is a gesture which, in *The White Angel Bread Line* (1933), approaches the condition of prayer [23]. We notice it again at a street meeting of the San Francisco Waterfront Strike (1934) where a member of the audience listens with an intensity that makes economics and politics a source not just of hope but of potential redemption. In a quite literal sense Lange's emphasis on hands offers a visual continuation of the linguistic practice whereby field- and factory-workers are metonymically reduced to just that: hands. Tina Modotti did much the same thing in her tightly-framed pictures of the hands – of a washerwoman, of a worker resting on a tool – from the mid-1920s, in Mexico. But how much humanity Lange and Modotti insist – resides in these work-coarsened hands.

Explaining her working methods Lange commented that there are 'people who are garrulous and wear their heart on their sleeve and tell you everything, that's one kind of person; but the fellow who's hiding behind a tree, and hoping you don't see him, is the fellow you'd better find out about.' The most eloquent testimony, in other words, may come from those most reluctant to give it.

All of these elements can be seen in her picture *Migratory Cotton Picker, Eloy, Arizona*, November 1940 [11]. In bright sunlight a man covers his mouth with his hand. The palm is facing the camera. It is not a natural pose but it could be derived from the gesture of wiping his mouth with the back of his hand after drinking. He is young,

steering wheel. In normal time this would have lasted a few seconds. Slowed down like this Leigh spent twenty minutes getting almost nowhere. Her fingers flexed and relaxed, clenching and pulsing as though in the grips of the most extreme nervous agitation. Hitchcock is often lazily termed a master of suspense but here that suspense became so extreme as to seem ontological. Narrative (to go back to Lange's picture of the Javanese dancer) is not always necessary but must be implied, felt – and in this sequence it is felt through Leigh's fingers.

11. Dorothea Lange: *Migratory Cotton Picker, Eloy, Arizona,* 1940
© the Dorothea Lange Collection, Oakland Museum of California, City of Oakland.
Gift of Paul S. Taylor

handsome, but the hand is that of someone twenty or thirty years older. The hand seems almost to belong to someone else, poking into the picture from an elbow beyond the frame. His eyes are in deep shadow so that it is the hand that identifies him, that both silences and speaks for him. 'All I have is a voice,' Auden declared at the end of the 1930s; all this man has are his hands which are exactly the same texture as the long-weathered wood on which he leans. (This piece of timber is angled in such a way that it could almost *be* his upper arm.) The hand is criss-crossed by the dirt tracks of the life he has led — which is exactly the same as the life he has to come. The palm is the landscape — the face of the land — through which he travels. You don't need any knowledge of palmistry to understand that his life, whatever its length, will be as hard as the earth whose qualities — dry, capable of epic endurance — it has taken on. The picture's optimism comes from the contrast between face and hand, by

the way the face, at this stage, is still relatively unlined, untouched by the life of the hand; its pessimism or hopelessness from the knowledge that it is only a matter of time before it becomes just as creased and worn. That is the destiny we read in his palm.

John Steinbeck claimed that Robert Capa 'could photograph thought'. What he meant was that Capa could photograph *people thinking*, which is not quite the same thing. (Photographers here lack the conventional advantage of comic book artists who have recourse to the thought bubble, distinguished from the speech bubble by its broken or hyphenated line.) Almost from the moment of the medium's invention photographers wrestled with this distinction, or tried to make the latter synonymous with the former. One way of doing so was to use clever, thoughtful people – Carlyle, for example – and show them in such a way as to suggest that, behind the eyeballs, the brain was whirring. In 1906 Albert Bigelow Paine made a series of portraits of Mark Twain on the portico of his house. Entitled *The Development of Moral Thought*, the sequence of seven photographs showed Twain, white-haired, cigar-smoking, rocking back and forth in a chair, gazing into the middle-distance, cogitating for all he is worth. To ram the point home – before, eventually, undermining it – Twain added handwritten captions to explain how the photographs showed, 'with scientific precision, stage by stage, the progress of a moral purpose through the mind of the human race's oldest Friend'. The endeavour comes to nothing and the series culminates with the author sitting back, abandoning his attempts at moral improvement and concluding that 'I'm good enough, just as I am.'

A more successful, less programmatic example would be Roman Vishniac's well-known portrait of Albert Einstein. The photographer himself recalled that 'an idea had suddenly come to him, and the room was filled with the movement of the great man's thought'. Vishniac waited for several minutes and then, when he saw that Einstein 'was off in a world of his own', started taking pictures. Part of the power of the photograph comes from the fact that behind Einstein are empty shelves. 'Unlike the studies of most scientists in Princeton, his had no books at

all in it – he had nothing to work with except the pad, the pencil, some notes he had taken from his pocket, and a blackboard he had been using to figure out formulas.' The lack of clutter adds to the impression that we are approaching pure – i.e. incomprehensible – thought. However, we are still only getting a portrait of a clever person thinking. More recently, Steve Pyke has made a series of pictures of philosophers but, when all is said and done, most of them just look like old blokes with wayward hair, bags under their eyes, and eyebrows that have taken leave of their senses.

At the risk of getting out of my depth philosophically, it seems logical that since thought has to be represented by a thinker the problem could be either resolved or exacerbated – in the weird world of philosophy exacerbation might, for all I know, be a necessary prelude to resolution – by the representation of a representation. Certainly, one of the most famous photographic depictions of thought is not of a thought or of a person thinking but of a famous artistic representation of thought: Edward Steichen's picture of Rodin's *The Thinker*.

Steichen arrived in Paris in May 1900 and soon secured an invitation to visit Rodin at his studio. The sculptor was sufficiently impressed with his portfolio to invite him back and Steichen returned repeatedly over the coming months. At first he made a portrait of Rodin in profile with his Victor Hugo monument in the background; later he made a negative of *The Thinker* and then, in 1902, combined the two to make a picture of the sculptor contemplating his creation. The effect is nicely conveyed by Rilke who, every bit as besotted as Steichen, presented himself to the *maître* in 1902 and described *The Thinker* in the following terms: 'He sits silent and lost in meditation, heavy with vision and thoughts, and, with his whole strength (the strength of a man of action), he thinks. His whole body has become a skull and all the blood in his veins has become brain.'

Sculptor, poet and photographer all convey the same thing: thought not as abstraction but as an almost physical activity. The danger with this kind of thing – this kind of thinking – is that it becomes a form of rhetoric: the image of thinking devoid of its (insubstantial) substance. In this respect it is significant that Steichen went on to become a great –

and, in some quarters, thoroughly despised – fashion photographer.*
This early attempt at representing thought, of recording its styliza-
tion, initiates a trajectory which will culminate in Richard Avedon.

With an elegance worthy of his subject, Adam Gopnik has argued
that Avedon's work

> throughout the forties and fifties tracked the dissemination of
> existentialism as a pop style . . . Ideas aren't ever 'in the air'; but
> they do quickly imprint themselves on lips and eyes and throats –
> an idea becomes a fashion as soon as it becomes a fad. It's not that
> Avedon's pictures are in any sense philosophical illustrations. It's
> that, in the early fashion work, he became to existentialism what
> Fragonard had been to the Enlightenment. Just as the French
> painter invented a whole new vocabulary of gesture and expres-
> sion to suggest a world remade by learning . . . Avedon absorbed
> the new look of meaningful *angst*, and turned it into a vocabulary
> of loveliness.

And neither Avedon nor Gopnik stops there:

> All artists reflect the ideas of their times, but it is given to some
> artists to reflect the intellectual romance of their time . . . [T]he
> romance of any idea, made visible, becomes in a way a *critique* of
> the idea, a revelation of its fragile human basis, and therefore of
> its contingency, even its absurdity.

Who would have thought it? Some of the most successful photo-
graphs of thought – of ideas – turn out to have been made in what is often
thought of as the brainless area of glamour or fashion. The interface of

* cf. Walker Evans, writing in *Hound and Horn* in 1931: Steichen's 'general note is money,
understanding of advertising values, special feeling for parvenu elegance, slick technique,
over all of which is thrown a hardness and superficiality that is the hardness and super-
ficiality of America's latter day.' A year earlier Edward Weston had dismissed Steichen as
'too clever, artificial'.

fashion-thought has today become so commonplace that even totally gormless models know how to look like they're thinking. The most frequently photographed English footballer, David Beckham, never sounds particularly clever. What sets him apart from his team-mates, though, is the ability to *look* intelligent.

Away from public thinkers and models, photographers have sought out activities that encourage thought or moments that convey *thoughtfulness*. Chess, for example. Talbot made one of the earliest chess photos — *Nicolaas Henneman Contemplates His Move* — in September 1841. After this opening photographic gambit his example was followed by Brandt, Kertész, Marc Riboud, Cartier-Bresson, Capa and others.

For Borges, in his poem 'The Just', 'Two workmen playing, in a café in the South, a silent game of chess' are helping, even though unconscious of doing so, to save the world. It doesn't have to be a 'café in the South'. Cogitation makes where you are playing irrelevant. The game exempts you from your surroundings, however squalid. Wherever it is played, chess, with its inviolate, agreed-on rules, creates a sanctuary from whatever violence or chaos might be raging nearby. Nowhere is this more apparent than in Capa's picture of Republican soldiers behind the lines in Madrid in 1936. They are swathed in blankets and coats, lying in what looks like a trench. Being Capa he shows a player (wearing goggles round his head and binoculars round his neck) not contemplating a move but in the process of making one, of turning thought into act, scenting victory, holding the white knight in his hand.

Hands, in Lange, are not only eloquent but elegant. Cracked and grimy they may be but, like the people themselves, they are never broken or grasping. These hands give an air of stoic refinement to people in threadbare dungarees. *Woman of the High Plains* (1938) has the poise of a dancer. Lange's Okies often end up with their head in their hands but this gesture of near-despair also keeps them from sinking into it. Steichen's photo of Rodin's statue embodied a classical idea of thinking; Lange's photographs depict something more elemental, practical and burdensome: what Steinbeck called 'figuring'. Her subjects are constantly

on the brink of a destitution to which they never quite succumb — they are always figuring a way of getting out, getting by or moving on. It is often said that hardship reduces people to the level of animals. Lange makes the opposite point: that hardship confronts people with problems whose very simplicity renders them unfathomable. At this degree of penury, even satisfying the most basic needs – food, shelter – requires calculation, cunning. At a certain point of hardship – as the famous image of the *Migrant Mother* [89] demonstrates – even instinct requires thought if it is to stand a chance of being acted upon. The familiar look of dust-bowl angst is also the expression of endless and futile cogitation. In an era of extreme economic scarcity what struck Lange was the potential surplus of thought this scarcity generated, exacerbated and, ultimately, wasted. And it is in the hands – rather than the head or the eyes – that this mental activity is most vividly apparent. Even when the heart has all but shut down the fingers are still fidgety with life; when passive they have the troubled serenity of dreams which continue unabated and unsatisfied.

In Pittsburgh, in 1955–56, W. Eugene Smith photographed a young boy making handprints on a wall [12]. It is a delightful picture, an image of harmless naughtiness so timeless as to hark back to the dawn of history when men made their first daubs on a cave wall. There is also something slightly troubling about it, partly because Smith also photographed the same boy holding a wooden sword with a long stick resting on his chest in such a way that he could, almost, be impaled on it. There is a *Lord of the Flies* quality about this second picture; the first is more subtly unsettling. Whether this is inherent or a result of echoes set up by other pictures is difficult to say. One thing is certain, however: just as a city or town is sometimes 'twinned' with another thousands of miles away, in another country, so photographs separated by many years, taken by different photographers with different intentions in mind, can become so closely associated that the meaning of one or both is irrevocably changed. Sometimes, in fact, it is a photograph that brings two distant towns into sudden proximity. In this way a photograph by Smith and one by

James Nachtwey twin Pittsburgh with a place called Pec — and a childish game becomes an intimation of massacre.

12. W. Eugene Smith: *Untitled [Boy making handprints on wall]*, 1955–56

© Magnum Photos

In the same year that Smith took this picture Elliott Erwitt photographed Lange in Berkeley, California. Appropriately enough her hands, which cast a shadow over part of her face and pudding-bowl (as opposed to dust-bowl) haircut, feature prominently in the picture. Her elbows are on the dining table and her hands are clasped together as if she is arm-wrestling herself.*

* Erwitt includes this picture in *Handbook*, a collection of photographs on the theme of hands. Viewed in isolation from its neighbours, each of these pictures works. But the fact that we are seeing them in the context of a book of and about hands highlights what is best observed discreetly, foregrounds what should be *incidentally* revealing. The 'clue' that is vital precisely because it might be overlooked stares us in the face, and the clue is always the same. Aside from the portraits, the rest of the book is an assortment of hand-picked stuff that is either light-hearted (hands on asses in Rio) or sentimental (little baby clutching mummy's big finger). The final picture is of a man at Hyde Park corner holding a sign announcing that THE END IS AT HAND, the last in a series of gags whose punch line is announced in the title, known in advance, and always the same.

A photo about Diane Arbus by William Gedney; a photo about Dorothea Lange by Elliott Erwitt . . . The British critic Gilbert Adair has written that, 'at least for the general public', the peculiar representational standing of photography boils down to this 'question of the pecking order of *by* and *about: London Fields* is a novel *by* Martin Amis *about* the London of the 1990s; whereas a snapshot of the Queen Mother is first and foremost *about* the Queen Mother and only secondarily *by* Cecil Beaton.' Since I find it as difficult to generate interest in a picture *about* the Queen Mother as I do in a photograph *by* Beaton I'd prefer to take a different example.*

As a teenager I was obsessed with D. H. Lawrence in a way that I never was – or have been – by any other writer. I loved pictures of him every bit as much as I loved his books – possibly even more so. My favourite showed Lawrence in his late thirties (I guessed) in profile, looking down. For years that was all it was to me: a picture *about* Lawrence. Then I learned that it was, as Lawrence himself put it, *by* 'a man Edward Weston'. Later still I learned that this man, Edward Weston, had taken many superb photographs and was as important to the history of photography as Lawrence was to the history of the novel. I also learned a little more about the circumstances in which the photo was made.

In 1923 Weston had left his wife and three of their four boys to go to Mexico with his lover, the Italian actress and model Tina Modotti, and his eldest son, Chandler. By the time Lawrence and Frieda passed through Mexico City, in November 1924, Weston and Modotti had established a photographic studio and were at the centre of artistic life in the city. A mutual friend, Luis Quintanilla, brought Lawrence to visit Weston who formed an 'agreeable' impression of the English author. A few days later Lawrence returned to sit for a portrait. It was the

* It might have been neater if Adair himself had taken a different example: the 1974 picture *about* mod and moody Martin Amis *by* Bill Brandt, say.

briefest of contacts, 'too brief,' Weston considered, 'for either of us to penetrate more than superficially the other: no way to make a sitting'. Weston was disappointed by the results – 'not technically up to standard' – but Lawrence wrote back and said that he 'very much' liked the two pictures that had been sent to him. He was so impressed by them, in fact, that he urged Quintanilla to write an article about Mexico, Weston and himself for *Vanity Fair* as a way of boosting the photographer's reputation.

Not that this made Lawrence better disposed to photography generally.

The following year, back at his ranch in New Mexico, Lawrence wrote an article, 'Art and Morality', lambasting 'the habit we have formed: of visualizing *everything*'. 'As vision developed towards the Kodak,' Lawrence decided, 'man's idea of himself developed towards the snapshot. Primitive man simply didn't know *what* he was: he was always half in the dark. But we have learned to see, and each of us has a complete Kodak idea of himself.' Having got himself worked up Lawrence then launched into one of his characteristic surges of intuitive analysis and prophecy:

> Previously, even in Egypt, men had not learned to *see straight*. They fumbled in the dark, and didn't quite know where they were, or what they were. Like men in a dark room, they only *felt* their own existence surging in the darkness of other creatures.
>
> We, however, have learned to see ourselves for what we are, as the sun sees us. The Kodak bears witness. We see as the All-Seeing Eye sees, with the universal vision. And we *are* what is seen: each man to himself an identity, an isolated absolute, corresponding with a universe of isolated absolutes. A picture! A Kodak snap, in a universal film of snaps . . . The identifying of ourselves with the visual image of ourselves has become an instinct; the habit is already old. The picture of me, the me that is *seen*, is me.

Weston shared Lawrence's horror of the snapshot culture from which he kept himself proudly aloof. And though forced to make a

living doing commercial portraits (which he despised), when it came to serious portraiture Weston placed a proto-Avedonian emphasis on some kind of compact between photographer and subject. The difference is that by Avedon's time the elision of the self with its image is irresistible, a given. There is simply no getting away from it and no alternative to it. His work, in fact, is predicated on this. (Avedon's ability to 'photograph thought' is, perhaps, one of the incidental perks of the condition.) By contrast, Weston's work was, on the one hand, a concerted denial of Lawrence's prophetic assertion (or at least an attempt to keep it at bay) and, on the other, an affirmation that, in certain circumstances, the you that is seen *is* you.

Weston became incandescent on this score several years later, in 1930, after an acrimonious encounter with the sculptor Jo Davidson (who would make a clay head of Lawrence a few days before his death, in March of the same year). Barely resisting the urge to 'spit in [Davidson's] face', Weston argued that 'Photography's great difficulty lies in the necessary coincidence of the sitter's revealment, the photographer's realization, the camera's readiness. But when these elements do coincide, portraits in any other medium, sculpture or painting, are cold dead things in comparison.'* In terms familiar to readers of Lawrence, Weston believed that in 'the very overcoming of the mechanical difficulties which would seem to restrict the camera . . . lies its tremendous strength. For when the perfect spontaneous union is consummated, a human document, the very bones of life are bared.' By 1932 he had further refined his conviction that a photograph is 'not an interpretation, a biased opinion of what nature should be, but a revelation, – an absolute, impersonal recognition of the significance of facts.'

There are numerous ironies here. Weston felt that his contact with Lawrence had, by his own terms and standards, been too brief to make a decent sitting – and yet, by 'keeping [him]self open to receive reactions from his own special ego', succeeded in making one of the best

* Lawrence was tacitly on Weston's side grumbling, from his death bed, that Davidson's bust was 'mediocre'.

ever pictures of the author. Lawrence hated 'photographs and things of myself, which are never me, and I wonder all the time who it can be'. As vehemently as Lawrence resisted the idea that 'the me that is *seen* is me', Weston believed, with a passion that never abated, that through photography he could 'present the *significance of facts*, so they are transformed from things *seen* to things *known*' [italics in original]. More than any other pictures of Lawrence, Weston's show — to those of us who never set eyes on him, who know him mainly through his words — what Lawrence really looked like. The very simplicity of this achievement grants it the quality of a revelation.

This encounter between a photographer and a writer serves, among other things, as an illustration and, ultimately, a digressive refutation of Adair's by-about distinction.* But what about photographs *of* photographers?

Everyone who went to the show of Avedon's portraits at the Metropolitan Museum of Art in New York in 2002 knew that the picture of the tousled-haired guy in a sweatshirt was by Avedon; not everyone knew it was *about* Robert Frank. The picture, in other words, was defined by the person who took it rather than the person in it.†

Context, in this context, is all-important. If we see a picture of Strand by Stieglitz in a book or exhibition devoted to the former then it is primarily about Strand; in a book or exhibition about Stieglitz

* Presumably Adair was not entirely convinced by it — why else seek shelter behind the convenient mass of 'the general public'?

† Janet Malcolm notes that Frank is one of the few people photographed by Avedon to 'exhibit an individuality based on character rather than on peculiarities of physiognomy'. It is hard not to see him in Avedon's picture as the objective representative of his own ad hoc aesthetic as seen by its contrary, one that is formal, unchanging. Avedon highlights the contrivance of the photographic session negatively, stripping it down to a no-frills encounter between photographer and subject. The camera will record what's put in front of it. It is up to the subject to make the most of this unyielding contract. Frank opts to make the *least* of it by being determinedly indifferent both to the occasion and to what results from it. His hair is a mess, he's unshaven and wearing a sweatshirt that looks like it might have done time in the basket of the dog whose chin he strokes. 'Do your worst,' Frank seems to be saying, 'and you'll still be doing *more* than I am.' It goes without saying that this is as much a pose as that adopted by the most enthusiastic of Avedon's subjects.

then it is primarily by the former. It is when viewed in a neutral context, in an exhibition devoted solely to pictures of Stieglitz by Strand and Strand by Stieglitz that the issue is brought into the sharpest possible focus. For our purposes this exhibition comprises two pairs of photographs.

Stieglitz made two well-known pictures of Strand, the first in 1917 when Strand was twenty-six. Only a few years earlier Strand had turned up at Stieglitz's gallery at 291 Fifth Avenue and asked him to comment on the work he had brought along. Singling out a blurred landscape that Strand had made in Long Island Stieglitz said that while the soft focus lens gave the image an immediate pictorial appeal, it also made everything – grass, water, the bark of a tree – look the same.* Strand took to heart Stieglitz's advice to clear the fog from his work and soon was making less diffuse, more distinctive work, a selection of which he took back to 291. This time Stieglitz's response was unequivocal: 'This place is your place, too,' he said. As good as his word he showed the pictures at the gallery and printed four of them in *Camera Work*.

By 1917, having pioneered abstraction and candid shots of street life, Strand had advanced the creative potential of the photograph beyond anything that Stieglitz could have prescribed. Acknowledging the gigantic strides made by his protégé Stieglitz devoted the whole of the final issue of *Camera Work* to Strand's new photographs. He had also

According to Adam Gopnik, Avedon's pictures depend on 'a compact between sitter and photographer that an inward psychology exists and that it can be willed outward.' The catch is that once you sit for Avedon you enter into this compact even if – *especially* if – you spend the session refusing to enter into it. There is no way of evading the Avedonion pact: there are just different ways of responding to it. In these circumstances it requires as much effort to project indifference as it does intensity. Indifference, in fact, assumes its own peculiar form of intensity. In this situation there can only be studied indifference. So it is that Avedon captures the steadfast self-belief that Frank needed in order to persist with work that seemed untutored, sloppy, indifferent. Furthermore, in this unforgiving studio light Frank can be seen to have become as (unhappily) compromised or trapped by his ostensibly more adaptable aesthetic as Avedon is by his own uncompromising methods.
* Arbus made an almost identical discovery for herself in 1962, abandoning the 35mm camera in favour of a twin-lens reflex because 'skin would be the same as water would be the same as sky'.

intended to exhibit them but, in the face of mounting financial pressures and the proliferation of galleries showing modern art in the wake of the epochal Armory Show, Stieglitz decided to close the gallery in the spring of 1917. His picture of Strand was taken when the young man was helping Stieglitz to do just that. Strand is wearing an apron, holding a hammer, smoking a pipe, a combination of elements which nicely suggest a trade which is both contemplative and practical, art and craft; a stylistic rejection of the artist as aesthete and dandy in favour of the artist as worker. Stieglitz had used his gallery to urge photography out of the twilight of the painterly; now Strand, who had moved radically ahead of his mentor, was helping him 'to rip 291 to pieces'.

Stieglitz's picture of Strand is reciprocated by one that Strand made of Stieglitz in the same year. Nietzsche, who Strand had been reading at that time, said that only a poor pupil remains a pupil but, *in Strand's view*, the relationship remained that of master and pupil – an impression heightened by the way that Stieglitz looks far older in this picture than he does in a picture done by Steichen a couple of years previously. Stieglitz is wearing a cardigan and a coat, leaning against a printing press. The heavy machinery gives him the look of an industrial magnate. The two pictures cannot but suggest a hierarchy of status: Stieglitz as a captain of photographic industry, Strand as worker or tradesman, apprentice even.

In Stieglitz's later picture of 1919 Strand is wearing a jacket and tie, smoking a cigarette [13]. He could be a writer, a painter, but whatever he is, he is unequivocally a modern master. That one can draw few clues as to his exact vocation is proof of the uncontested parity photography has achieved with the other arts. The mastery Strand has attained as an individual is also an expression of the status attained – largely through his efforts and those of the man behind the camera – by the medium in which he works and by which he is now depicted. He is framed by a blurred painting or photograph which, like the pictorialist heritage, is in the background. He gazes at the camera with what I am tempted – though it could just be the cigarette – to call smouldering confidence. Photography can hold its own alongside painting, art or music. More personally he looks at Stieglitz as an equal. It is a photographic meeting of equals: *by* and *about* are precisely equivalent.

13. Alfred Stieglitz: *Paul Strand*, 1919
© National Gallery of Art, Washington, D.C., Alfred Stieglitz Collection

There is a moment in friendships – sometimes this moment can last a lifetime – of absolute equality. What each person gives is balanced exactly by something that the other contributes, even if one party is unaware of it. Stieglitz recognizes this In spite of himself. What is captured in this picture of Strand, in other words, is both a historic and biographical moment – and that, according to John Berger, is exactly what defines the nature of portraits by Strand: a moment 'whose duration is measured not by seconds, but by its relation to a lifetime'; in the case of this portrait *of* Strand, two lifetimes.

Strand took his second picture of Stieglitz at the older man's house at Lake George in 1929 [14]. Strand and his friend Harold Clurman had stopped off there en route to New England at the end of June. Stieglitz

14. Paul Strand: *Alfred Stieglitz, Lake George, New York*, 1929
© 1971 Aperture Foundation Inc, Paul Strand Archive

was in a state about his wife, Georgia O'Keeffe, who was away in Taos with Strand's wife, Rebecca (Beck). The two women were having a wonderful time together but Stieglitz was tormented about whether O'Keeffe was coming back.* No sooner had he greeted Strand and Clurman than he embarked on 'a long discourse on life, part lament, part harangue' that lasted for hours. Stieglitz had always had a reputation as a talker. In his heyday at 291, Steichen recalled, Stieglitz 'was always there, talking, talking, talking: talking in parable, arguing, explaining'. On this occasion he talked through lunch, talked all afternoon, through dinner and beyond. When Strand and Clurman retired to their room, exhausted by the torrent of words, Stieglitz stood over their beds, still talking.

In view of Stieglitz's wired condition Clurman and Strand decided to stay a few more days. Stieglitz spent his time writing letters to O'Keeffe, supplementing the letters with telegrams, then writing more letters elaborating on what he had said in the telegrams. When

* According to Benita Eisler, author of *O'Keeffe and Stieglitz: An American Romance*, the two women were engaged in a passionate sexual relationship; Richard Whelan, author of *Alfred Stieglitz: A Biography,* thinks this is not likely, 'though they certainly acted as though they were in love'.

Strand returned to Lake George for a longer stay in July the two men, on their own, while their wives were off in New Mexico, found themselves in a condition of relative equality once more. I don't know exactly when Strand took this photo but I like to think it was done the morning after one – if not the first – of Stieglitz's talkathons.

At a certain point friendships arrive at a balance between memories of shared times and the beckoning future. They begin to unravel with the tacit awareness that the store of memories exceeds any that will be generated in the future. This can be followed by a realization that the friendship is all memory-based, when there is nothing but memory, and that in order to protect these memories it is best to call a halt. This is why there is often a feeling of considerable satisfaction in knowing that a friendship is effectively over. For Stieglitz and Strand that moment lay some way off. It would not be until 1932 that Strand, in his own words, 'walked out of An American Place', Stieglitz's new gallery, but the photograph he made of him that summer when the two men were deserted by their wives *looks forward to that time* – to the moment when there would be nothing but memories, when there would be no shared future.

By 1929 Strand had evolved his famously objective and dispassionate style of portraiture. Stieglitz responds in kind. The picture that results from their photographic encounter is an extraordinarily mature version of that childish game of not being the first to blink. Stieglitz looks numbed by his own excitability, dumb with volubility. Interestingly, he looks younger than he does in the picture Strand had made twelve years earlier; in that time the relative difference in ages has come to count for less. They are achieving a different kind of equality: they are two guys whose wives have, effectively, run off with each other. And the lack of the two wives reveals a further lack: of whatever might be left in their relationship to prevent its being defined by the absence of their women. They were left, simply, with the fact of themselves.

Just as there is a phase of equality in friendship so there is also a moment of disequilibrium when one party is aware that this phase is past. When both parties know this then a new frosty or fraught kind of

equilibrium is achieved. It is marked by mutual unease where before there had been mutual ease and relaxation. This unease is intensified by the fact – one of its symptoms – that it cannot be talked about. In the aftermath of Stieglitz's talking, Strand's photograph records all that remains unsaid.

Of Stieglitz – of photographs of Stieglitz – however, more must be said for he was, like Matthew Brady before him, the most photographed photographer of his day. Steichen did an autochrome (an early form of colour photography) of his friend and colleague in 1907. An elaborately posed affair in which the subject plays his part in creating the intended effect, it is pretty similar to an autochrome that Stieglitz did of himself in the same year. There is, in other words, almost no discrepancy between Stieglitz's considerable sense of self-regard and the way that he was regarded by Steichen. In 1911 Stieglitz did another self-portrait in which his face is emerging from the pictorialist darkness. Four years later Steichen photographed him as the impresario of 291, the background cluttered by framed pictures. His hair is shorter but the moustache (already greying in the 1907 portrait) and features are almost unchanged. The difference, very slight, is in the expression: a hardening of the mouth and eyes. The change from Steichen's 1907 portrait to this one is not particularly striking, nor is the change from this portrait to Strand's of 1917, but the change from the Steichen of 1907 to the Strand of 1929 is dramatic. What this relay of portraits enables us to do is to see Stieglitz changing in two ways: unnoticed and imperceptibly as he must have appeared to those in regular contact with him, and dramatically in ways that are perceptible only to those who re-encountered him after gaps of several years. Without these incremental links the psychological seeds of Imogen Cunningham's 1934 portrait would not be apparent in Steichen's of 1907; with them they become retrospectively determining.

Cunningham's picture is especially intriguing because, having neglected to bring her own 8x10 camera, she used Stieglitz's. In a strictly mechanical sense, then, it is a self-portrait. Stieglitz is leaning in front of an O'Keeffe painting at An American Place, wrapped up in an

overcoat, left hand held loosely by his right [15]. In 1914 Cunningham had written 'frankly' to Stieglitz that her 'ambition' was 'to be represented in *Camera Work* some day'. (The magazine ceased publication in 1917, before that ambition could be realized.) Twenty years later, after photographing Stieglitz and 'watching [him] like a hawk', she wrote again, explaining that the visit had 'confirmed my ancient memory of you as the father of us all'. For his part, Stieglitz often thought back to her visit 'with pleasure'. And both he and O'Keeffe were 'delighted' with the prints even though, he added, 'I never know about portraits of myself.' Perhaps this was not such a bad thing for if Cunningham really did regard him as a father figure then there was something almost patricidal about the photograph. Late in her own life Cunningham looked back with pleasure at having caught 'that grim little look in the

15. Imogen Cunningham: *Alfred Stieglitz*, 1934

eye, you know, disliking everything and everybody'. Including, it should be said, himself.

Particularly towards the end of his life, Stieglitz, despite his overwhelming influence on art in America, felt his endeavours to have been in vain. During bouts of depression to which he was prone, Stieglitz regarded himself as a failure and his efforts as futile. It was in the midst of one of these periodic fits of despondency that he was approached, in May 1944, by Usher Fellig, better known as Weegee.

Weegee shared Stieglitz's early obsession with the technical diffi-culties of photographing the city at night but had pursued this enthusiasm from a very different starting point and to wholly different ends.

While Stieglitz, as Walker Evans never tired of pointing out, had always been able to rely on a private income, Weegee left school at the age of fourteen to help support his family. In 1914, aged fifteen, he moved out of the family home and scraped by on a mixture of odd jobs (including playing violin in a silent movie theatre on Third Avenue). For some of this time he was homeless, living on the streets whose tragedies and drama would become his stock-in-trade in the 1930s. Frankly sensationalist, Weegee's work of this period is a far cry from the pure – or, as Evans would have it, 'screaming' – aestheticism of Stieglitz's. The latter had claimed, in 1896, that 'Nothing charms me so much as walking among the lower classes, studying them carefully and making mental notes. They are interesting from every point of view.' The sentiment might be genuine but the tone conveys the essen-tial aloofness and detachment of Stieglitz's relation to those he studies and, in the famous photo *Steerage*, looks down on [44]. Having grown up among the lower classes Weegee devoted himself to profitably cap-turing their lives in flashlit close-up. Simultaneously exploiting and empathizing with his subjects* – 'I cried when I took this,' he famously

* As one might expect, Arbus was a passionate admirer of Weegee's work: 'He was SO good when he was good,' she wrote in 1970. 'Extraordinary!'

said of a picture of two women watching a relative die in a blaze – Weegee was a commercially savvy operator who worked relentlessly to secure his reputation as the photographer-king of the New York underworld.

By the time of their meeting, the contrasts in the fortunes of Stieglitz and Weegee could hardly have been more marked. They were like two buckets in a well, one on the way up, the other on the way out. Already notorious as a crime photographer for the tabloids Weegee was on the brink of the nation-wide fame he had craved for years (it would come, the following year, with the publication of his book *Naked City*). Stieglitz, though, was dejected, animated only by his myriad grievances. In the back room of An American Place, Stieglitz talked to the in-demand photographer for hours, pouring out his disappointments and worries. 'It never rings,' he said, pointing to the phone by his cot. 'I have been deserted'. Weegee thought the room smelled of disinfectant 'like in a sick room'. Stieglitz said that he hadn't made a picture in ten years, that 'the rent was not going to be ready and he was afraid he was going to be dispossessed'. Then he suddenly 'slumped over in pain. "My heart, it's bad," he said in a whisper as he slumped over on the cot'. Weegee 'waited till he recovered then left quietly' – though not, it hardly needs saying, before immortalizing his visit in a photograph [16]. Stieglitz sits on his cot, wrapped up in a waistcoat, jacket and overcoat. The moustache is clipped in exactly the same way that it has always been but his white hair is thin, wispy. His hands are on his knees. He stares blankly into the harsh light of the flash which sends his shadow sprawling back on to the pillows behind him.

He is still there on the cot when photographed, in June 1946, by a less brash admirer, Cartier-Bresson. It is as if, in the interim, Stieglitz has hardly moved. In Cunningham's picture he was standing; in Weegee's he sat forward on his cot; in Cartier-Bresson's he is leaning back, wearing a sleeveless cardigan rather than his usual insulation of coats and jackets. The relaxed pose could be that of one of the young men photographed by Nan Goldin in an East Village studio in the 1980s – but this is an old man whose energy is draining from him. And it is from this, I think, that the gentleness of the picture derives. Energy

16. Weegee: *Stieglitz*, 7 May 1944
© akg-images/Weegee

can be a goad, a source of torment as well as sustenance. In a way Stieglitz ended up worn out by his own prodigious energy. Sometimes, he had written to Edward Weston a few years earlier, he wondered if life was 'worth the torture, but somehow one fights on'. The knowledge that the time would soon come when he would be free both of the torture and the need to fight on was as comforting as the pillows stacked up behind him. He could relax back into them at any moment. Knowing this brought with it an easy acceptance of the fact that (as he had written to Weston) he was 'an old man. Maybe have been an "old man" for many years'. This knowledge, the opposite of energy, was a source of contentment rather than torment. Within three weeks of Cartier-Bresson taking this photograph Stieglitz, who had 'all but killed [him]self for photography', would sink back, close his eyes and never open them again.*

* In his letter to Weston Stieglitz lamented the way that, while photography seemed to be booming, there was 'so little vision. So little true *seeing*.' Several years ago John Berger told me how he had visited Cartier-Bresson (then about the same age that Stieglitz had been when he had photographed him in 1946). What struck Berger most about Cartier-Bresson were his blue eyes which, he said, were 'so tired of seeing'.

By all means tell your board that P. H. has been definitely a part of my
development as an artist, tell them it has been the most important
part, that I like it brown, black, red or golden, curly or straight, all
sizes and shapes.
Edward Weston (responding to objections by the directors of
the Museum of Modern Art to prints showing pubic hair)

Like Strand – like so many aspiring American photographers in the
early twentieth century – Edward Weston had made a pilgrimage to
show his photographs to Stieglitz who was critical and encouraging.
'Quick as a flash he pounced upon the mother's hands in *Mother and
daughter*,' remembered Weston. Stieglitz also showed Weston a few of
his photographs of O'Keeffe: 'the hands sewing, the breasts, a rather
abstract nude'. That was in 1922, the year after Stieglitz had exhibited
more than forty photos of O'Keeffe at the Anderson Galleries – the
first selection from an ongoing composite portrait that continued,
intermittently, for another fifteen years. Visitors to the exhibition were
shocked at the intimacy and overt sexuality of some of these pictures.
Their frankness is less surprising if one bears in mind that, for a decade
and a half, Stieglitz had been stuck in an all but sexless marriage.
Stieglitz had been looking forward to photographing his fiancée, Emmy,
in the nude once they were married. As far as one can gather that is
pretty much the only aspect of an evident mismatch he was keen on.
And then, when they *were* married, in 1893, she wouldn't let him. She
was worried he'd show the pictures to his friends – and she wouldn't
have sex with him either.

Aged fifty-three when he became involved with O'Keeffe in 1917,
Stieglitz wasted no time in photographing his new lover. He liked
photographing O'Keeffe's hands and he also liked photographing her
breasts. When he combined these two passions he made O'Keeffe
look, bizarrely, as if she were examining herself for possible tumours.
Either that or Stieglitz must have instructed her to imagine she were
trying to make bread. There are a surprising number of these pictures
and it is hard to tell just what Stieglitz was getting at. In circumstances
like this one can imagine a photographer asking his model to 'touch',

'stroke', 'caress' or 'fondle' herself; Stieglitz's preferred verb seems to have been 'knead'. Looking at these baffling pictures – judging by her expression, O'Keeffe was no wiser than the rest of us – does, however, serve a useful purpose. Not to put too fine a point on it, one becomes impatient for O'Keeffe to get the rest of her kit off.

Having photographed her hands endlessly, over and over, Stieglitz photographed O'Keeffe's body as if the camera were a hand moving longingly over her. Stieglitz said that when he photographed he made love.* Looking back on their life together O'Keeffe, in 1978, was more literal about the order of things. 'We'd make love. Afterwards he would take photographs of me.' After that he'd disappear into the dark-room and look at the pictures of his naked lover – the pictures he'd been wanting to do for God knows how long. Whenever Stieglitz exhibited selections from these pictures he tantalizingly kept back the most explicit ones because, he felt, 'the general public is not quite ready to receive them.'

Lucky us, we can see them all – even the most revealing.† Except Stieglitz printed them in such a way that they're not revealing at all. In 1918–19 he made a series of seven intimate portraits of what he termed O'Keeffe's 'torso' [17]. In six of them her legs are demurely closed; in one of them her legs are wide open but Stieglitz – spoil-sport! – has printed it so that her pubic hair is a mass of ink-dark shadow. For Janet Malcolm this is what 'gives the picture its tremen-dous erotic impact' and 'saves it from being lewd and unprintable in an art book'. That was in 1979. These days any self-respecting exhibition of nude photos has to have pornographically explicit images to prove that they *are* works of art. More importantly, the erotic power of Stieglitz's pictures would be enhanced if we could see more. I am not simply echoing Norman Mailer's outraged claim that, in her notorious *Sex* book, Madonna 'should have had a beaver shot' of herself and that

* Evans felt the same way. 'My work is like making love,' he told an interviewer in 1947.
† Or perhaps not. Benita Eisler claims that there also exist 'sexual explorations of her body so intimate that they have yet to be published or exhibited.' These prints apparently 'play out darker chapters in the relation between the photographer and his subject'.

17. Alfred Stieglitz: *Georgia O'Keeffe – Torso*, 1918–19
© National Gallery of Art, Washington, D.C., Alfred Stieglitz Collection

the lack is 'an evasion'. No. Eroticism is all about subtlety, and, as printed, subtlety is exactly what the picture lacks: the heavy 'dodging' employed by Stieglitz is crude – a negative equivalent, in fact, of soft porn airbrushing. To pick up on his own favoured metaphor of tactility, it is heavy-handed.

As it happens, we can judge for ourselves, for in 1921 Stieglitz took a roughly similar shot and printed it in two different ways. These two prints, numbers 676 and 677 in the so-called Key Set, show O'Keeffe with her legs fractionally less open than in the 1918 series. 677 is printed like the earlier negative so that there is an impenetrable black triangle between her legs. 676, however, is slightly more reveal-ing and infinitely more effective: her pubic hair looks like pubic hair, not shadow, and in the midst of it we can just make out the impression

of her pussy. Printed like this the picture achieves a perfect balance between delicacy and frankness. Malcolm argues that the dark printed picture conveys exactly the same sense of sex as a mysterious, 'profoundly serious, almost religious experience' which 'reached its apogee in the novels of D. H. Lawrence'.* Quite right too. But no aspect of Lawrence's writing has aged less well than the passages dealing with the phallic seeking out and the loins of darkness. As in the worst of Lawrence, the dark print is dated. Its longing is a species of dread. Like Cal in Bernard McClaverty's novel, it is 'sullen with lust'; the other, like the desire of which it is the object, is timeless, light.

Stieglitz is not the only great photographer to have made erotically charged pictures of his wife but he is, perhaps, the only great photographer to have made erotically charged pictures of another great photographer's wife.

It seems O'Keeffe was not romantically attracted to Stieglitz when they first met but, like everyone else, she was somewhat mesmerized by him. Although she spent a lot of time with Stieglitz in New York when she travelled from Texas for a brief visit in May 1917 it was, apparently, Strand that she fell for. By the time she returned to Texas both photographers were in love with her. The following May Stieglitz dispatched Strand to Texas, partly to nurse O'Keeffe (she was suffering from depression and flu; there were fears that she might succumb to TB) and partly to persuade her – on Stieglitz's behalf – to come to New York. Strand stayed for a month and, at the end of May, O'Keeffe agreed to travel east. She arrived in New York in June; by mid-July Stieglitz had left Emmy and he and O'Keeffe moved into a studio together ('O'Keeffe and I are One in a real sense,' he crowed). In September Strand was inducted into the army. When he returned to New York a year later Stieglitz and O'Keeffe were settled as a couple and a creative partnership.

* Stieglitz was a great admirer of Lawrence's work, particularly *Lady Chatterley's Lover*. He was also keen to exhibit the novelist's controversial paintings – an eagerness partly explained by the fact that he had never actually seen them.

In 1920 Strand met Rebecca Salisbury who, physically, was strikingly similar to O'Keeffe. As Stieglitz had done a few years before he began photographing his beloved, a project that continued after they were married, in February 1922. The two couples became close – almost too close. To Stieglitz and O'Keeffe it seemed that Strand was trying to duplicate both their relationship and their ongoing photographic collaboration. Things became more complicated when Beck spent some of the summer of 1922 with Stieglitz and O'Keeffe at Lake George. While Strand was working in Maryland, Stieglitz did a number of portraits of his friend's wife. Beck was 'really first class as a model,' he wrote to another friend, 'but somehow I am unable to make my end work as I want it to. Perhaps I'm trying nearly impossible things – but somehow when I do get a good negative I jab holes into it or do something equally destructive to it.' To Beck herself he wrote, 'For an hour or more I have been tickling up your rear into most perfect condition of delight'. Less flirtatiously, he stressed the unambiguous results of their sessions which, he claimed, 'clarify some things'. He was confident that 'Paul will be glad too when he sees the results'. Stieglitz was referring to the 'portraits' he had made, but if the nudes 'clarify' anything it is that Stieglitz – who said that he made love when he photographed – was looking on his friend's wife with undisguised longing.* What Strand made of them is anyone's guess. From portraits in the hay they move to the lake where Stieglitz photographs Beck floating in the water. One picture shows her from just below her breasts to almost her knees, her skin stroked by the light-rippled water. In another intoxicated image the frame is extended so that we see her breasts as well, one nipple just breaking the surface of the water [18]. Another shows her standing in water which reaches just to her naked pussy. These three pictures are the erotic climax of the shoot. Thereafter Stieglitz seems to have asked her to start – you guessed it – kneading her breasts. She

* According to Benita Eisler the relationship between Stieglitz and Beck was consummated in September 1923, while Strand was in Saratoga and O'Keeffe in Maine.

18. Alfred Stieglitz: *Rebecca Strand*, 1922
© National Gallery of Art, Washington, D.C., Alfred Stieglitz Collection

complies but, in these and other pictures, we glimpse the look of barely concealed impatience that one notices again and again in pictures of O'Keeffe.

As far as I can tell, this photographic game of mixed doubles was entirely one-sided. Strand did no nudes of O'Keeffe. He seems actually to have done only a few nudes of Beck (none of which he bothered printing), thereby lending credence to Stieglitz's remark – to Rebecca – that his own photographs were 'entirely different from [Strand's] things of you'. While Stieglitz had made love to his friend's wife photographically Strand observed her with intense psychological scrutiny. He photographed her bare shoulders; he photographed her sleeping. Her face is monumental, brooding. Stieglitz noticed in her 'a messiness somewhere which will ever remain messy'; Strand conveys a heaviness in her soul. Something about her was old even when she was young and in Strand's pictures you can see her, as it were,

ageing before your eyes. She blossomed briefly in those pictures of Stieglitz's but Strand succeeded in capturing a melancholy lying in wait. She was one of those free spirits of the early twentieth century who all the time felt the nineteenth century bearing down on her shoulders. She is torn between stillness and motion, between confinement and liberty. For someone of only limited creative talent, the artistic freedom that Strand, Stieglitz and O'Keeffe urged her to develop became an obligation and confinement in itself. All of this is conveyed in Strand's pictures of his wife. She claimed to be happy, she *was* happy but, at some level, Strand – or, more exactly Strand's camera – saw that her destiny was not a happy one. Strand had loved O'Keeffe; Rebecca had been photographed – made love to – by Stieglitz. She never gave herself to Strand photographically as she had to Stieglitz. But a condition of her doing so was that Stieglitz's photographs did not show her face. Her happiness was impersonal, not identifiably her own.

Beck killed herself in 1968, long after she had separated from Strand with whom she remained friendly. Brandt believed that the oracular powers of a good portrait were such that it 'could suggest something of [the subject's] future'. More explicitly, Arbus claimed it was possible to see the suicide in people's faces. But how far in advance of its happening does this become apparent? At what age?

To recap, Stieglitz became irritated that Strand's pictures of Rebecca intruded too much on turf he and O'Keeffe had staked as their own. Stieglitz, in other words, was jealous that Strand was photographing his – i.e. *Strand's* – wife. Strand, meanwhile, was not permitted to be jealous that Stieglitz had photographed his wife more sexually than he ever would. It was equally out of the question that he might be permitted to photograph O'Keeffe as Stieglitz had photographed both his own and Strand's wife. This tight knot of friendship, support and rivalry expressed something fundamental about relations with Stieglitz: he would support and promote and help you all he could, selflessly. He would do all that, but you could not be intimate with him unless you

could tolerate his urge to dominate.* He couldn't practise photography without mastering it, and he wasn't satisfied by that mastery until he had elevated the medium itself to a position alongside the art of Picasso or Cézanne. Richard Whelan cleverly identifies this tendency at the outset of his biography: 'afraid he could not be loved for who he was, he resolved to ensure that he would at least be loved for what he did'. Even his generosity was part of an urge to dominate. He could not know another man without achieving some kind of ascendancy over him, even if – as happened with the young Strand – this manifested itself through bestowal and patronage.

In 1923 Waldo Frank told Stieglitz that he was 'incapable of a relationship of equality with anyone'. At some level his love for O'Keeffe was inextricable from a desire to dominate her. Looking back on his composite portrait O'Keeffe recalled it as a joint undertaking in the sense that 'you had to collaborate . . . you had to sit there and you had to do what you were told.' If the project was a success that was because something in O'Keeffe – an 'astonishingly aggressive woman', as Joan Didion described her – remained stubbornly resistant to and independent of his intentions in spite of her willingness to comply. This was exactly what rendered her endlessly and elusively fascinating to Stieglitz as both lover and photographer. Stieglitz was always looking for what he came to call 'equivalents' for his innermost feelings. Flitting in and out of something that is never quite beauty but is often very close to it, O'Keeffe consents to this lop-sided collaboration without ever being reducible to an 'equivalent'.

By comparison, Dorothy Norman – who, in 1927, became an infatuated assistant, disciple and, eventually, lover – looked at Stieglitz like an adoring puppy, or a seal about to be clubbed. She struck

* Actually, the word that keeps coming up in accounts of Stieglitz is not 'dominate' so much as 'absorb'. Clurman wrote to Strand in 1932 that 'Unless you can be close to Stieglitz without being absorbed by him . . . he is not health.' Beck was even quicker to pick up on this, asking Strand in 1920, 'Aren't you absorbing too much of Stieglitz?' Weston certainly thought he was, writing in 1942 that he 'found too much of Stieglitz in Strand at that time' (the early 1920s).

O'Keeffe as 'a person with a mouthful of hot mush' but Stieglitz was intoxicated by – or, as O'Keeffe saw it, 'very foolish about' – her. During one photographic session in 1931 Stieglitz said 'I love you'. After some coaxing Dorothy then uttered his name. 'Alfred,' she whispered. What he saw and preserved on film at that instant of transfiguration was, Stieglitz wrote to her later, 'God's light in your Face'. It was the day 'you heard the Voice – you saw the Light'. In 1923 Stieglitz had modestly reported to Hart Crane that some people who had seen his cloud studies or *Equivalents* felt he had 'photographed God'. Here he had photographed the face of someone worshipping their God.

Lest we get carried away by Stieglitz's own idea of what was at stake in these portraits it is worth remembering that the seal's position of extreme vulnerability is also one of precarious insight. As well as embarking on a series of photos of Norman (just twenty-two when they met), Stieglitz bought her a camera and encouraged her to take her own pictures – many of which are of the man she loved and revered. In a sequence from 1935 Norman focuses tightly on the liver-spotted hands holding his spectacles. In others we see him lying back on pillows or curled up on a sofa as if remaining awake is using up all his energy.

After all their long and often troubled years together O'Keeffe wrote, in the early 1940s, that she had come to 'see Alfred as an old man that I am very fond of'. However exalted her feelings for him, Norman's camera cannot but see Stieglitz in the same way: as an old, very tired man. If we knew nothing about either the photographer or subject we would assume these were pictures of an old man taken by his granddaughter. The fact that Norman looked on him so fondly, indulgently, did not blind her to his faults.

In Stieglitz, the will to power was both highly and insufficiently developed. Highly developed in that he had to overcome others; inadequately developed because he was powerless to achieve the ultimate Nietzschean project of *self*-overcoming. The devoted Norman was as alert to this as the fiercely unsentimental O'Keeffe who 'put up with what seemed to me a good deal of contradictory nonsense because of what seemed clear and bright and wonderful'. A month after Stieglitz's

death Norman wrote to Steichen that although adept at getting others to question themselves 'his whole philosophy was based on evasion of questioning himself.'

For everyone else there was no question of evading or avoiding him. As photographer, curator, impresario and polemicist Stieglitz had established photography as an art in America. A monument to his own achievements, he was, as Edward Weston concisely put it, 'a Napoleon of art'. When Weston showed him his prints in 1922 this 'superb egoist' 'spoke with the idealism of a visionary'. The intensity, force and extent of Stieglitz's influence meant that to extricate themselves from it people had to reject him wholeheartedly. For Evans this was quite simple: the 'heavy tenets and manner' of this 'screaming aesthete' practically obliged one to work in 'inspired *opposition*' to him. For others such opposition amounted to a form of regicide, or deicide even.

After meeting Stieglitz in New York, in 1922, Weston headed back west. Then, in 1923, he travelled south to Mexico City with Tina Modotti. Shortly after settling there, Weston dreamed that someone told him 'Alfred Stieglitz is dead.' Weston was immediately aware of the 'great import' and 'symbolic significance' of this. For years Stieglitz had been 'a symbol for an ideal in photography' to which Weston had devoted himself. Immediately he realized that this dream pointed towards 'a radical change in my photographic viewpoint'.

In May 1927 a friend wrote to Weston, by then back in Glendale, California, that Stieglitz felt that his 'prints lacked life, fire, were more or less dead things not a part of today.' These reported remarks immediately reminded Weston of the dream he'd had in Mexico and brought home forcefully that he and 'too many others' had put Stieglitz on 'a pedestal'. 'One admits the fall of a hero unwillingly,' wrote Weston, but by 1932 he had managed to do just this. He was willing to give Stieglitz 'all due credit for an important contact at a moment in my life when I knew what I wanted, and got it. That time has long since passed.' Stieglitz, though, was not happy to be relegated to the dustbin

of past influence in this way, grumbling, in an article published in *Creative Art* in 1928, that Weston had cited painters and writers as forces in his life but had 'avoided mentioning photographers' (by which Stieglitz principally meant himself). Weston, needless to say, was outraged by this but dismissed it as part of the older man's habit of 'boresome whining'. And so, in part, it was. In other ways Stieglitz's response to the article was insightful. Writing to Strand in September 1928, Stieglitz expressed his fear that Weston, 'fine a fellow as he is, has a goodly streak of the American pseudo running through all of him . . . If he'd only forget trying to be an artist – maybe he'd come close to being one.'*

In the wake of all this reverential back-biting and anguished admiring it is pleasant to note that Stieglitz's last letter to Weston – the one in which he laments the lack of 'real seeing' – is warm-hearted and generous. After telling him that he, Stieglitz, is incapable of cynicism, jealousy or envy, he congratulates Weston on his forthcoming wedding. That was in 1938, the year after Stieglitz made his last photographs.

The two men spent the bulk of their lives on opposite sides of the continent. They met twice but never photographed each other. These words – what they said about each other – are a substitute for the photos that do not exist. That's one way of looking at it. Another would be that they met, repeatedly, in their work.

Leaving aside those few photos of Rebecca Strand, Dorothy Norman and the odd shot of his niece, Georgie Englehard, the mass of Stieglitz's nudes are of one woman – O'Keeffe. Weston, on the other hand, had an amazing number of girlfriends, all good-looking and all more than happy to take their clothes off for him. He was one of those men who, as they say, got more ass than a toilet seat. The expression is particularly apt in Weston's case since, photographically at least, he got quite a bit

* A fine example, it might be said, of the pot calling the kettle black. For Evans Stieglitz was 'undoubtedly the most insistently "artistic" practitioner of all time; with the adverse effect that it was he who forced "art" into quotation marks and into unwonted earnestness.'

of toilet as well. Weston had long considered photographing 'this useful and elegant accessory to modern hygienic life', but only got round to doing so in Mexico, in October 1925. Drawn to the 'extraordinary beauty' of its functional and glossy enamel he became completely 'thrilled' when he first saw it in the ground glass of the camera: 'here was every sensuous curve of the "human form divine" but minus imperfections.' There is no irony here (Weston seems to have been temperamentally incapable of such a thing). For Weston, the fact that humans – Swift's Celia, most famously – needed to go to the toilet did not constitute one of the imperfections of the human form. According to his biographer Ben Maddow, part of the attraction of Charis Wilson, whom he met in 1934, was that she was a new type: educated, aristocratic, 'but coarse and open about sex and the less interesting functions'.

Part of Weston's interest in the toilet was the way that its form was a faithful expression of its function. Conveying this beauty proved more technically difficult than he envisaged, partly because he worked under great stress, 'fearing every moment that someone being called to nature would wish to use the toilet for other purposes than mine'. He admitted to being disappointed by several results but, after much persistence, ended up with several negatives. Choosing which one to print from was problematic, though, because he was not sure which of his 'loves, the old or new privy [I] like best'.*

Within a few days he had commenced a new series of pictures: nudes of Anita Brenner. Though not very enthusiastic at first, he soon became as excited by her 'aesthetically stimulating form' as he was by the toilet. What he admired in this, his 'finest set of nudes', was that 'most of the series are entirely impersonal, lacking in any human interest which might call attention to a living, palpitating body'. Viewed in this light there was nothing to choose between an ass and a toilet,

* Weston, apparently, was unaware that Stieglitz had exhibited Duchamp's urinal – or *Fountain* – at 291 and photographed it for a little magazine called *The Blind Man*, in 1917.

though, needless to say, Weston derided philistines who equated the two.

By July 1928 he had 'a new love', Fay Fuquay, of whom he had taken

> one extraordinary negative. She bent over forward until her body was flat against her legs. I made a view of her swelling buttocks which tapered to the ankles like an inverted vase, her arms forming handles at the base. Of course it is a thing I can never show to a mixed crowd. I would be considered indecent. How sad when my only thought was the exquisite form. But most persons will only see an ass! – and guffaw as they do over my toilet.

Weston made a print of this 'posterior view' in March 1929 and was struck by its sculptural qualities: 'the figure is presented quite symmetrically, great buttocks swell from the black centre, the vulva, which is so clearly defined that I can never exhibit the print publicly – the lay mind would misunderstand.' Effectively this view of the posterior was only for the eyes of posterity.

Weston was as dismissive of the psychoanalytically educated mind as he was of the lay mind, responding contemptuously when people pointed out the orifices and phallic forms in the rocks he photographed obsessively. Only someone who was sexually repressed would need to go to these lengths, he insisted. Weston was utterly unrepressed sexually and knew exactly what he liked. He liked form and he liked women in equal measure – and the camera was his way of having both. Although at various times he had referred to models and privy as his 'love', he observed both with the thing that was 'perhaps my only love': the camera.

One of the reasons that so many women were happy to pose nude for Weston was that he left them in no doubt that they did so in the service of high art (of which he was the diminutive embodiment). This was not just 'kisses and embraces in the darkroom' (though there was a lot of that too); this was *work*. Weston goes on and on about the 'Herculean task' of making negatives and doing prints, about the way

that all this effort was so back-breaking as to bring him to the brink of nervous exhaustion.*

As if photography weren't exhausting enough, there were the practical difficulties posed by the sheer number of women throwing themselves at him: 'Why this tide of women?' he asked himself. 'Why do they all come at once?' Whereas Weston was always seeking out new subjects to photograph, with women it was the opposite way round: 'I never go out hunting affairs, they seem presented to me.' At other times Weston recognized that his sexual promiscuity was difficult to disassociate from his myriad photographic passions. In 1928, reacting against his own 'ridiculous' hope for a settled and monogamous life, he realized that to 'go through life with one woman . . . would be analogous to making my last print, nailing it to the wall forever, seeing it there, until I would despise it or no longer notice it was there.' This intimate relation between photography and desire in Weston's life and work is brought out most clearly in his famous account of a portrait of Tina Modotti taken in 1924.

Like Weston, Tina had been effectively, if not legally, married when their affair began in 1921; her 'husband', the artist Robo Richey, died of smallpox early in 1922, in Mexico, where he was trying to organize an exhibition of photographs by, among others, Tina's lover. After his death Modotti completed plans for the exhibition, the success of which was instrumental in tempting Weston to go south with her. The idea was to set up a photographic studio with Modotti serving as an administrator and guide. In return Weston would teach her photography.

It was an exhilarating time to be in Mexico City. 'There was,' in Bob Dylan's famous words, 'music in the cafés at night and revolution in the air'. And there were raucous parties too, during which Weston enjoyed dressing up in Tina's clothes, swilling tequila, flaunting his fake breasts ('with pink point buttons for nipples') and exposing his 'pink gartered

* Stieglitz was also at pains to stress the immense sacrifices and Balzacian labour demanded by photography. *Winter, Fifth Avenue* of 1893, for example, was 'the result of a three hours' stand during a fierce snow storm on February 22nd, 1923'. *Icy Night* was done, he claimed, in the midst of a fierce gale when he was recovering from pneumonia.

legs most indecently'. The fact that these antics 'shocked' some onlook-
ers only heightened his enjoyment. As well as being intoxicating and
liberating, though, the couple's relationship became increasingly fraught.
As is the case in any self-respecting bohemian scene, they insisted on their
right to take other lovers. Jealousy was made more tormenting by the
way that it was supposed to have been outgrown. Weston's numerous
pictures of Tina sunbathing, naked, on the Azotea are luxurious, inflamed
with desire, but the 1924 portrait records the tensions and frustrations
simmering beneath an ostensibly idyllic and open relationship. With its
combination of emotional-sexual intensity and obsessive technical preci-
sion, Weston's description of how it came to be made is unsurpassed in
the history of photography: 'She called me to her room and our lips met
for the first time since New Year's Eve — she threw herself upon my prone
body, pressing hard — hard — exquisite possibilities — then the doorbell
rang . . .'

The mood was broken but next morning, under the brilliant
Mexican sun, Weston resolved to do a portrait which would 'reveal
everything — something of the tragedy of our present life'. And so it
came about that Tina

> leaned against a whitewashed wall — lips quivering — nostrils dilat-
> ing — eyes heavy with the gloom of unspent rain clouds — I drew
> close — I whispered something and kissed her — a tear rolled down
> her cheek — and then I captured forever the moment — let me see
> F.8–1/10 sec. K 1 filter — panchromatic film — how brutally
> mechanical and calculated it sounds — yet really how spontaneous
> and genuine — for I have so overcome the mechanics of my camera
> that it functions responsive to my desires — my shutter co-
> ordinating with my brain is released in a way — as natural as I
> might move my arm — I am beginning to approach an actual attain-
> ment in photography [. . .] The moment of our mutual emotion
> was recorded on the silver film — the release of those emotions fol-
> lowed — we passed from the glare of sun on white walls into Tina's
> darkened room — her olive skin and sombre nipples were revealed
> beneath a black mantilla — I drew the lace aside . . .

Photography does not permit the same freedoms as painting. Pierre Bonnard painted his wife Marthe for almost forty years – but always as she looked at the age of twenty-five. Stieglitz faithfully photographed O'Keeffe as she changed and aged. Weston aged but was drawn, consistently, to a particular physical type of woman of a certain age (Modotti was twenty-four when they met, Weston ten years her senior). To keep photographing this woman he had constantly to rediscover her in new incarnations, to trade her in for newer and younger models. He was forty-eight when he met Charis Wilson in 1934; she was nineteen.

From his journals – what he termed *Daybooks* – Weston emerges as a compact, wilful little guy, unwaveringly serious about his art, resolutely selfish and prone – especially if mechanical things broke or didn't work properly – to sudden losses of temper. Even his anti-bourgeois non-conformist bohemianism had a determined, uptight quality to it. He still loved parties and 'gaiety', but by the time Charis met him he had become habituated to a strict regime of health and artistic efficiency. When she came to live with Edward and his sons in Los Angeles in the summer of 1934 she was struck by the way that his boys had mastered an array of skills that made them more practical to their father than she was. Charis was immediately enlisted in the Westons' regime of frugal self-sufficiency, but her main task – the one only she could perform – was to be the gorgeous young woman featured in some of Weston's greatest photos.

Janet Malcolm finds Weston's nudes 'sexless and impersonal' and, compared with Stieglitz's of O'Keeffe, 'timid and repressed'. It is true that, at various times, Weston was fixated by the abstract potential of the naked human body, that in some of his pictures the object under scrutiny could as well be a pepper as a female body. But many of his nudes – especially of Charis – are as erotically charged as any ever made. Even the ones that are not especially erotic – like the one of Charis floating in the pool at her father's home after his death in 1939 – are intimate and deeply personal. If some are 'impersonal' that says something about the nature and power of the sexual current coursing through them. Weston may not have thought of his pictures 'in erotic

terms', but in the photographs he made of Charis in the Oceano dunes in 1934 she doesn't simply look aesthetically pleasing or even beautiful, she looks like she's just woken up from some lovely, horny dream of pure art or pure sex, and in this slightly dozy state can't remember which, only that Edward figured prominently in both. In a 1937 picture of her stretched out on an arid, barren landscape, lying on a blanket of shadow, shielding her eyes from the glare, it is as if even the sun cannot tear its gaze from her. [19]*

The erotic force of the nudes is in no way diminished by the fact that, in the most sexually alluring of all the pictures Weston took of Charis, she is fully clothed. This is the photo taken on a hiking trip at

19. Edward Weston: *Nude, New Mexico*, 1937

* I first saw this picture in 1989, while living in New York with my girlfriend of the time. I was thirty-one; she was twenty-three. One day she came home with some books salvaged from a skip that had been loaded up with water-damaged stock from a used book store where there had been a flood. One of these books was a once-handsome, now nearly ruined edition of photos by Weston. She used a couple of landscapes in a piece of art she was working on. I tore out and kept two badly buckled pictures: this one of Charis and the one he'd done of Lawrence in 1924. That was when I became interested not just in what the picture was about, but who it was by.

Lake Ediza in 1937 [20]. She's wearing knee-length walking boots, her hair is swathed in a thick scarf to keep mosquitoes at bay. By her own account, she was exhausted — but she still looks like a model from a special outdoor issue of *Vogue*. (Weston may have been entirely uninterested in glamour, but this is one of the most glamorous photographs ever taken.) She is sitting with her back against a rock that looks like a prehistoric version of one of Brassaï's graffiti-scarred walls. She gazes at the camera, 'knees akimbo, hands crossed loosely between [her] legs'. This accurate description needs to be elaborated on somewhat. The hands are as elegant and pure as the Buddha's but the sexual connotations of their arrangement, enhanced by a crease in her trousers, just to the left of the sex that they conceal, are unmistakable. All the time you are looking at it the picture forces you to wonder, with heart-thumping curiosity, what it would be like if she *were* naked.

It's an amazing picture, proof of something which, during the 1970s and 1980s, was almost taboo: that to be seen, to be photographed like this, can be as great a destiny as that of the artist who made the work. Weston cleverly allowed Charis to glimpse this possibility when, as soon as she came to model for him, he demonstrated the

20. Edward Weston: *Charis, Lake Ediza*, 1937

workings of the camera to her. Looking under the hood she was aston-
ished by 'the brilliance and clarity of the picture transmitted by the
4x5-inch mirror' of the Graflex. It was an intimation of what she her-
self could become, of how she might appear.* Charis recalls these early
meetings many decades later in *Through Another Lens*, the memoir writ-
ten when she was in her eighties. What knowledge, when you are old,
to know not only that you once looked like this but to be able to see
that, in the unique temporal preserve of the photo, you still do.
Whereas O'Keeffe, looking back on the photos Stieglitz made of her,
did so somewhat grudgingly – 'It was something *he* wanted to do' –
Charis relished this vision of her youthful self.

Charis, in this picture, is a few years younger than Dorothy
Norman on the day Stieglitz photographed her as she 'saw the Light',
but she is confident of her own role as a collaborator in the production
of a work of art. The peculiar boon of photography is that the model is
directly involved in the finished work of art – rather than in the process
of its creation – in a way that Bonnard's Marthe or Picasso's Marie-
Thérèse Walter are not. If, as Arbus would later insist, 'the subject of
the picture is always more important than the picture' then Charis, the
model, is more important to the result than the man taking it. Had he
been there at the time and taken the photo from the same angle, with
similar equipment, wouldn't Ansel Adams, say, have achieved pretty
much the same result? The possibility is not as far-fetched as it sounds
for Adams was with them on this trip (constantly assuring them that the
mosquitoes that never ceased plaguing them would disappear),
together with Imogen Cunningham's son, the drolly named Ron
Partridge. And yet something about the picture insists that it would not

* Something similar happened with Tina Modotti. According to one of her many biog-
raphers, 'Tina discovered in Edward's portraits a new scaffolding for her identity. Still
young, she fell in love with what she saw of herself in [Weston's] eyes as much as with the
human being before her.' I suspect photographers like Weston were themselves as trans-
fixed by – and addicted to – the magic of what they saw in the ground glass as they were
by the photos that would be developed from it. The equivalent now would be the people
one sees at tourist spots, gazing not directly at the world itself but at arm's length, via the
high-resolution screens of digital cameras.

have turned out this way had it been made by Adams – even if he had borrowed his friend's equipment and taken it from the same angle at the same moment. As it happens Adams *did* take a picture of Charis in the course of this trip. She is wearing exactly the same clothes, her head is wrapped in the same scarf – and the result, pleasingly, is unexceptional in every way. Weston's, by contrast, is a photo of a very young woman looking at the man she adores, looking at her adoringly and preserving that intensity and reciprocity in a photograph. That's the remarkable thing about this photo: it preserves the moment when its enduring magic was created.

And yet, perhaps, there is already a premonition of something that will come later, something we notice in some of Stieglitz's portraits of O'Keeffe: a hint – no more than that, perhaps not *even* that – of what will become irritation, of how, after driving Weston around America in the late 1930s (more on this later), Charis will feel driven to leave him.

Time passes. People grow old, fall out of love, go their separate ways. Charis and Weston met in 1934, married in 1939; in the fall of 1945 she wrote to tell him that she was leaving him, and in 1946 they were divorced. Weston took his last picture in 1948. He died in 1958. These are the dates. Nothing has caused me more problems in writing this book than the interminable need to establish and verify dates. I hope they're all correct but in one sense dates are irrelevant. The value of a life cannot be assessed chronologically, sequentially. If that were the case then the only bit that matters – like the closing instants of a race – would be how you felt in the seconds before your death. (This is one of the questions posed by photographer Joel Sternfeld – 'Is what we are at the end ultimately what we are?' – in his book *On This Site*.) The moments or phases that make a life worthwhile can come early or late. For athletes, and women dependent solely on their beauty, they always come early. For writers, artists and everyone else they can come at any time. If you are unlucky they do not come at all. Sometimes these moments are preserved in photographs. The acts – in an artist's (or model's) case, the works and, in an athlete's, the results – that redeem a life can come in advance of everything requiring redemption. Chronology can, sometimes, obscure this.

a back may reveal a temperament, an age, a social condition.

Edmund Duranty on Degas

In 1927 — dates again! already! — Weston made a number of imper-sonal, sculptural studies of women's backs. Nudes, naturally: perfect expressions of his unaccommodating belief that 'the camera should be used for a recording of *life*, for rendering the very substance and quint-essence of the *thing itself*, whether it be polished steel or palpitating flesh.' He was convinced also that photography existed in order to deal 'with the immediate present, and with only one moment of that pres-ent'. As a result, his subjects tend to be devoid of historical context, independent of social commentary. Evans explicitly disavowed any ide-ological component in his work ('NO POLITICS whatever'); with Weston any such disclaimer would have been superfluous.* The photographs of backs embody this extended, defining phase of Weston's work. In the sharpest contrast, Dorothea Lange explored the ways that photographs of people's backs could be used to convey the framing socio-political context.

I want to approach Lange's photos of people's backs obliquely — from the side, as it were. Her famous photo of the *High Plains Woman* in profile, clutching her head, is more expressive than the frontal close-up of the same woman in which we are confronted with the unambiguous fact of her face. The resemblance to Virginia Woolf — the consequent elision of hardship with aristocratic or artistic anguish — suggested by her profile is quite absent from the latter. No residue of the body's ele-gant and expansive language can be read in the face which is drained of everything except a tight-lipped refusal to succumb. In 1952 Lange photographed the lost profile of a woman in New York who has the alluring mystery of a beauty glimpsed on a street. When she turns to face the camera more directly she is ordinary, plain, troubled, survey-ing the street with the forlorn hope of someone waiting for a bus on the

* Naturally Weston has attracted a certain amount of criticism on this score. 'The world is going to pieces,' Cartier-Bresson chided in the 1930s, 'and people like [Ansel] Adams and Weston are photographing rocks.'

97

High Plains. The *profil perdu* conveys not so much a person as a moment – familiar to everyone – when all the romantic possibilities of the city converge, fleetingly, on that person. It is poetic, full of a hope by which the other, franker image sets little store. *Not* because she turns out not to be beautiful – I'm trying to articulate a reaction to a photograph not a woman's looks – but because the first photo is like a promise that will be broken hundreds of times before it is kept.*

Considering that Lange was plainly and frankly petitioning and propagandist in approach (she could not understand why 'propaganda' was considered 'a bad word'), it is hardly surprising that her photos work best not when con*front*ing appearances but pondering their mystery and ambiguity. It is scarcely less surprising that this aspect of her work should develop its own kind of certainty or deliberation, that Lange should become so thoroughly and resolutely indirect as to bring about a complete reversal of approach. Thus it happens that on occasions

* Photos do exist of these rare moments when the promise, like a rendezvous waiting to happen, is kept, when the glimpsed stranger beckons like destiny. Because Weston was always starting new affairs his work offers numerous opportunities for observing the phase immediately following this, when the longing is reciprocated and – such is the contract required by the view camera – formalized. Only the handheld camera (a Leica, most famously) or snapshot can capture the moment before this, before any kind of relationship – or even contact – has been established. Indeed Joel Meyerowitz likens the excitement of high-speed street shooting to those moments

> when you're on the street, and, as you're walking along, a woman turns the corner going away from you, and for an instant you have a glimpse of the side of her face, of the gesture of her shoulder, the shape of her body, and you are *committed* . . . You are in love for an instant, or your senses are *rocked* for an instant. That person then disappears and is lost to you forever. What you *feel* in that instant, that glimpse of something just out of reach, is what tells you to make a photograph. It is a *feeling*. That's my physical equivalent out there. For a moment she fills that place that is always open, a place where sensation can reside for an instant . . .

Because this moment is charged, fleeting and unrepeatable, photographers working in glamour, fashion and advertising are always trying to simulate or contrive it. Eventually – as the success of photographers like Rankin or Corinne Day proves – even the casualness becomes formalized, codified, commodified.

she turns her back entirely on the frontal portrait by focusing on people who have turned their backs on her.

It goes without saying that while Lange captions these pictures 'Backs', they are also pictures of hands and hats. One of the most famous of her pictures of 'Backs' shows two men talking. The one with his back to us is wearing a creased white shirt and fisherman's hat; his hands are clasped behind his head in a way reminiscent 'of prisoners of war'. Striking proof of Lange's ability to use hands rather than the face as a way of individualizing her subject, it also shows how she uses the back as a way of making the peripheral or hidden the centre of attention. It is typical of Lange, too, that there is nothing sly about this, no sense of her doing something behind anyone's back: these pictures are, in fact, as up-front as any she made. Curiously, while the *profil perdu* arouses our curiosity, these satisfy and sate it completely. The *profil perdu* alerts us to what is hidden, what is hinted at but not revealed; these backs do not tell us everything we need to know so much as block additional inquiry by affirming unambiguously that further investigation would yield little of value. The face smiles, adjusts itself, is constantly lending itself to new adjectives; a back is a noun whose adjectival options are strictly curtailed (long, broad). The face reveals people in relation to others, to the world; certain portraits show people's relationship to – their idea of – themselves, but the back simply is. The style is not fly-on-the-wall but, if we look closely at a picture made in 1935, it might be called fly-on-the-sleeve [21].

Or take her picture of a sheriff's back in *Morgantown, West Virginia, 1935*. To this English observer a sheriff is distinguished by two related things: the ability to fill out a gun belt and a desire to sit. And that's exactly what we get here – arse (for sitting), gun and holster. We don't see his face but this picture of his back is circumstantial proof that he is chewing gum. Gum or tobacco. Certainly his jaws must be moving in a regular way that acts either as a stimulus to thought or its substitute. He's not actually sitting but he's doing what he can to take the weight off his feet. There are times when a sheriff perhaps leans on a suspect to get him to confess to a crime. If at first this seems an abuse of his power this picture makes it clear that it is an extension of a broader

21. Dorothea Lange: *Back*, c.1935

© the Dorothea Lange Collection, Oakland Museum of California, City of Oakland.
Gift of Paul S. Taylor

disposition to lean on *something*, in this case a mail box. Effectively, he's turned the mail box into a rocking chair, a perch from which to watch the world go by.

Since his job is about sitting and since his arse is featured prominently this picture cannot but tell us something about the working of the sheriff's digestive tract. For a man who likes sitting, the toilet is a kind of second home – not just a place you drop into like some swift-moving vegetarian. No, this is more like a sojourn, an extended and straining attempt to prove that the truth will out. He sits there as the night's ballast is dumped, heavy as a gun, contemplating the opposite wall like it's a street, in the grips of a deep-seated reluctance to get to his feet. When he does so he leaves the room as if it were the scene of a crime – and you don't need forensics to establish who it was in there, even when he's gone and the cistern is busy replenishing itself after struggling to destroy the evidence of his passing.

Except, it turns out, this is a case of mistaken identity. The picture is not by Dorothea Lange, it's by Ben Shahn [22].

Again and again we come up against this when studying photography: a subject identified strongly with one photographer – so much so that

22. Ben Shahn: *Sheriff During Strike, Morgantown, West Virginia*, 1935

© Library of Congress, Prints and Photographs Division, LC–USF33–006121–M3

one identifies the photographer by the subject – turns out to be shared and replicated by several others. Looking at photographs taken under the auspices of the FSA we see dozens of classic Langean pictures of people's backs taken by John Vachon (in Oconomowoc, Wisconsin, in 1941), by Russell Lee (at a hamburger stand, Alpine, Texas, in 1939). Stepping outside the FSA archive, Eudora Welty photographed three farmers, sheltered but unshaded by a triangle of roof in the town of Crystal Springs. All are wearing hats, two are in profile; one, with his back to us, is distinguished by the cross straps (X marks the spot) of dungarees that are at once decorative and broadly functional. His hands are large paws resting on cattle-rearing hips. The left hand is partially in his pocket, a gesture reminiscent of a gunslinger's but suggesting the opposite: not quick on the draw so much as slow on the uptake. But slow to take offence too, and ready to hear you out, even if he's heard it all before. And how, in the circumstances, could he not have heard it all before? Isn't everything a farmer could ever have known – and could, in those days of pre-dust bowl certainty, ever need to have known – already there, indelible and ever-present as the sky? We don't need to hear what they're saying to see what they mean.

The mistake is not to have thought that pictures by Welty and Shahn were by Lange; rather it is an inevitable side-effect of the larger

one of identifying a photographer by a particular subject. Lange claimed that every photograph was a self-portrait of the photographer. If this is the case, then many photographers look like – in fact are often indistinguishable from – each other. This question of whether a photograph is defined by the person who took it or by what it is of is absolutely central to all discussion of the medium's history. In a sense the wonky structure of this book – the result of looking at different photographs of the same thing – assumes, as Arbus claimed, that the subject is paramount. But it assumes this in the hope that by showing the similarities between certain photographs, the differences between the photographers who have approached these same things will become clearer. Conceding the primacy of the subject affirms the distinction of the artist.

In the encyclopedia described by Borges one of the categories is animals 'included in this classification'. In this inadequate encyclopedia of photography one of the categories would be 'photographs that look like photographs taken by someone else'. These are among the most distinctive pictures in the book: the pattern at the centre of (someone else's) carpet.

Roy DeCarava shared Lange's fondness for photographing people's backs. By the time he took up photography, in the late 1940s, America had emerged from the bleak years of the Depression but the problems of race and poverty remained intractable. Although DeCarava's work is politically conscious in a way disdained by Evans, his approach is far less overt than Lange's. The damage inflicted on the people in his photographs is not as obvious but it is conveyed through a similar or related set of tropes. In 1957 he took an extreme close-up of the back of a man's jacket. There is no room for head, neck, or arms, just the fabric of the jacket pulled tight, straining the middle seam that has been neatly stitched and mended. It recalls another of Lange's pictures, of the mended stockings of a stenographer, in San Francisco, in 1934. Like all of Lange's photographs this was intended, as its caption makes clear, as *A Sign of the Times – Depression*. DeCarava's picture is no less poignant for its absolute lack of context. The impulse behind it could seem to be aesthetic – an interest in the abstract patterns of light and shade as the

fabric creases and bunches – were the eye not drawn, softly but insistently, to the stitches at the picture's centre. This is typical of DeCarava's style: an understated and unpolemical observation of the small indignities, inconveniences and obstacles that define people's lives. To adapt a line of Thomas Hardy's: he is a man who notices such things. The picture of the man's back is intensely moving precisely because whoever has done the sewing has tried hard to mend it *invisibly*; DeCarava has responded in kind – noticing it but doing so with equal discretion. Lange was all the time keen to discover and represent people's dignity. As became the case with Paul Strand, the danger of this approach is that people can be *reduced* to their dignity. DeCarava, on the other hand, does not bother with any visual rhetoric, be it political or individually heroic.

One might have expected DeCarava, an African-American, photographing in Harlem in the 1950s and 1960s, to be militant, angry, but his views are always accommodating, often relying on visual synecdoche. A fraction of a scene, a glimpse of a person, is enough to convey them in their entirety. As novelists sometimes enable us to see characters without describing them, so, in one of DeCarava's most severely abbreviated images, we do not need to see the woman's face or body: we know what she looks like from her white glove, her cigarette and handbag. While other photographers might have registered its vastness, DeCarava represented the 1963 March on Washington through a series of intimate close-ups, one of them showing only a woman's sandalled feet, the backs of her calves, the hem of her dress. On the vertical border of the picture the feet and skirts of the two women standing alongside her can just be seen. The photograph of a woman being dragged away and arrested – again we can see only her shoes and ankles – is so stubbornly undramatic as to imply an aesthetic of non-violent passive resistance.

It is not only in their pictures of people's backs that Lange's and DeCarava's paths cross. The fact that they run into each other again is all the more remarkable if we take into account some of the ground that had to be covered photographically to make such a meeting possible.

*

To generalize hugely, in photography the history of women and hats is the history of glamour, of fashion.* The history of men and hats, on the other hand, is the history of realism, of the enduring (as opposed to the transience of the fashionable). Needless to say these distinctions are not hard and fast. One problem is that the classic documentary images of the Depression have retrospectively acquired a stone-wash glamour of their own. Fashion-wise, this lives on in the hard-wearing market share of Carhartt and other brands specializing in American 'workwear'.

Nevertheless, the story of the Depression can be told quite simply through photographs of men's hats. To tell this tale it may be necessary to take a few small liberties with chronology, to shuffle the pack of images a little, but to do so is to keep faith with photographers' own practice. No one expects pictures in a magazine to be presented in exactly the order they were taken. Chronology is regularly subordinate to the aesthetic or narrative demands of sequence. This is not to distort history, merely to arrange things so that it can be seen more clearly.

Everyone wore hats back in the 1920s and 1930s, or all the men did anyway. The hat was a fact of life. Everyone looks the same in that they are all wearing hats; you recognize people by their hats even though everyone is wearing pretty much the same hat. In film noir, and in Weegee's crime photos of the 1930s, the individual is distinguished by the air of sinister anonymity the hat imparts to its wearer; in documentary photography of the period the hat serves to personalize the human cost of impersonal economic forces. It would doubtless be possible to unearth a whole bunch of statistics about the fate of hat manufacturing in the 1930s, how the product that I am using as an all-purpose indicator of the times was itself caught up in the upheaval it

* Vicki Goldberg reckons that 'a case could be made for calling Lartigue the first fashion photographer.' How appropriate, then, that in 1907 Lartigue, aged 13, had 'a new idea: that I should go to the park to photograph those women who have the most eccentric or beautiful hats.'

describes and symbolizes – but such an undertaking will have to await a more diligent chronicler and analyst. I'm interested only in what is going on within the frame, not in what really happened but what photos lead me to think may have happened. My area of research – if we can dignify it with that word – is restricted to the forms of knowledge that are intrinsic to photographs, that can be intimated or extrapolated from them.

Before the crash, hats are a sign of American affluence and democracy. The men wearing them are brimful of hope and expectation. This hope lives on after October 1929, but it soon acquires an anxious quality as people watch and join demonstrations. In a photograph taken by Lange in San Francisco, in 1933, the brim of his hat imparts a dark halo to a man at a May Day Demonstration. En masse, though, hats are a sign of gathering political force, of people united (by their headgear). The most powerful expression of this was Tina Modotti's *Workers' Parade* (Mexico, 1926), an aerial view of sombreros, moving inexorably forward on the tide of history. Any hopes of such solidarity finding expression north of the border will prove short lived as the Depression generates individual tragedy on a mass scale. This transition is registered by Hansel Mieth's picture at the San Francisco Waterfront in 1934. As in Modotti's photograph, a mass of people, all wearing hats, are seen from behind. But whereas in Modotti the men stride confidently forward, here there is panic as a scrum of bodies reach out their hands for something – work? food? – that is in desperately short supply. We get a pre-echo of this in Lange's *White Angel Bread Line* of 1933, one of those felicitous images in which, the photographer claimed, 'you have an inner sense that you have encompassed the thing generally' [23]. Most of the people in the crowd have their backs to the camera. The man in the centre has turned away, has, so to speak, turned his back on any idea of collective action, preferring instead to face the Langean truth of stoic resignation. This is not the only way he is singled out: his fedora is in far worse shape than that of anyone else's in the picture. He is like a premonition of what is to come. By the end of the decade everyone else will have followed his example of battered resilience. That this is an accurate reading of the picture is suggested by

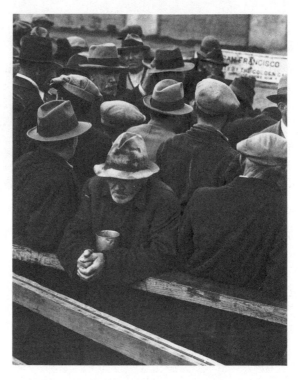

23. Dorothea Lange: *White Angel Bread Line*, San Francisco, 1933

© the Dorothea Lange Collection, Oakland Museum of California, City of Oakland.
Gift of Paul S. Taylor

a less well-known version in which another man, smartly dressed this time, faces the camera. This alternative shot presents a random accumulation of detail; it lacks the sense of historical inevitability as conveyed by the power of visual convergence.

Film-makers have long been aware that having a character wear the same clothes throughout a movie makes the subsequent work of cutting and assembly much simpler. The story can be chopped and changed without any major continuity problems. Within the ongoing film of the 1930s described here (a film made up of numerous still images), that simple signifier, the hat, means that we can see the same person in any number of photographs – *even if it's not, strictly speaking, the same person*. And not just in photos by Lange; no, the 'same' person crops up in the works of any number of photographers. We next see the man from the

White Angel Bread Line in 1952, for example, in a picture by Roy DeCarava. We will . . . I was going to write '*We will return to this*', but I hope this kind of reminder is superfluous by now. Those words are printed, invisibly, at the bottom of almost every page.

Made in Texas in 1938, Lange's *Tractored Out*, shows an isolated farm-house surrounded by dry swirls of ploughed earth. Evidently there is nothing left to farm. The land has had all the life ploughed out of it. If there were just one of these plough lines it would constitute a path, a route. As it is, the suggestion is that all options – all possible routes – have been exhausted. They all lead to the same place – nowhere. The story of Lange's photos is the story of how this look of the land – creased, lined, parched – will transmute itself first to her people's clothes, then to their hands and then, finally, to their faces. All, in fact, will become near synonyms of what Lange and her husband Paul Taylor called 'human erosion'. There will be nothing to choose between land, clothes, faces and hands. Lange herself stressed this connection with the land, observing of the ex-tenant farmers that 'their roots were all torn out'.

In 1937 she took a picture of one such farmer, on the edge of a pea field in California's Imperial Valley, 'squatting in the dust – perplexed and figuring' [24]. His face is as wrinkled as his shirt and his shirt is as creased as the plough-scored land. There's nothing to choose between them. His boots are covered in dust, his hands are a pair of shrivelled potatoes and, to cap it all, he is wearing the most battered hat in the entire history of the Depression. I've made an exhaustive inventory of all the hats in as many photos as I could find and this one takes what remains of a crum bling biscuit. His life is reduced to that of a dry old lizard, sheltering beneath the shadow of his hat, capable of living on almost nothing. The same man – or a man who, by virtue of the identifying hat, is indistin-guishable from him – crops up in another picture made in the same place, in the same year. His shirt is buttoned up but loose around the emaciated leather of his neck. There was a time when he waited on good news. Then he just waited on any kind of news. Now he just waits.

He is, however, still holding his head high. Eventually the moment will come when he holds his head in his hands and his eyes drop to the

24. Dorothea Lange: *Jobless on Edge of Pea Field, Imperial Valley, California*, 1937
Courtesy of the Dorothea Lange Collection, Oakland Museum of California

floor. Lange's 1934 photograph of a man beside his wheelbarrow is thus an unambiguous image of defeat [25]. His head is bowed; instead of a face there is just the hat. In other pictures her subjects' hands – their theatricality, elegance or drama – are a sign of superfluity. Life has not yet shrunk from the extremities. In this picture the hands, crucially, are nowhere to be seen. He sits, head bowed. All we can see is his hat.

Studying Samuel Beckett at university, I learned that Estragon's and Vladimir's waiting was an expression of something called the human condition. In reality this universal condition manifests itself in specific circumstances; 'absurdity', likewise, always has an identifiable material or economic causality behind it. Consistent with this, Lange noted that five years earlier she 'would have thought it enough to take a picture of a man'. Now she wanted to take a picture of a man 'as he stood

25. Dorothea Lange: *Man beside Wheelbarrow*, 1934

© the Dorothea Lange Collection, Oakland Museum of California, City of Oakland.
Gift of Paul S. Taylor

in his world'. The first symbolic prop is provided by the wall: he is a man with his back to the wall. She also deliberately showed 'his livelihood, like the wheelbarrow, overturned'. The wheelbarrow is a scavenged carcass of itself. It's particularly poignant in Lange because of the enormous symbolic hope associated with the wheel. If you have wheels you can keep going. Thus in some of her most heroic pictures people are clutching the steering wheel of clapped-out cars, still clinging to the motor of self-determination. And they are still wearing their hats. This tenacity – of hat and spirit – can itself be a source of torment. The longing to give up, to quit, manifests itself in a desire not to shuffle off the mortal coil but to get rid of the battered old hat. In *The Grapes of Wrath* the rest of the Joad family look on as Uncle John, at the end of his tether, unable to go on, heads to the liquor store to get dead-drunk.

'In front of the screen door he took off his hat, dropped it into the dust, and ground it with his heel in self-abasement. And he left his black hat there, broken and dirty. He entered the store and walked to the shelves where the whisky bottles stood behind wire-netting.'*

When times get really hard — and that is another lesson of documentary photography of the period: times can always get harder — the hat is reduced to being no more than a pillow. On Skid Row in San Francisco in 1934, Lange photographed two men sleeping, curled up on the hard bed of Howard Street [26]. They have gone from having their backs against the wall to their heads on the

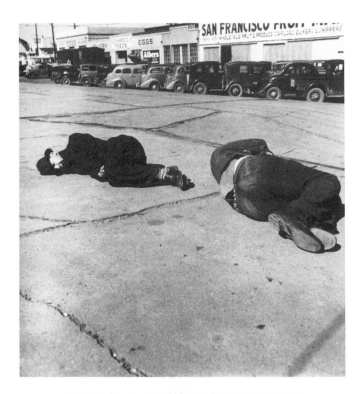

26. Dorothea Lange: *Skid Row, San Francisco*, 1934

© the Dorothea Lange Collection, Oakland Museum of California, City of Oakland. Gift of Paul S. Taylor

* He is later brought back from the dead, forced to keep going, by Tom Joad who — naturally — retrieves his hat too.

sidewalk. And still, you feel, the hat is a source of comfort – better than nothing.

A further degradation comes with the familiar figure of the blind beggar who, in John Vachon's image of the same year, is seen begging outside the McLachlen Banking Corporation in Washington DC [27]. His situation is like a pre-echo of the contemporary phenomenon whereby the homeless camp out by ATMs, near the source of a river from which they are unable to drink. Vachon exploits this juxtaposition of destitution and corporate might to considerable effect. As in Lange's picture of the man with the wheelbarrow, his back is against the wall, but in this case the wall exists to keep him from the wealth accumulating behind it. In images by Strand, Hine and others the blind man's label told his whole story. In this picture the writing is on the wall, literally, and refers not to him but to everything from which he is excluded. And where in Lange the wheelbarrow is the symbol of how the man's life has been overturned, here the hat itself has gone belly up – has gone from protecting the head to serving as a begging bowl. No longer reliant on himself, he's abandoned his individuality or identity. Earlier images of the blind had shown them offering

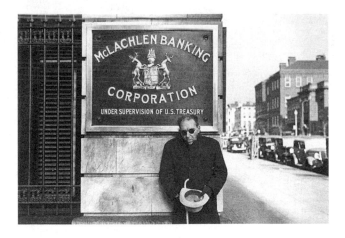

27. John Vachon: *Blind Beggar, Washington DC*, November 1937
© Library of Congress, Prints and Photographs Division, LC–USF33–T01–001047–M4

111

something (music, usually); here he just stands, and the hat, as far as we can see, is empty.

We have seen people crashed out on the sidewalk, in their hats, begging with their hats, with their hats in their hands. Within this narrative of economic and social collapse as reflected in the fate of the hat, Edwin Rosskam's picture from Chicago in 1941 registers yet another new low [28]. In the doorway of a building we see a man, collapsed on a stone ledge, bare head between his knees. The brim of his hat, just visible behind a column, has fallen from his head and lies on his feet. It is the final defeat. He can't go on. The verdict is visually clinched by the crumpled white handkerchief in his right hand: he has surrendered.

But remember the lesson of the 1930s: however bad things get, they can always get worse. Hard times can always get harder. So even this is not the final stop in this journey through the Depression. That would be recorded by a photographer who had kept himself sternly aloof from the dominant concerns of documentary photography of the time.

Photographers sometimes take pictures of each other; occasionally they take pictures of each other at work; more usually they take

28. Edwin Rosskam: *Entrance to Apartment House in the Black Belt, Chicago, Illinois*, April 1941

© Library of Congress, Prints and Photographs Division, LC–USF33–005169–M4

photographs – or versions – of each other's work. Consciously or not they are constantly in dialogue with their contemporaries and predecessors. How can one regard an untitled picture taken by Winogrand some time in the 1950s except as a kind of homage to or essay on Lange (by Lange, of course, I mean *the kind of subject matter one associates with Lange*). In the right-hand side of the frame a burly man in a suit and straw hat stands with his back to the camera [29]. He is talking to a guy on his left who is sitting down (we can see only his head), looking up at him. To *his* left there is a hat on a stand. Since the hat is so often a marker of humanity it's like a human hat-stand, long and skinny as a Giacometti but more basic, closer – in Martin Amis's phrase – to a human pool cue. It's as if there are three people in this picture, two of whom are wearing hats.

By the 1950s the great era of the hat in photography had passed. Wearing a hat was optional where once it had been almost obligatory, and it was no longer a reliable indicator of the ravages inflicted on men by economic forces beyond their control or understanding.

29. Garry Winogrand: *Untitled*, 1950s

The hat became just a hat. So closely is the hat identified with documentary photography of the 1930s that it could be seen as a symbol of that phase and style of photographic history. As such Winogrand's photo illustrates vividly how far photography has moved from the classic 'documentary style'. It is a text-book illustration of what, according to Szarkowski in the 'New Documents' show (1967), distinguished Winogrand, Arbus and Friedlander from their predecessors such as Lange. The latter 'made their pictures in the service of a social cause . . . to show what was wrong with the world, and to persuade their fellows to take action and make it right'. By contrast, a 'new generation of photographers has directed the documentary approach to new and more personal ends'. Winogrand's picture takes as its subject something – the hat – that was almost synonymous with that earlier phase and shows how it is in the process of being superseded. By these terms the man on the right represents the 1930s; the hat-stand on the left represents the future of photography. The 'propaganda' of the 1930s will give way to something quirkier, more idiosyncratic. Whatever ravages were inflicted on the hat in the 1930s it was never dehumanized. On the contrary, it was inseparable from its wearer. Now we see the symbolic separation of the hat from its wearer. Lange was faithful to George Steiner's comment on Balzac: that if he 'describes a hat, he does so because a man is wearing it'. The photographers of the new generation will describe a hat because it just happens to be somewhere. Winogrand's picture is an expression and demonstration of exactly this transition.

Obviously, Winogrand was not the first person to take a picture of a hat when it was not on someone's head, when it was detached from the wearer, but Winogrand's was the picture I noticed. Luck? Yes, but no luckier than the fact that he happened to see it in the first place. Winogrand was looking for things to photograph – things that would chime, that assumed a certain kind of compositional rightness – but, in keeping with Lange's preference for working 'without plan' or preconceptions, he didn't have anything particular in mind. He wasn't

looking for a hat any more than I was. But something about this hat, at this moment, struck him and it did me too. Coincidence? The question makes no sense. As Cartier-Bresson said, 'There are only coincidences.'

Here is another one: as he waited on the subway stairs in 1952 DeCarava . . .

But no, let's wait. Like all coincidences this one will appear all the more remarkable if we consider some of the myriad conditions and contingencies that led to its occurring. In turn that will raise other questions. How long can a coincidence extend before it ceases to be one? Does coincidence have to be momentary? How long is the moment, the ongoing moment?

Always the same stairs.

Jean Rhys

Eugène Atget often photographed stairs and steps. Like the roads and passageways that also feature prominently in his photographic inventory of Paris, they lead us deeper into the picture even as they indicate a way out of and beyond it. From a purely formal point of view the horizontal lines provide an intensification of perspectival recession – like sleepers in a length of railroad track – as the steps mount the picture plane.* The steps photographed by Atget could be worn, intricately decorated, domestic, curling out of sight at 91 rue de Turenne (one of four pictures acquired by Man Ray, in 1926, for publication in *La Révolution Surréaliste*), or monumental – heading to the sky, hulking

* Stieglitz took a classic shot of this type, of an arch in Bellagio, Italy, through which an alley of steps could be seen rising into the distance, in 1894. So firmly do we associate Atget with this kind of view that one assumes it was made either under the influence of or in homage to him. One of the strange features of Atget's work, however, is that it looks older than it is: we have to remind ourselves that he had not taken any pictures at the time Stieglitz made this view.

huge like some kind of Inca temple – at Versailles. They could be new, geometric, sharply angled like the ones he photographed at Saint-Cloud in 1922, or leaf-strewn, worn and rounded (so much so that they are in the process of becoming simply a slope) like the ones he photographed there two years later. The stairs do not always lead to the light (in a 1904 view at Saint-Cloud the steps lead into an impenetrable darkness of tree and shadows) but they are almost always leading *up*. Atget rarely photographed stairs from the top, looking down; invariably he was at the bottom, looking up. In this way the stairs serve as hills, metaphors, that is, for the further exhaustive endeavours that lie ahead: climb them and there will be other – possibly better – views, other photographs.

In Brassaï, by contrast, the sense is always of stairs leading down. This is not always the case – he is not always at the top looking down, but there is always the sense of a more intimate knowledge of a city being found *down* the steps, of the truth of a place being found in its basements (places of abasement, as often as not), in the city beneath the city. The symbolically representative picture is taken in Montmartre in the mid-1930s, looking down an endless, tree-shrouded flight of stairs. It is winter, the trees are bare, the sun is shining. There is no end in sight to the stairs, just a descent so long that, by the time you get to the bottom, the street lamps will have been turned on and day will have turned to night. Day leads to night, and steps, in Brassaï, always lead down. The darkness beckons.

Kertész had an all-purpose fondness for steps. Steps-wise, his Paris is a combination of Brassaï's and Atget's. In Mondrian's studio he observed, through a doorway, the *escalier* curving out of sight as it had in Atget's photo of 91 rue de Turenne. Kertész was one of the first photographers to exploit and explore the bird's-eye view of the city, enjoying the foreshortening, distortions and sneaky privileges of being perched high above the unfolding choreography of the streets. To that extent it was perfectly natural that he should survey Paris from the top steps of an *escalier* or a flight of steps at Montmartre. He liked the interdependent geometry of steps, handrails and the angle-dance of shadows the sun threw between them. In

New York in the 1950s he photographed *Stairs, Railing and Woman* in such a way that the play of angles and shadow creates a vorticist severity of forms. Pictorially, the stairs contributed a diagonal that lent the photographs their unequal symmetry, simultaneously animating and stabilizing the scene. The zigzag of fire-escapes, cross-hatched by a shadow-imprint of themselves, raised this to a new, almost abstract extreme. They took the place of the city-steps clinging to the quays of the Seine that he photographed so often in Paris in the 1920s.

Kertész, unlike Brassaï, was not interested in the psychological suggestiveness of descent, but he knew all about stairs leading up. With that premature sense of what it will be like to be old and tired, his early Paris pictures display the kind of symbolism appropriate to his years in New York. In what seems a deliberate allusion to Atget's leaf-strewn image of Saint Cloud he photographed the curve-worn steps of Parc de Sceaux in Paris, in 1928. As usual, Kertész's fascination with the curves and diagonals of the steps is partly formal and geometric. But the steps are thick with fallen leaves, drenching the picture with an arranged melancholy that, for a photographer still only in his twenties – in the spring of his career and life – is simultaneously autumnal and precocious. In 1931 he photographed a steep and narrow flight of stairs, hugging the wall of a building in Lyons [30]. There's a resemblance, again, to a photo by Atget of the *Passage Vandrezanne, Butte-aux-Cailles.* Taken in 1900 it shows a narrow alley curving steeply between two walls, striving towards the light like a plant. Water runs down the gully or gutter on the right-hand side of the *passage.* In Kertész's picture the running water to the left of the steps echoes the shining hand-rails climbing up them. The image is like an urban version of Robert Frost's famous view of woods on a snowy evening. The stairs are old, dark and steep. Near the top is a silhouetted figure. Kertész stands at the bottom looking up longingly at this representative of his future self. Such is the effort required to climb these stairs – the journey of a life-time, as it were – that there are times when he wishes he'd already got it over with.

30. André Kertész: *Lyons*, 1931

© Estate of André Kertész, 2005

DeCarava was fond of photographing people as they came up or down stairs. Stairs constitute one of the basic facts of life in DeCarava's view. You walk up and down steps for the same reason you climb a mountain — because they're there. The difference is that whereas you can choose not to climb a mountain, there's no getting away from stairs. In the absence of an elevator or an escalator you're always going to come up against them. At times, it seems, there are nothing but stairs. A photograph taken in 1987 shows two men climbing subway steps that fill the frame entirely. There is no beginning and no end in sight. The steps are vertiginous, daunting as a cliff and offering the same sheer definition of self. The two men clutch the hand-rails like climbers, roping themselves to the rock-face of the everyday. Not that DeCarava's people waste energy pondering the metaphorical connotations of their daily ascent. The alcoholic's mantra 'one day at a time' becomes something altogether more pedestrian: one step at a time. That's how you get to higher ground.

Very often in DeCarava's pictures, his people — it is inappropriate to call them 'subjects' when they are photographed so tenderly, intimately — are about to leave the frame, about to pass out of the photograph. Staircases or steps provide the perfect settings for this. DeCarava's gaze lingers on steps precisely because the people using

them do not. A woman descends a flight of stairs. DeCarava photographs her before she emerges fully into view. We see just her legs, her dark coat and one hand. It is as if DeCarava has decided to come up with a photograph which, in its straightforward and unfussy simplicity, is a documentary rendering of that spectacular icon of modernism, Duchamp's *Nude Descending a Staircase*.

DeCarava's own link to the European avant-garde was provided by Cartier-Bresson, whose work exerted a considerable influence on his style and approach. Like Cartier-Bresson, he chose certain spots that promised some kind of visual interaction between the place and the people passing through it and waited to see what would happen, who would happen by. Cartier-Bresson has described this tactic as baiting a trap but in DeCarava's case the results seem less the result of compositional cunning than of endless patience. One day, in 1952, DeCarava saw a man coming up the subway stairs. He is wearing a grubby white shirt and carrying a jacket under one arm. With the other he hauls himself up the hand rail. The hat he is wearing is identical to the battered fedora worn by the fellow spotted by Lange on the White Angel Bread Line in 1933. His mouth is set in the same curve of glum resignation. The question is this: did DeCarava photograph this man because he *recognized* him? Could he have recognized him after twenty years — *even though he had never set eyes on him before?*

Fed up with the way that Weegee had been 'peddling the same pictures' for years, an editor snapped at him: 'for all I know, it's the same dead gangster and the same gray fedora lying on the sidewalk.' I feel the same way — though it's a source of delight rather than frustration — about the figure in these pictures by Lange and DeCarava. It is as if the hat and the man and all that they symbolize are re-emerging into the daylight again, resurfacing. The difference is that this is a black man. The badge of oppression and hardship has passed from the Okie to the African-American. But the symbolic transfer is broader, more encompassing than that. In 'A Primer on the 30s' John Steinbeck decided that 'if we had a national character and national genius, these people, who were beginning to be called Okies, were it. With all the odds against

them, their goodness and strength survived'. In its way, DeCarava's photo is a primer on the 1950s.

People are photographed, they die. And then they come back and are photographed again, *by someone else*. It's a kind of reincarnation. A guy last seen twenty years ago in a picture by Lange suddenly turns up again in one by DeCarava. What has he been doing in the meantime? What has happened in the long interim? The questions make no sense. Think back to Kertész and the pictures of accordion players he took in Hungary and New York. In photography there is no meantime. There was just that moment and now there's this moment and in between there is nothing. Photography, in a way, is the negation of chronology.

Kertész's famous 1931 picture of a circus acrobat doing a handstand on a Pisan tower of chairs at Gare Montparnasse is a dramatically reversed extrapolation of what is actually a fairly familiar metamorphosis. Kertész watched a stack of chairs being turned into a wonky ladder; it is far more usual for steps to become chairs, seats or benches. (Any kind of steps will do: the steps leading up to a house become bleachers from which you watch the world pass by.) It is appropriate, then, that in photos of the 1930s there is an aspirational hierarchy – or ladder – of seating: kerb, step, stoop, chair, rocking chair.

The kerb is the lowest of the low. After that you are out in the street.* Without steps or kerb you can only squat. The squat is what you resort to when you have nothing left to sit on. Inevitably, then, the squat is one of the most photographed poses of the Depression. In

* Cartier-Bresson noticed this in New York, in 1959. Gazing down a narrow alley between vertiginous walls he snapped a fellow perched comfortably on a kerb, passing the time of day with a stray cat. Many of the photos in *America in Passing* were made in the 1940s and 1950s but Cartier-Bresson tended to see the country through an optic formed earlier by American photographers. This meant that on occasion, as editor Gilles Mora surveyed images for possible inclusion in the book, he was struck by a 'dullness of vision, so untypical of Henri'. The corollary of this was the way 'things that American photographers took in their stride, accepting them without question' became 'a source of endless astonishment'.

Caruthersville, Missouri, 1938, Russell Lee photographed four farmers squatting on the sidewalk. Behind them is a shop window stacked with items – Super Suds, Oxydol, Clean Quick – that are beyond their means. Needless to say, the man photographed by Lange wearing the most battered hat of the Depression is not sitting on a chair but squatting [24]. There is nothing between him and the hard earth. The next stage is to sit or lie down on it. From there it's a short step to being buried in it.

The kerb is the lowest form of step which, in turn, is a rudimentary kind of chair – and all chairs bend over backwards to become rocking chairs. The rocking chair is the throne of the Republic, symbol of leisure (whether achieved or inherited), of what John Berger, in another context, terms 'sedentary power'.

Take Lange's photo of a sheriff – not the one that looks like it was taken by her, but one she really did take – outside the jail in McAlester, Oklahoma, in 1937 [31]. In the photo of a sheriff that turned out to be by Shahn the viewer's attention became unavoidably focused on his girth. It is as if, in the world of gun belts, one size fits all and career advancement is determined largely by an individual's ability to grow into the job. Generally speaking, potential employees are asked to fill

31. Dorothea Lange: *Sheriff of McAlester, Oklahoma, in Front of the Jail*, 1937
Courtesy the Dorothea Lange Collection, Oakland Museum of California

out an application form; sheriffs are expected to fill out their gun belts. Once they've done that they spend their days hitching up their trousers, chewing gum, and just *being* a sheriff. This does not involve work as such: it involves sitting in a rocking chair — irrespective of whether the chair was meant to be rocked. In Westerns a sheriff was identified by his badge; on the evidence of Lange's photo the badge has been replaced by a chair that rocks reluctantly. Thus it comes about that the sheriff is preoccupied less by fine points of law than by a fine point of balance. It's a seat of the pants job from which all suspense has been removed — except that expressed by the chair's precariousness. There are crimes and felonies to be investigated but, from the sheriff's point of view, the only law that counts is gravity. The sheriff's holster-encouraged bulk provides essential ballast in this regard. Lesser men would tip over backwards; the sheriff's gut ensures that he stays firmly put. This is not to say that a sheriff only sits in a chair, but whatever else he is doing there is the suggestion that his main aim in life is to take the weight off his feet.

If the sheriff's role is largely a question of comportment then his nominal function — controlling the population — is expressed primarily by a physical disposition, by his posture and bearing. The ability to sit, in other words, is itself a form — quite literally a *position* — of power. This is confirmed by Lange's 1938 picture of a white haired plantation owner in Greenville, Mississippi. Strictly speaking, he might not own a plantation but he does own a rocking chair — not a chair that is being made to rock against its wishes but a dedicated rocker. For all his skill the position of Lange's sheriff is precarious, potentially dangerous. The sheriff invests a lot of his being into retaining his place (his foot is slightly blurred, as if he were constantly needing to shift his balance). At a more elevated level, however, you're free to sit back in your rocker, cultivate a Nietzschean moustache and stroke it as though the accumulation of wealth through several generations constitutes a form of old knowledge, a trusty fund of inherited wisdom.

Steps easily become chairs. They also, on occasion, turn into beds. In 1890 the youthful Stieglitz did a portrait of himself stretched out over

four steps of a building in Cortina. As an image of carefree bohemia it's quite unconvincing. It would be okay on flat ground (Charis Wilson ended up, naked, in a pretty similar position in Weston's photograph of 1937) but you would have to be stupefied by booze to find any ease or comfort on steps like these. Stieglitz's pose is an expression of artistic aspiration and you don't aspire to sleep on steps, you end up doing so. Whereas it is nice and natural to sit on a stoop or steps, to sleep on them is a sign of near-dereliction – at least in America.

In the crowded cities of India, however, what in the States would be seen as a sign of collapse is so widespread as to seem quite normal. For William Gedney, who made prolonged visits to India in 1969–71 and 1979–80, this was one of the boons of photographing in the sub-continent. In Benares everything was on display constantly. 'Indian streets serve as much a part of an Indian's life as his home,' he wrote in his journal. 'One of the great freedoms of Indian life is its streets. The right of people to squat anywhere . . . people sleep, work, play, eat, fight, relax, relieve themselves, die in streets. All human activity takes place there.' In America, in the 1930s, squatting and sleeping on benches were indicators of people's plight; in India they were evidence, also, of lightness and grace. The complaint that Gedney's pictures of America at night were about what you couldn't see was cancelled out in India. As Gedney wandered Benares at night he photographed the 'bodies of citizens sprawled on narrow ledges', their limbs 'bent in unconscious grace'. In an undated manuscript fragment he had written of the – by no means uncommon – pleasure of looking 'at the one you love while he is asleep'. In Benares he photographed all sleepers as if they were loved. These pictures of people dreaming are like a dream come true for Gedney. He became a custodian of dreams, passing the night like Whitman in his poem 'The Sleepers':

> I wander all night in my vision,
> Stepping with light feet, swiftly and noiselessly stepping and
> stopping,
> Bending with open eyes over the shut eyes of sleepers,

Wandering and confused, lost to myself, ill-assorted,
 contradictory,
Pausing, gazing, bending, and stopping . . .

There are two kinds of empty bed: the made and the unmade. Made
beds are nice and inviting but unmade ones are usually more interest-
ing (even if they are not particularly inviting).* An unmade bed is even
more suggestive of the people who occupied it than an empty chair.
Szarkowski suspects that empty chairs did not mean 'the same thing
before photography as they do now'. The same cannot be said of the
unmade bed which can be seen as an elementary form of photograph in
that the sheets bear a faint imprint of our presence. This imprint is
sometimes embellished with other traces so crude – stains, stray pubic
hairs – that we are reluctant to let others see our unmade beds (and are
not eager to see those of others). Partly this is a matter of decorum but
it also expresses a deeper fear, one that has less to do with sex than
death. In Marguerite Yourcenar's *Memoirs of Hadrian*, the Emperor
rhetorically asks 'how often, when I have risen early to read or to
study, have I replaced the rumpled pillows, and disordered covers,
those almost obscene evidences of our encounters with nothingness,
proofs that each night we have already ceased to be.' If an unmade bed
is a proto-death-bed then to photograph it is, by these terms, to record
a premonition of someone's eventual passing away.

The unmade bed's capacity to suggest its absent occupant made it
a natural choice for the task Dorothea Lange assigned her students
while teaching photography at the California Institute of Fine Arts in
1957–8: to take a photograph of a personal environment with no

* I first became interested in the idea of the unmade bed when I heard Leonard Cohen,
in 'Chelsea Hotel #3', singing about someone (Janis Joplin, it was rumoured) giving him
head 'on the unmade bed', pronouncing 'the' so that it rhymed not with 'see' but with
'uh', as though the 'u' of unmade were not a vowel. Somehow, at the risk of sounding a
bit Ricksian about the whole thing, this made the bed seem even more unmade, as if the
'the' had not been neatly tucked in. Like most people I stopped being interested in
unmade beds when Tracey Emin exhibited hers at the Tate in 1998.

people in it. News of this assignment found its way to Imogen Cunningham, who arranged some hairpins on her bed – made it, in other words, look *un*made – and photographed the result. Cunningham sent a contact print to Lange as a gift and homage.

In turn the photographer Jack Leigh – who died while this book was being written – might have the pictures *White Chair, Unmade Bed* or *Iron Bed, Rumpled Sheets* as tributes or responses to Cunningham [32]. Both images are part of a series of black-and-white images of rooms, empty except for items of clothing and furniture. *White Chair* shows a glossy white chair in front of a dark door and, to one side, the rumpled sheets and pillow of a single bed. The bottom half of *Iron Bed* is a sea of white sheets washing up against the vertical bars of an iron bedstead which frame the horizontal wooden panels of the wall behind. The sheets look clean. The two pillows on the iron bed cuddle sleepily up to each other. Everything has been lovingly calibrated and recorded. In both photographs the unruffled emphasis on tone, on the intersection of line and form, is quite dispassionate. The discovered, possibly contrived, arrangement of light and shade simultaneously insists on the human story that preceded the picture while aesthetically denying it.

32. Jack Leigh: *Iron Bed, Rumpled Sheets*, 1981
© Jack Leigh

Leigh often seems consciously to be revisiting the kinds of subjects and places that Walker Evans made his own. In particular his photograph of the unmade iron bed was a response to – or at least it reminds me of – Evans's picture of a *made* bed in a Hudson Street Boarding House, in New York in 1931.* In turn this makes me think of Atget's gloomy photograph of the bed in the *Intérieur de Mr F. négociant, rue Montaigne* (1910). In dim light, flanked by hulking furniture, the two pillows glow white (relatively speaking). For Szarkowski this is a bed 'in which all the world has slept badly' – so badly that it might actually be considered a photograph of insomnia. In keeping with this the bed itself is entirely undisturbed by any hint of human repose.

The bed photographed by Evans in the Hudson Street Boarding House is similarly uninviting [33]. John Cheever, who spent the night – or part of it – in the photographer's bed at about this time, thinks that Evans took the picture 'because he couldn't believe that anyone could live in such a miserable place'.† Where Leigh's bed was pristine, freshly laundered, white, the one photographed by Evans is grim, sagging. The room itself is even grimmer. The roof is so low that it is practically impossible to sit up and read in bed, let alone stand. Any beauty that the picture possesses is derived entirely from the dispassionate purity with which the photographer observed and recorded it. This is a quality common to many of Evans's pictures of the 1930s. As one witness observed, Evans 'kept his white gloves on' when he was photographing slums.‡

Over time everything becomes more explicit. In 1910 good taste and decorum dictated that one did not photograph unmade beds. It was

* Biographer James Mellow considers it 'more than likely' that the picture was taken in 1934 or early 1935.

† Cheever also notes that Evans 'had an enormous cock that showed only the most fleeting signs of life'.

‡ Arbus intuited something of this aspect of Evans's work in the course of repeated visits to his 1971 retrospective at MoMA. 'First I was totally whammied by it. Like THERE is a photographer, it was so endless and pristine. Then by the third time I saw it I realized how it really bores me. Can't bear most of what he photographs. Can't explain that confusion.'

33. Walker Evans: *Bedroom in Boarding House in Hudson Street*, 1931–35

© Walker Evans Archive, The Metropolitan Museum of Art, 1994. (1994.256.642)

too intrusive, invasive. This is another reason why, in Atget's photo, Mr F.'s bed actually has some of the expressiveness that one associates with the unmade bed: just to be in the room feels like a form of subtle trespass.

Atget would not have taken a photograph of an unmade bed. Evans would not have taken a picture of his bed after Cheever, by his own account, 'came all over the sheets'. By the time we get to Nan Goldin any such reserve has long since evaporated. Beds feature prominently in her work from the mid-1970s because most of her friends lived in studio apartments. The bed was always there. It dominated the room, became the stage on which the ongoing *Ballad of Sexual Dependency* was enacted. The beds in Goldin's works are crammed with clutter: bags, a phone, clothes, books, sellotape, film. The bed becomes an orange

life-raft floating in a sea of brown squalor. Looking at Goldin's beds I am reminded of the moment in *Bad Timing* when Harvey Keitel tells Art Garfunkel of his disgust for people who live in disorder, in a 'sort of moral and physical sewer'. Keitel is a detective, scanning the scene for clues. The problem in Goldin's pictures is the sheer quantity of evidence: the mass of flotsam and jissom that ends up on the bed. By this I mean not just the things but the *people* routinely crashed out on them. The people are part of the mess. The best example is a photograph of Brian, stretched out, face down, on a bed surrounded by junk and clothes. Still more stuff is crammed under the bed and heaped on top of it. By the terms of that earlier metaphor of the bed as life raft, this one is sinking.

In Goldin the distinction between made and unmade beds doesn't make sense (basically, they are never made). Since they are often piled with people's things the distinction between beds being occupied or unoccupied is equally hard to sustain. There is, for that matter, scarcely any distinction between a portrait of a friend and a self-portrait. This is part of the pictures' famous intimacy. Goldin photographs her friends in the same way she photographs herself. She photographs Bobby masturbating. She photographs herself masturbating Brian on a bed. Then, a few moments later, she photographs his semen soaking into the blue sheets.

Strangely, the absolute frankness of Goldin's pictures of beds brings us back to the discretionary decorum of Yourcenar's Hadrian whose unmade bed was imprinted with intimations of his own mortality. As addiction and AIDS took their toll on Goldin's friends in the 1980s and 1990s, so the bed became a site not of fun, untidiness or debauchery but fatigue, illness, collapse and, eventually, death. The beds that were once semen-stained, cluttered with the abundance of disposable living, are scrupulously clean, stripped of everything but the bare necessities of life-support.

These beds also became the focus of immense compassion as people in their thirties and forties have to learn something which, typically, comes much later in life: care for the sick, infirm and bed-ridden. In a remarkably short time the people Goldin pictured

lying on their beds, sleeping off hangovers, are seen lying in open coffins, sleeping the big sleep. These later pictures subtly change the earlier ones. Photographs of Goldin's friends, lying in bed – dead to the world, as the saying goes – seem prophetic: snaps of the fate that awaits them.

The prize, if such a thing existed, for the most disgusting picture of a bed, goes to Stephen Shore, one of the photographers who, along with William Eggleston, pioneered the use of colour.* In 1972 Shore photographed the unmade bed of a friend who had not changed the sheets for six months. The undersheet was once blue; the pillow white. Now the pillow is yellow, the middle of the sheet a smudge and dry swamp of brown. Hadrian's intimation of mortality has here become a horrible fact. It is only a photo of an unmade bed but it is proof of a self-neglect that is more disturbing than the self-abuse witnessed so explicitly by Goldin. Arbus, it will be recalled, wanted to photograph the suicide on the faces of Hemingway and others. Shore photographed something just as intimate without even showing his friend's face. We know nothing about this friend, but there is nothing else *to* know. There is no need to photograph him because – as this bed makes plain – he has, in a sense, already gone.

> *I had a special association with that bench.*
>
> Sven Birkerts

Though it can serve as one, a bench is not a bed. Nor is it a chair. Chairs move around, congregate in different ways, reconfiguring themselves according to the demands of the social situation in which they find themselves. In their limited way they even enjoy a bit of

* For the record, Shore also photographed a quite disgusting toilet. What for Weston was a shiny symbol of 'modern hygienic life' has become its swampy opposite; to piss in this toilet is to risk catching something debilitating.

travel – chairs on the terrace of a Paris café go inside for the night – but the bench has no inner life like this. The bench sits it out, waiting for dawn. As such, its nocturnal life is potentially more romantic than the chair's.

Brassaï and Weegee were alert to this, of course. In 1955 Weegee – who, after leaving home at the age of fifteen, had spent many nights sleeping on the benches in Bryant Park – snapped a young couple playing records on a portable record player in the cosy darkness of Washington Park. At night, when there is not a chair in sight, Brassaï contrives to make a bench on the Boulevard Saint-Jacques as seductively intimate as a sofa or a pair of seats at the cinema. It can never quite become a bed, however; or rather, it can never – or only rarely and uncomfortably – become a bed in the sense of a sexual destination and consummation, only a bed as a place where you crash, senseless, homeless, or both. The bench never has any say in who ends up on it or how late they stay. There's never any chance of an early night. You might not want to party but you're part of a crowd that won't let you say no. The only chance is to move away, to start a new life somewhere else – and that's not going to happen. Every day is like the morning after the night before. If no one can come up with anything better they're always going to come back to your place and, since it's happened so many times before, they're not going to be too fussy about keeping it clean. A bench is a public house for people with no home to go to, a pub that never shuts. Everyone's always welcome, even when they're not. People take refuge on a bench when there is nowhere else left but the bench can only take refuge in its own limitless powers of endurance. As such it maintains a vestige of dignity which it imparts to those who sit on it, even when they don't sit but slump. Things could be worse: a bench is better than the ground and, as with tables, you're always better off on than under one.

We have seen how, in pictures from the Depression, the hat covering the face becomes a symbol of destitution. The two elements – hat and bench – are multiplied harshly together in Weegee's photo of a night shelter in the Bowery (c.1938). At the front of the picture a man

stretches out, luxuriating in the fact that he has a whole bench to himself. Behind him are another eight or nine rows of benches in which men are wedged together. Their arms are folded, their heads — some bare, most covered by identical hats — lean forward on the bench in front like a somnolent congregation praying in church. It is as if in New York there is such a surplus of misery that taking it lying down is a privilege. The rest have to share it, four to a bench.

In Brassaï's Paris things do not seem anything like as terminal. If there's a bench to hand the impression is often one of dormant respectability. As long as you are sitting on a bench, in daylight, there is always the suggestion that you're just having a nap, that you've nodded off. Now a nap, in this context, could last for most of your life, but the idea of some kind of waking — of waking and feeling briefly revivified, ready for action — is always implied (even if that action is going to land you right back where you started).

A chair can adapt itself to its environment; a bench weathers the storm, takes whatever life throws at it. Its view of the world is fixed, determined, stubbornly opposed to change yet powerless to resist it. There is often a sense that the benches themselves are spectators, looking on at the passing human trade. Whatever happens they have seen it all before — even things they're seeing for the first time. Not that the mood of a bench is always the same. No, like anything that spends its days outdoors, the bench has its seasons, its moments in the sun.

All the great photographers are capable of metamorphosing themselves, if only occasionally and accidentally, into other photographers. They have all taken photographs which look like photographs by other great photographers. For Lartigue this became a point of extravagant principle: 'One shouldn't be only two photographers but thousands', he declared. Appropriately enough the most resplendent example of this chameleon-like quality is a photo by Brassaï that is as serene and elegant as one by Lartigue. On the Riviera, in 1936, the photographer who claimed the night as his own photographed a man sitting beneath a blazing white umbrella in the afternoon sun [34]. He's sitting on a bench, his back to the sea and

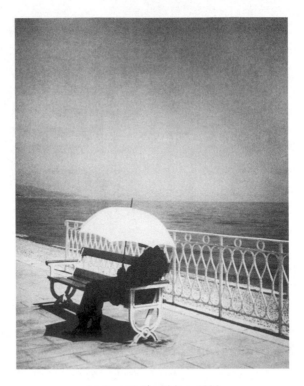

34. Brassaï: *The Riviera*, 1936
© Brassaï Archives: Mi.IISIAM 1995–226

the luminous grey sky that takes up exactly half the frame. It is a visionary photograph or, rather, it is a photograph of a visionary umbrella. The defining quality of the visionary, as Larry Harvey, founder of the annual Burning Man festival, has pointed out, is that light does not fall upon a scene but appears to emanate from it. In this instance all the light in the picture – and all the shade! – emanates from that umbrella.

A few metres further along the Promenade – in the next frame, so to speak – one can imagine Lartigue taking his famous picture of *Renée at Eden Roc*, wearing a white blouse and hat, demure as Princess Di (one ankle hiding the other), leaning against railings, framed by sea and sky, looking as *Vogue* as can be. The two pictures – Lartigue's and Brassaï's – are paired in my mind, not simply because of their

radiant elegance but because of some shared, barely perceptible hint of melancholy. In Lartigue this is provided by the two huge umbrellas, looming dark as thunder over the horizon; in Brassaï it is suggested by . . . the bench.

It is not unlikely, writes Szarkowski, 'that Jacques Lartigue, in his early teens, and Eugène Atget, in his fifties, saw each other photographing in the Bois de Boulogne, in the years before the First World War'. And what about Brassaï and Lartigue, did they see each other? Did they meet? In a sense, yes. In these two pictures they *shared an umbrella*.

There is something inherently sad about a bench. Benches at bus stations have taken on the resignation, the long aftermath that frustration and impatience leave in their wake, of all who have sat there, longing to be gone, forced to settle for a wait on the bench when what they wanted was a seat on the bus. Nowhere is the defining quality of the bench — its absolute immovability — felt more powerfully than at a bus or train station. Perhaps this is why people are often reluctant in these situations to sit and relax. They prefer to sit and jangle change in their pockets, to glance again and again at the timetable that conspires, somehow, to be both implacable and unreliable. To sit down on the bench means to give in, to accept the reality of the situation, to succumb, in fact, to the intolerable *benchness* of the situation. John Vachon captures this perfectly in a picture of a man from out of town sleeping beneath a NO LOAFING sign at a railroad station in Radford, Virginia, 1940. He is not just stretched out; his dark suit is so difficult to distinguish from the bench that he seems to have merged into it.

I said that benches have their seasons — and so they do. But at some level, for the bench in the park, that season is always tending towards autumn. No wonder that Kertész had a special fondness for them. One of his earliest photographs was of his younger brother, Jeno, sitting on a bench in the Woods of Népliget, Budapest, in 1913 [35]. Jeno is wearing an overcoat, his hat is also sitting on the bench beside him. The floor of the forest is strewn with fallen leaves. Some way off we can see two other benches, one empty, the other . . . I was going to say that it

35. André Kertész: *Jeno in the Woods of Népliget, Budapest*, 1913
© Estate of André Kertész, 2005

was occupied by another solitary sitter but, looking again, I'm not so sure. The blurred outline which I had assumed to be a person looks like it might just be a trick of light and leaves. But there was somebody there; like David Hemmings in *Blow-Up*, I was sure of that. It is as if, between my last looking at the picture and my looking back now, the person has got up and left. The mistake actually compounds the very thing that occasioned it: the picture's mood of lingering and precocious melancholy. Jeno is only seventeen but he surveys the vacant woods with the look of a man in the autumn of his life, mourning his lost youth while still in its midst. André was just a few years older than his brother when he took this picture but, as was also the case with his early photographs of musicians, it is like a negative from which he will continue to make variant prints for the rest of his days.

It would be claiming too much to say that the silhouetted figures seen in many of Kertész's photographs seem always to be heading towards or looking forward to death, but it would be quite reasonable to suggest that they are always on the look-out for a bench. And the bench represents a kind of death. A bench is . . . on the bench: side-lined, condemned to spectate, peripheral. The man on the bench is a surrogate for Kertész's own situation, observing life but no longer

36. André Kertész: *Broken Bench, New York, 20 September*, 1962
© Estate of André Kertész, 2005

participating in it. Still, at least – like the people photographed by Brassaï and Weegee he has a bench. On 20 September 1962, in New York, after all those long years of snubs and slights, Kertész took a photograph that summarized his own situation – or his own perception of his situation perfectly [36].

Near the top of the frame two women are seated on a bench; in the distance is scattered an assortment of empty chairs and benches. A third of the frame is completely dominated by the back of a man in an overcoat looking down at a broken park bench. It is quite possible that after enough knocks and disappointments your favourite bench in a park could mean almost as much to you as a pet dog or a wife once did. Pathetic? That's the point: how sad it is that there are people for whom a bench could mean the difference between melancholy and break-down. 'Think of being them,' Larkin urged:

> Turning over their failures
> By some bed of lobelias,

Nowhere to go but indoors,
No friends but empty chairs . . .

And now the bench is not just empty, but broken. Etymologically, it would make sense if the man with his back to the camera were a recently declared bankrupt (*banca rotta*) but, equally, he could be just a passer-by, looking at it quizzically. If, to put it crudely, Kertész wanted the broken bench to reflect the observer's dilapidation, he also saw – and saw himself as – someone looking on, curious, sympathetic but detached. It is this telescoped ambiguity that contrives to save the picture from the sentimentality it courts. I say 'contrives' because the photograph was not the happy – in the Kertészian sense of '*un*happy' – accident that it appears. Kertész's wife, Elizabeth, had met and taken under her wing a mentally unstable young woman who had to be committed to a hospital. The two women in the background are Elizabeth and the patient. The man with his back to the camera is Frank Thomas, Elizabeth's partner in the cosmetics business that provided the bulk of the Kertészs' income during the long years when André's photographic vision was unwanted, wasted. By the time this photograph was taken Thomas had become totally reliant on the Kertészs because – like the accordionist André had photographed on 6th Avenue in 1959 – he was blind. Presumably Kertész and his friends happened upon the bench and Kertész then arranged things to give the picture the symbolic association he wanted.

Kertész's melancholy view of the bench is, it goes without saying, not the only one. For Winogrand the bench is like a busy street in which people are sitting rather than walking. In his photograph of a bench at the World's Fair, of 1964, eight people are simultaneously connected – it is difficult to make out where one group of people ends and the next begins – and self-contained [37]. This bench is like a dream of New York in which separate individuals are united by the simple fact of being crammed into a small place. In a Chinese whisper of gestures, every movement is echoed, elaborated, repeated, passed on and back. A photograph of a bench, it is also a photograph of legs, dresses, shoes, bags and hands. Three different conversations are going on but, just as all

37. Garry Winogrand: *World's Fair, New York*, 1964
© the Estate of Garry Winogrand, courtesy the Fraenkel Gallery, San Francisco

the different nations are part of the World's Fair, they are all part of the same conversation. It is primarily a picture of women, bookended on one side by a middle-aged white man reading a newspaper and, at the other, by a young black guy. As always in Winogrand there is a sense of other photos going on elsewhere (the two women on the right seem to be looking in the direction of one of these). This is fundamental to Winogrand's conception of working in New York: there is always something else to look at. (Kertész was accused of saying too much in his pictures; Winogrand's don't let you get a word in edgeways.) There might even be more stuff to look at on the same bench which extends beyond the frame in either direction, as if the city is in fact an infinite bench in which easy harmony and respect hold sway. This is suggested by the way that, on the far left, the black man and the white woman are talking. Nothing very remarkable about that but it is impossible not to notice that the woman next to her is whispering something – about the conversation taking place to her right? – in *her* friend's ear. As always in Winogrand there is just enough ambiguity or hesitation to make you

realize — and there is something very New York about this too — how precarious such harmony is. I don't want to make too much of this, don't want anything to detract from the civic understanding and good manners of the scene. The atmosphere is entirely convivial. Convivial but not romantic. In Winogrand romance is, at best, a marginal possibility.

The margins and what is to be found in them are central to Diane Arbus's entire photographic enterprise. In 1968 Arbus seems to have briefly experimented with the idea of photographing the same person at home and on a park bench. In one picture she records a woman, in her underwear, seated on her bed in a crowded and cluttered apartment (the kind of apartment that will later be the locus of Nan Goldin's creative enterprise). Another picture shows the same woman in an overcoat, smoking, sitting on a park bench. On the one hand we have an intimate, private glimpse of bearable isolation; on the other, the public appearance of bearable loneliness. That is the crucial thing about Arbus's pictures: there is no refuge, no hiding place. We might think that we are able to hide our real selves from the world but the public face is every bit as revealing as the private one. Arbus also photographed a man in the same way — naked, at home, and reclining on a park bench. It is only when we look at the background details of the apartment — the bedspread, a can of something — that we realize that the person in all four pictures is the same. As a man Bruce Catherine is seated in the middle of the bench. As a woman Catherine Bruce is also seated right in the middle of the frame, at the far end of the bench. Through this simple device Arbus suggests how, while she is, obviously, the centre of her own world, she is on the edge of something (respectability? a breakdown?).*

These pictures of Arbus's and Winogrand's of the bench at World's Fair reveal what the two photographers had in common and what distinguishes them from each other. Winogrand is drawn to the chance

* In 1967 Arbus was herself photographed on a park bench by John Gossage. She is sitting in the middle of the bench, legs crossed, camera slung around her neck. She has the bench entirely to herself and this, together with the framing of the picture and the vacancy of her gaze, effectively strands and isolates her.

minglings, the inexhaustible visual patterns of social flux thrown up by the city. Arbus sees the inexhaustible possibilities of eccentricity, a multiplicity of isolations.

The mutual proximity of these photos by Winogrand and Arbus makes their pairing almost inevitable. But what about Kertész's photograph of the broken bench and Paul Strand's *White Fence* [38] of 1916? Are they related in some essential way? (Did Strand prepare the way for Kertész?) Or is it only through the intervening contingencies of my own exposure to them that they are linked?

Strand's picture was the logical culmination of everything he had been striving for up to that point. In late 1914 or early 1915 he had shown his work to Stieglitz whose own vision had by then been decisively reshaped by the European Modernists he was exhibiting at 291. Strand's own first exposure to this revolutionary art was at the Armory Show of 1913. Like many visitors, Strand was puzzled and

38. Paul Strand: *White Fence, Port Kent, New York*, 1916

excited by the challenge of Post-Impressionism and Cubism. He was also stimulated by the intense discussion the work of Picasso and the other artists initiated in and beyond the Stieglitz circle. By 1914 shows of modern art were cropping up all over New York. Everyone was debating the 'abstraction' question. So strong was the momentum generated by this new movement that realism itself came to be seen, modishly, as a kind of negative or reverse abstraction.

Having studied the works of art and the theories at work in them, Strand spent the summer of 1916 at a cottage at Twin Lakes, Connecticut, learning 'how you build a picture, what a picture consists of, how shapes are related to each other, how spaces are filled, how the whole thing must have a kind of unity'. He began by photographing crockery and fruit, using these familiar objects to build a picture of defamiliarized spheres and concavities. Once he'd got the hang of that he moved to the porch and used a table, chairs and the wooden railings to create curves and angles of light and dark on a larger scale. The constant wheeling of the sun provided different ways of arranging a repertoire of shapes in new permutations so that the shadow-streaked floorboards became a keyboard of light and dark. Isolating these shapes from their fixed role and place in the world was not enough for Strand. He further stressed their independence by hanging his pictures upside down so that they floated free of the representational claims of the everyday. Having mastered this kind of abstraction he wanted to use the compositional skills he had acquired to return to the human world – to reintegrate his pictures with the world from which he had painstakingly abstracted them. In doing so he would harness the excitement of experimentation with the homely truth he had glimpsed in the course of a trip through Texas in 1915. Fascinated by the way the monotony of the landscape was 'broken by shacks and little houses', Strand noticed that things 'become interesting as soon as the human element enters in'.

White Fence is the product of exactly this reconciliation. In keeping with the work at Twin Lakes, it is the repeated black-and-white, positive-and-negative pattern that holds the picture of the fence formally together, but there is something else at work in it as well – as Strand himself explained years later.

Why did I photograph that white fence up in Port Kent, New York, in 1916? Because the fence itself was fascinating to me. It was very alive, very American, very much part of the country. You wouldn't find a fence like that in Mexico or Europe. Once when I was in the Soviet Union, I was taken into the country by Edouard Tisse, the cameraman for Eisenstein and others, and along the way I saw a fence against dark woods – it was a very special fence, containing the most amazing shapes. And I felt then that if I'd had the camera with me I could have made a photograph that had something to do with Dostoevsky. That fence, and those dark woods, gave the same sort of feeling you get in reading *The Idiot*. You see, I don't have aesthetic objectives. I have aesthetic *means* at my disposal, which are necessary for me to be able to say what I want to say about the things I see. And the thing I see is *outside* of myself – always. I'm not trying to describe an inner state of being.

Strand himself came to feel that *White Fence* formed 'the basis for all the work' he went on to do. One critic went further, claiming, in 1966, that it was the '*locus classicus* for the subsequent development of the main tradition of American photography'. If this is true then the tradition can be seen to culminate in a photograph by an Englishman.

Michael Ormerod was born in 1947, in Hyde, Cheshire. He studied economics at Hull University and photography at Trent Polytechnic. After that he ran a freelance photography business and taught at Newcastle College. All his best-known pictures were made in America where he died – in a road accident while photographing in Arizona – in August 1991. That is all I know about him. I could find out more but I prefer him to be defined – like E. J. Bellocq – entirely by what he saw.

Stephen Shore has said that his 'first view of America was framed by the passenger's window' of a car. As someone born outside America, Ormerod's first view of the country was framed by photos and films, by images. The work collected in the posthumously published book, *States of America* (1993) is like a reprise and distillation of some of the

dominant tropes of American photographs, from the early twentieth century to Eggleston. Ormerod was surely aware of Strand's picture, and his own photograph of a white fence is, in part, a response and homage.

Behind the white fence photographed by Ormerod in the 1980s (there are no captions or locations in the book) is a small, well-tended and manicured park with a tree-lined path curving pleasantly through it [39]. The fence itself is broken: five of the white uprights are damaged, two of them completely shattered. The neighbouring posts, though, continue to go stiffly about their business, not getting involved. I first saw this picture on the cover of John Cheever's *Journals* where it served as a preview of the kind of immaculate suburban devastation recorded with photographic precision in the pages within. Cheever comments more than once on 'the moral quality of light', and Ormerod's fence – damaged, glowing white, casting faint shadows – is evidence of just that. In Cheever's world marriages go wrong, turn bad, persist as, and even after, they fall apart. 'The most wonderful thing about life,' Cheever wrote in 1958, 'seems to be that we hardly tap our potential for self-destruction. We may desire it, it may be what we dream of, but we are dissuaded by a beam of light, a change in the

39. Michael Ormerod: *Untitled*, undated

wind'. Blame, in Cheever's stories, is the result of inadequate scrutiny: the more closely a situation is examined the more difficult it becomes to assign; in the *Journals*, where Cheever subjected himself to the most intense self-scrutiny, blame represents a lack of lucidity.

In Ormerod's lucid image, the damage to the fence is obvious and inescapable. It could be the result of any one of dozens of different stories (vandalism? An accident involving a kid's tricycle?), but there is no attempt at explanation, no sense of symbolic urging. The British art critic John Roberts thinks the picture is 'perhaps Ormerod's own allegorical comment on the "Vietnam syndrome"', which strikes one both as a plausible tribute to the picture's immense suggestive power and, as a response to what is actually shown, necessarily wide of the mark. Commenting on a story of Updike's, Cheever observed that 'he has developed an impractical degree of sensibility'. He also believed that his 'own stubborn and sometimes idle prose has more usefulness. One does not ask, skating on a pond, how the dark sky carries its burden of starlight. I don't, in any case.' Does Ormerod?

Although Ormerod's is only a photograph of a broken fence it is also a commentary on Strand's picture. Since that picture of Strand's occupies so important a position in the evolution of American photography, Ormerod's is, in turn, a commentary on and contribution to that tradition. Is Ormerod suggesting, therefore, that the photographic tradition initiated by Strand has been broken? Or that the tradition is resilient enough to accommodate all manner of internal ruptures and revolutions? The photo raises these questions without even asking them. Its very literalness – this is a picture of a broken white fence – prompts us to ask if it is more than a picture of a white fence: if it is a picture of more than a white fence. Certainly in the wake of Ormerod's sudden death, the broken fence takes on the quality of self-epitaph and prophetic elegy.

All of which leads one to conclude that, contrary to appearances, as far as photography is concerned, Updike was right and Cheever wrong. One *can* ask, skating on a pond, how the dark sky carries its burden of starlight. Recalling the notes written by Gedney after Arbus's death one might even speak of 'the *necessary* burden' of starlight.

*

From Ormerod's broken fence it is a very small step to Kertész and his picture of a broken bench. But is there a connection between Kertész and Strand – between an unbroken fence and a broken bench – or does this connection only exist because of Ormerod's photograph? Strand's and Kertész's paths do not seem to have crossed – but I am glad that Ormerod's picture brings them together. In this sense Ormerod introduces Kertész and Strand to each other. And once this introduction has been made a number of pictures by Kertész begin to look like Strand's, and vice versa. There is, for example, the picture Strand made of Morningside Park in 1916 [40]. You could hardly hope for a more Kertészian image. Two thirds of the picture is cordoned off by the diagonal railing of a set of shadow-mounted steps (which form a series of contrary diagonals). The remaining triangle in the top left-hand corner is occupied by some children and a group of four benches, huddled around each other as if to create a little exterior room. One child has his arm around the shoulder of a friend as if he is consoling or comforting her. As is often the case in pictures by Kertész their backs are to the camera. It is the kind of photograph Kertész would have taken to suggest how, now that he has ascended the steps of age, he is separated irrevocably from – but reminded constantly of – a childhood which,

40. Paul Strand: *Morningside Park, New York*, 1916

Pl. 1. Philip-Lorca diCorcia: *New York*, 1993

Pl. 2. Bruce Davidson: *Subway*, 1980–1

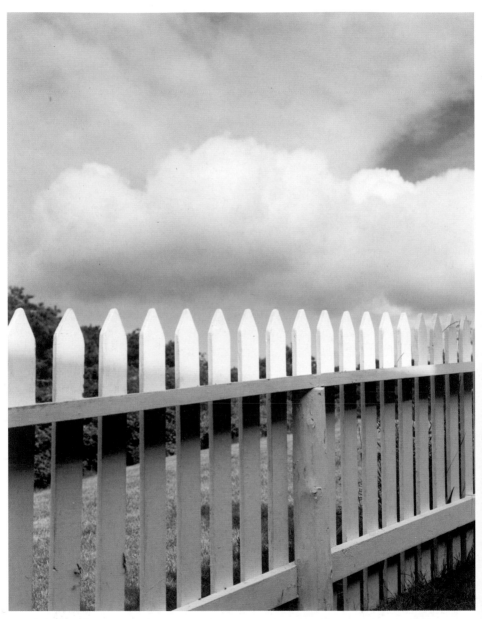

Pl. 3. Joel Meyerowitz: *Truro*, 1976.

By kind permission of Joel Meyerowitz Photography

Pl. 4. Joel Meyerowitz: *Still Life with Newspaper*, 1983.

Pl. 5. William Eggleston: *Gas Station*, 1966–74

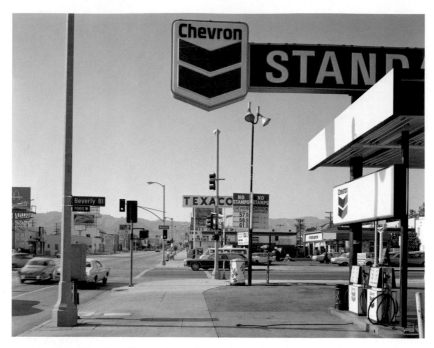

Pl. 6. Stephen Shore: *Beverly Boulevard and La Brea Avenue, Los Angeles, California*, 21 June 1975.

Courtesy of Simon Greenberg Gallery

Pl. 7. Peter Brown: *Strip Centres, Duncan, Oklahoma*, 1986.

By kind permission of Peter Brown and Harris Gallery, Houston

Pl. 8. Michael Ormerod: *Untitled*, undated

© Michael Ormerod/Millennium Images

Pl. 9. Peter Brown: *Barber Shop, Brownfield, Texas*, 1994.

By kind permission of Peter Brown and Harris Gallery, Houston

Pl. 10. Walker Evans: *Train Station, Old Saybrook, Connecticut,*
6 December 1973

Pl. 11. Walker Evans: *Traffic Markings, Old Saybrook,*
Connecticut, 15 December 1973

© The Walker Evans Archive. The New York Metropolitan Museum of Art,
New York, 1994 (1994.245.10)

Pl. 12. Walker Evans: *Coffee Shop Hallway, Oberlin, Ohio,*
January 1974

© The Walker Evans Archive. The New York Metropolitan Museum of Art,
New York, 1994 (1994.245.119)

though happy, still conveys a gestural inkling of the sadness that is to come in later life.

Strand also did a number of bird's-eye shots which duplicate one of Kertész's favourite angles of approach. One in particular, taken from a viaduct in New York, looks down on the ground patterned by what could be taken for the shadow-girders of the Eiffel Tower, at the side of which are the blurred forms of two figures, standing, talking. Both photographers took views from their window looking down on the pure geometry formed by snow in their backyards or in the park. Both liked the way that, seen from above, sheets hung out to dry or the roofs of lower houses formed a collage of flattened shapes. For Strand, who made these pictures in 1917, this was a phase, a point of departure. For Kertész it was both a starting point and a destination.

As a sixteen-year-old, Kertész had become obsessed with a young woman who lived across the street from his parents' house in Budapest. He would spend hours looking out of his window at her window, recording every glimpse of her in his diary. The first picture he took on arriving in Paris in 1925 was an oblique view of the windows across the street from the window of his hotel on rue Vavin. Having become interested in the photographic 'overview' in Paris, Kertész sought out similar views after he came to live in New York. By 1952, when he and Elizabeth moved to Two Fifth Avenue, into a twelfth-floor apartment with a view of Washington Square Park, he had come to feel that this was his destiny: to gaze down from his window as he had done from his parents' house in Budapest in 1911–12, as he had in Paris. The difference, as he grew older, was that the snow came round more and more quickly. He became increasingly conscious of the corollary of Shelley's affirming question: 'If winter comes, can spring be far behind?' Yes, but that, in turn, means that if summer's here then winter can't be far behind.

Strand's *Winter, Central Park* [41] shows the calligraphy of a tree scribbling shadows on the greying snow. In one corner is the blurred form of a child dragging a sled. The picture is composed entirely of the stark black lines of tree, shadows and this blurred figure. It was taken in 1913–14 and is like a detail from — or cropped version of — a

41. Paul Strand: *Winter, Central Park, New York*, 1913–14
© 1980 Aperture Foundation Inc, Paul Strand Archive

picture Kertész made in Washington Square Park [42]. Kertész is standing further back but if a part of it were isolated, we would have something very like Strand's. The other important difference is that Kertész took his picture in 1952. In the intervening years the young girl pulling a sled has grown into an old man shuffling along in a coat. It's a similar picture, but it has aged.

Everywhere Kertész looked he saw reflections of his own situation. A walk in the snow became a form of solace and an expression of the sadness from which it was intended to provide relief. Snow turns the city into a wilderness; parks become as vast as the central plain – the *puszta* – of Hungary. Dwarfed by the scale of their undertaking, Kertész's overcoated men inch their way through the snow. They come to the trusty benches, their normal places of rest, to find that they are no longer benches and have become a form of urban snow-fence. There's nowhere to sit because the snow has taken up residence (not intentionally, it's just something the snow has drifted into) so he walks on . . .

A man in a dark overcoat, wearing a hat, hands in pockets, walking slowly (often, but not always, away from the camera). The darkness of

12. André Kertész: *Washington Square Park*, 1952
© Estate of André Kertész, 2005

the coat and hat means that he is often no more than a silhouette. He turns up all the time in Kertész's pictures. This is not to say that he only crops up in pictures by Kertész. He turns up in the work of many other photographers (he is there for all to see) but he lingers in Kertész's, by which I actually mean the reverse. Kertész's camera lingers on him, dwells on him. The very type of the émigré, he looks, at times, as if he has been cut out of a picture from Hungary and pasted into New York, with its vast modern architecture of bridges and warehouses.

As is often the case with motifs one associates particularly with Kertész's middle and old age these figures first crop up in his youthful work. We encounter them . . . Let me rephrase that: we encounter *this* figure – for there is really only one, recognizable immediately by the overcoat and hat which obliterate any other defining characteristic – in

147

1914 in Budapest, walking at night over the lonely cobbles [43]. Camus said that when we see birds in the evening we always think of them as heading home, but we never feel this when looking at Kertész's overcoated man. There is never a lighted window, beckoning. No, it is the streets themselves, the act of strolling – the *overcoat*, in fact – that have taken on the constancy of home. Even then the man looks like a shadow of his former self. He seems incapable of moving quickly and it is impossible to imagine that he has ever been capable of running, and yet Kertész began photographing this man at the same time that he made energetic pictures of himself and his brother, stripped almost naked, racing, in love with motion. Even then something in Kertész yearned nostalgically for the future, for a time when those summer days with his brother would be a memory, fading, in the minds of men who walk, even in snow, as though they are wearing slippers, pacing the streets like the ward of a chilly hospital, suffering a nameless ailment for

43. André Kertész: *Bocskay-tér, Budapest*, 1914

which the only cure is to keep on walking, 'An echo from those days came back to me,' writes Cavafy:

> . . . something of the fire of our young life when we were
> together.
> I found a letter and stood re-reading it until the day faded.
>
> Saddened, I went out on to the balcony,
> To change my mood a little by seeing [. . .]
> The comings and goings in the streets and the shops.

What Kertész sees when he looks out at the street is often this silhouetted representative of his own feelings about being adrift and unappreciated in New York. The people in the streets, heading to shops, are emissaries of his own sadness. That is the lot of the photographer: you walk the streets or sit on a bench – or you look out of the window at people walking or sitting on benches.

In John Boorman's film *The Emerald Forest*, one of the Amazonian Indians takes a psychotropic drug that releases his bird or animal spirit. While he lies zonked out in a hut his puma- or condor-self soars and speeds off into the jungle and sky of the spirit world. I often find myself thinking of Kertész in terms similar to – if far less spectacular than – this. From behind his camera the photographer watches his surrogate walk out into the material world.

In this, as in so many ways, Stieglitz is a precursor or antecedent. Looking back on how he had made his famous photograph *Steerage* of 1907, Stieglitz remembered how, on the upper deck, 'looking over the railings, there was a young man with a straw hat. The shape of the hat was round. He was watching the men and women on the lower steerage deck . . . The whole scene fascinated me. I longed to escape from my surroundings and join these people' [44]. The photographer chances upon a scene that fascinates him. He longs to be part of it and finds a way both of recording the scene and including within it his vicarious representative, the participating observer.

44. Alfred Stieglitz: *Steerage*, 1907
© Library of Congress, Prints and Photographs Division, LC–USZ62–62880

The same figure was there – in a slightly different incarnation – in the photograph by Lewis Hine of the Blind Beggar in the Italian Market (p. 2). Dorothea Lange also articulated her idea of the photographer in such a way as to describe what is going on *within* the frame: 'a figure who is part of it all, though only watching and watching'. In certain circumstances the photographer can have it both ways, can be both the observer and the observed. While shooting at night Brassaï relied on exposures long enough to enable him to both take a picture and walk around and be one of the people featured in it.*

* The eleven-year-old Lartigue also took a childish delight in this possibility: 'Sometimes when I'm taking a photo, if I hurry, I can go and put myself in front of the camera so as to myself be in the photo I'm taking . . . The idea isn't bad but the result is that I'm always half-transparent in the photo.'

Something rather more complex is at work in another photo of Stieglitz's, taken in 1900–1 [45]. It shows the intersection of 30th Street running flat along the bottom of the picture, and Fifth Avenue moving diagonally upward from the left-hand corner of the frame. A horse-drawn cab — the same horse, I like to think, as the one seen blurring through the storm on Fifth Avenue in 1893 (see footnote p. 90) — stands at the bottom of the picture looking as permanent as the tree growing on the corner behind it. The photograph was made with a relatively fast exposure, fast enough to freeze the caped figure walking towards the camera while, beside him, cabs trundle slowly in the opposite direction.

To think, there was a time, over a century ago, when this moment was *now*! And that caped figure — even he must have had an inkling of the way

45. Alfred Stieglitz: *The Street, Fifth Avenue*, 1900–01
© National Gallery of Art, Washington, Alfred Stieglitz Collection

that 'now' becomes 'then'. When he crossed the street and passed the man with the camera, he would surely have glanced back to see what the picture looked like, only to discover that the very thing – himself – that defined it as a picture, a moment, was no longer there. In a few seconds he has come and gone, only his footprints remain; it is his peculiar destiny – or so this photograph insists – never to arrive at that backward looking vantage point, but to be rendered, momentarily and perpetually, as patient as the waiting horse and the buildings which are still there too.

This is the figure that is repeatedly seen by Kertész, leading the photographer – and us – through those moments when everything falls pictorially into place. Without him, without this external representative of the photographer's spirit, there would be no pictures. We see him in Hungary, we see him in Paris where he stands by the Quai d'Orsay, holding a cane behind his back watching two becoated figures walk towards him. We see him in New York, in 1954, gazing out at the river and the bridge in the background [46]. The sense of this man as the photographer's surrogate is emphasized by the way that the figure in the foreground is actually looking in the direction of another, almost identical person. If the camera pulled back, cinematically, we would see another figure, the photographer himself, looking at both of the others. And so it would go on until, by a kind of reverse telescoping, we could follow this relay of looks right back to the window of the apartment where the photographer is looking out.

There is nothing sinister about this figure, nothing of Poe's Man of the Crowd (nor, really, of the flâneur of whom he was the forerunner). No, this man is just a stroller, like a clerk without the day job, someone whose main aim is to kill time, of which there is always too much on his hands. He is one of those men who like to look at construction sites, the gaping holes in the earth which will form the foundations of a sky-scraper or a multi-storey car park. That is the nearest he gets to the great outdoors, the sublime. His coat is sufficiently cosy for the city to become an interior, a living room through which he shuffles. It's difficult to imagine him in any seasons other than winter or autumn. He does not wear the coat so much as inhabit it. He is always looking slightly askance at things. He is like an old woman peeking out from

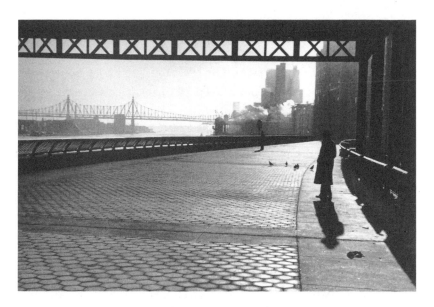

46. André Kertész: *New York*, 1954
© Estate of André Kertész, 2005

behind the curtain, even when he is out on the street, motivated by some infinitely diluted form of nosiness. He is content to observe life, always slightly bored and often waiting, even if only for a bus. Failing that he will watch other people waiting for a bus. Alert to the smallest changes in the things encountered in the course of his perambulations, he will always give you the time of day. Overhearing directions being given to a tourist he will listen, evaluate, wait and, if necessary, correct or amend. His life is marked by such an absolute lack of intent as to give it a purity of purpose: to get through the day. He has the patience of a tree, or a bench in its shade.

That is the difference between the figure observed by Kertész and those captured by Strand in 1915, hurrying down Wall Street. Strand wanted to photograph people 'rushing to work' outside the recently completed J. P. Morgan building, whose huge black windows float like monoliths above the scurrying human figures. The low sun sends their shadows streaming out behind them while, as Strand himself put it, 'the great black windows have the quality of a great maw into which the

people rush'. Kertész's figures lack all sense of urgency or hurry. They also have the quality of exclusion and election that marks all those who do not have an office to hurry to. The great thing about a job, as Arbus realized in 1969, is that it 'helps keep you from unanswerable questions'. Without the time-consuming distraction of a job even trivial questions assume the weight of fate itself. You have all day to dwell on the slights dealt out to you, the decisions wrongly made, but this, in turn, can generate its own solace: with nothing else to distract you such things start to seem like facts of life, as much a part of the human condition as a bench is part of a park. So when you come to a bench in the park, possibly your favourite bench, and find it broken, the experience comes as both a personal disappointment and corroboration of something to which you had already pretty much resigned yourself. In these circumstances, what can you do except look at it and try to work out how much should be read into it, how personally to take it, whether, actually, there is any difference at all between destiny and chance?

There are a number of artists who, though not pioneers or innovators, have the virtue of summing up many of the qualities of those who are. This is as true of photographers as it is of musicians or painters. Looking at the pictures of Steve Schapiro, for example, we see traces and reworkings of many of the classic themes of American photography. Schapiro is, so to speak, quite Frank about this: the first picture in his retrospective book *American Edge* is of a demonstrator on the Selma March of 1965, holding aloft the stars and stripes in what has become not only a political gesture but a symbolic salute to *The Americans*. This is not to diminish Schapiro's work. On the contrary, it is precisely because he lacks the obsessive singularity of the innovator that he is so valuable as a commentator on the medium: he enables us to see, in concentrated form, more general trends in the history of photography.

Let's say that the overcoated figure first walks into our cultural viewfinder in the early years of the twentieth century. He still crops up fairly frequently after the Second World War. Rudy Burckhardt spots him in the neon dusk of Times Square in 1947; Marc Riboud finds him in

England in 1954, scuttling along, looking slightly out of place in vernacular Leeds. René Burri sees him crossing a cobbled street in Prague in 1956, immediately after the Hungarian Uprising. In 1961 Schapiro shows him walking off, heading out of the frame [47]. He is blurred, starting to dissolve into the background. A part of the visual tradition is stepping out of sight, making room for others, for an aesthetic more in keeping with the jostle and simmering uncertainties of the new decade. In the foreground are two other men, one of whom, seen in extreme close-up, is entering the frame from the left. That old Eurocentric elegance, suave and sad, but possessed of its own certainties and consolations, has been replaced by something – personified by the close-up profile – more uncertain. Ironically, this aesthetic is also the product of European influence, specifically Frank's. There is a strong sense of valediction in

47. Steve Schapiro: *New York*, 1961

© Steve Schapiro, courtesy Fahey/Klein Gallery, Los Angeles

Schapiro's picture as this figure – himself marked by elegy and nostalgia – prepares to pass away, disappear. The Kertészian surrogate exits, stage right, dragging his rainy reflection behind him. After this he will make only a few fleeting appearances (stopping once more to observe the broken bench), lamenting his own disappearance. In the mid-1960s Kertész's rehabilitation will proceed apace. It is appropriate, then, that this figure whom one symbolically identifies with Kertész should disappear. He walks out of the history of photography, confident in the knowledge that his place in that history is fixed.

Except there is, I am beginning to suspect, a strange rule in photography, namely that we never see the last of anyone or anything. They disappear or die and then, years later, they reappear, are reincarnated, in another lens. That figure stepping out of the frame of Schapiro's photograph, for example, will turn up again, in 1993, in a town called Brcko.

> *I remember well standing at that one window and just*
> *watching the flow of life.*
> Dorothea Lange

It wasn't just Kertész . . . At some point all but the most intrepid – even the most intrepid – photographers are tempted to retreat inside and contemplate the world from their window. If this suggests a return to first principles – one of the very first permanent photographs, a foggy heliograph made by Joseph Niépce in 1826, was of a *View from the Window at Gras* – there is also an etymological inevitability about it. The camera reverts to its origins, returns to the room into which light – and dark – enters.

In Prague, in 1940, Josef Sudek did a series entitled *From the Window of my Studio*. Having created some of her most famous images on assignment in Italy and Israel, Ruth Orkin retired from photojournalism and spent much of her working life from 1955 onwards recording the view from her apartment on the fifteenth floor at 65 Central Park West. Duly collected in *A World Through My Window*

(1978), the results convey Orkin's satisfaction at what she felt to be an ideal and lasting way of reconciling the claims of photographer and housewife-mother.* It's more usual for the move inside to be periodic, an occasional withdrawal rather than a definitive and contented retreat.

The photographs that Stieglitz took from the places in New York where he lived and worked form three distinct clusters or phases. The first were taken from the back window of 291 Fifth Avenue in 1915. Several of these, particularly of roofs transformed by snow into flat and tilted blocks of white, were conscious attempts to demonstrate his understanding of the compositional lessons of Cubism. Between 1930 and 1932 Stieglitz made another series of photographs of the huge construction projects that could be seen either from An American Place on the seventeenth floor of 509 Madison or from the room where he and O'Keeffe lived, on the thirtieth floor of the Shelton on 525 Lexington. In 1935 he made a final series of views from the Shelton, looking west towards the Rockefeller Center.

The photos from the Shelton and An American Place record Stieglitz's response to the frenzied pace of construction that was in the process of hemming him in, spectacularly enhancing his view while simultaneously restricting it [48]. Financed and planned during the boom years of the 1920s the work was actually being done in the midst of the Depression, prompting Stieglitz to rail about the money that was being poured into such enterprises while 'artists starve'. (Typical of Stieglitz, that, to contrast the symbolic greed of capitalism with starving artists rather than workers or farmers.) The pictures themselves form a cool and detached contrast to these verbal complaints about what was going on around him. Rather than craning up at the symbols of Mammon towering over him, Stieglitz's viewpoint is on a par with what he is photographing. The building he is photographing from is part of an earlier stage of the process he is observing. The skyscrapers

* At the other extreme from Orkin a 1959 photo by his newly elected Magnum colleague, René Burri, shows Cartier-Bresson leaning out of Cornell Capa's apartment on Fifth Avenue, busily clicking away with his Leica. It is as if he has dashed inside only momentarily, between assignments.

48. Alfred Stieglitz: *Window at the Shelton, West*, 1931
© National Gallery of Art, Washington DC, Alfred Stieglitz Collection

sprouting up around him become equivalents of his own achieved ambition, vertiginous tributes to the medium whose rise he had done so much to engineer. Stieglitz had insisted that 'If what is happening in here cannot stand up against what is out there, then what is in here has no right to exist'. If what is 'out there' challenges what is 'in here' but fails to overwhelm it, on the other hand, then the former can be seen as validating and affirming the latter. The contest is aesthetic and symbolic, verging on the abstract, its outcome a self-complementing alliance between architecture and photography. The implacable might of the world outside reflects back the enduring power of Stieglitz's capacity to survey it.

People, both those building the skyscrapers (as heroically photographed by Hine on the girders of the Empire State Building) and

those who live or work in them, are nowhere to be seen. In one of the 1915 views from 291 there is a line of washing hanging out to dry; by the 1930s this seems a quaint memory of homeliness that has long since been displaced by the vaulting programme of construction. Not that there is any quality of lament in Stieglitz's pictures. 'We live high up in the Shelton Hotel,' he explained to Sherwood Anderson in 1925. 'The wind howls & shakes the huge steel frame – we feel as if we were out at midocean – All is so quiet except the wind – the trembling shaking hulk of steel in which we live – It's a wonderful place.' This is Stieglitz in his confident, buccaneering prime. Years later, when he is photographed by Weegee and Cartier-Bresson, he will be reduced to skulking in his cabin, fretting about rent and the sea of troubles threatening to break over him.

In 1922, from his apartment on West 68th Street, Stieglitz's friend and ally Edward Steichen trained his eye on the windows and fire escapes of the building opposite. The contrast with Stieglitz's sense of being 'midocean' could hardly be greater. It seems possible, almost, to lean out and touch the opposite wall. In one picture a pair of cardboard boxes on the landing of the fire escape are caught, as Steichen explains in his caption, haphazardly 'laughing' together. In another the fire escapes and backyards lined with washing are observed less with a view to their potential as elements within a pictorial arrangement than as a record of harmoniously demarcated communal living to which the exquisite composition does justice.

Another view from Steichen's window frames a window which frames – as Randall Jarrell puts it in his poem 'Windows' – 'A man nodding into the pages of the paper'. In Edward Hopper's paintings the figures glimpsed in large airy windows partake of the light and spaciousness of the outdoors. Here the man sits cramped in his hutch. He has scarcely more room to read his paper than one of the passengers photographed by Evans on the subway. A few years later, in 1925, Steichen would take night views from a window on 40th Street that make the city's buildings sleek, cool, deserted; the 1922 pictures have the casual intimacy of a village, an aspect of urban life that is, so to

speak, easily overlooked. In *Sunday Papers* the little square of window is the only relief from the endless rows of bricks that surround it [49]. The view from one window is of another window, every bit as humdrum. There's nowhere else to look. Even if you want to look away you can't.

When peering into Merry Alpern's *Dirty Windows*, on the other hand, it's all but impossible to tear your gaze away. Alpern spent the winter of 1993–4 with a telephoto lens trained on the back window of an after-hours sex club. The club was off Wall Street and Alpern's pictures reveal the murky, grimy backside of finance. But there's a glamour here too and a purity about the transactions as besuited clients hand over fifty-dollar bills to hookers in high-impact underwear. Sex, drugs, cash – that's all there is to it. Everyone is doing coke, getting

49. Edward Steichen: *Sunday Papers, West 86th Street, New York,* c.1922

Reprinted with permission of Joanna T. Steichen

high and trading money for sex. Clients roll on condoms and roll up bank notes to snort more coke. We cannot see any of this as clearly as we wish [50]. What we see is often frustratingly blurred and all the more alluring because of that. It is like a dream in which there is no room for manoeuvre. The camera is all the time craning forward, trying to penetrate a forbidden economy of sex and drugs. It's exactly the view of a window that the unpenitent voyeur craves. The picture frame is precisely that of the window frame and, after a while, the tightness of focus – the concentration needed to sustain this intensity of prying – becomes exhausting. Peeping turns into surveillance. It becomes a kind of prison. The window is like a TV with only one channel on which the same pay-per-view porno movie (never quite as explicit as you want it to be, hampered by poor reception) is endlessly

50. Merry Alpern: *Dirty Windows*, 1994

from the book *Dirty Windows*, courtesy Scalo Publishers

replayed. You crave distraction, variety. You crave freedom from this world in which pleasure is so narrowly prescribed. Quaint though it seems, you long, like Cavafy, for 'a little movement in the streets and shops'.

From a photographer's point of view, a window looking on to the street is a way of being of the world but not in it. You retreat inside but you can go on monitoring the street without the inconvenience, the jostle, the crowdedness. 'There must be eyes upon the street', wrote Jane Jacobs in *The Life and Death of Great American Cities*, an idea which so appealed to William Gedney that he copied it into his notebooks. He also transcribed Kafka's account of how the life of the solitary man is rendered bearable by 'a window looking on to the street' – not an empty street but one with people, life. This is the visual reciprocity of loneliness: solitude can only be expressed in terms of other people. To evoke the loneliness of Kafka's solitaries, the artist must find a surrogate: a figure on the street. Gedney gave definitive expression to this in a picture taken from his apartment in Brooklyn [51]. In the top third of the photo is a window of the house across the street: the window that looks out on and mirrors Gedney's own. The remaining two thirds of

51. William Gedney: *Brooklyn*, 1969
© Special Collections Library, Duke University

the picture shows a street scene, empty except for a man looking into a shop window and a silhouetted figure making his way down the sidewalk.

Gedney was a reclusive, quiet man, happy to spend time in his book-crammed apartment, glancing out at the world. The contrast with W. Eugene Smith who had worked on assignments all over the world (getting himself blown up in Okinawa along the way) could not be greater. Having been sacked from *Life* magazine in 1955 Smith had accepted a commission to do a small-scale project on the city of Pittsburgh. Given that the assignment was only supposed to last three weeks his sponsor in the city was surprised to see the photographer unloading some twenty items of luggage from his station wagon. Smith's refusal to abide by deadlines had strained the patience of all his employers but it was in Pittsburgh that his insistence on taking as long as the job required reached megalomaniacal proportions. For the first month he barely clicked the shutter, preferring, as he always did, to get to know his subject. He spent a year making over ten thousand exposures of every facet of the city. And this was just the beginning. Conceiving the Pittsburgh project as a photographic equivalent of Joyce's *Ulysses*, Smith then tried and kept failing to print and edit the mass of material into an order that would do justice to 'the tremendous unity of [his] convictions'.

Smith's biographer, Jim Hughes, paints an unforgettable picture of the photographer driving himself to the brink of madness as he grappled with his gargantuan undertaking. Wired on amphetamines, banging out letters full of delirious, teeth-grinding declarations of intent, Smith would work for three or four days straight and then collapse. Free at last to realize his ambitions of total artistic control, he began to suffer from a kind of dementia of seeing. In 1957, after separating from his family, Smith moved into a loft on 821 Sixth Avenue near 28th Street. It was, Smith wrote, 'a last ditch stand. The ditch being mental.'

As if in recoil from a project in which he had tried to see everything from every point of view, Smith now took pictures from the reassuringly limited vantage point of his window: cars going by, people

getting in and out of them, deliveries being made, snow falling . . .
Inevitably in the course of this deliberately restricted survey a familiar
figure strayed into his lens — familiar, that is, from Kertész: the over-
coated solitary, crossing the road, waiting at the street corner. At first
this seems unlikely. Despite the shared bird's-eye view of the world the
restraint and calm of Kertész seems a long way from the outspoken
rhetoric of Smith's style. But it was Kertész himself who pointed out
their underlying sympathies of style and approach. Smith, to Kertész,
was a kind of internal émigré, to be contrasted with those photog-
raphers who were willing to prostitute themselves to editors. 'Among
the exceptions, Eugene Smith is remarkable; he photographed in my
style. He sincerely admitted to me that I had influenced his career,'
Kertész insisted. 'He worked for *Life* and naturally they threw him
out.' And so it comes about that an unlikely meeting is embodied by the
silhouetted overcoated figure, standing at a street corner beneath a
zigzag of fire escapes; crossing a rain-slick street; clutching a box of
flowers; wading through snow.

Being Smith, he went about the business of recording the view
from his window in a way that was antithetical to Kertész's. Unable to
do anything without doing it obsessively, he soon had six cameras
trained on the street. When the floor below him became vacant he took
that over too. As well as looking outwards he turned his gaze inwards.
On the floor above was a loft where jazz musicians held jam sessions.
Smith, as one would expect, wanted to photograph them. But it came
as a surprise to the musicians when, in the middle of playing, a drill bit
appeared through the floor followed, a few moments later, by a length
of wire. Shortly after that Smith appeared at the door with a micro-
phone which he hooked up to the wire so that he could record the
music as well as photograph them playing it. Even that did not satisfy
him; soon he had rigged up microphones all over the building to record
whatever was happening. The mania to record was inseparable from a
deepening depression. 'My life has become of dank despair from the
corrosive elements which hobble it and which cost it the strength to
utilize its strengths', he wrote with characteristically muddled grand-
iloquence. And though he'd come up with a lyrical series title, *As from*

my window I sometimes glance, this was a thoroughly misleading description of what was going on: Smith was not sometimes glancing, he was looking compulsively, all the time, taking more and more pictures. He had got to the point, as Cheever put it in a summary of a story he was contemplating, 'where the observer is tragically involved, simply through having committed himself to observation without restraint'.

A friend recalled turning up at the loft to find Smith with six cameras loaded, leaning out of the window. He had already been sitting at the window for twenty hours straight and remained there for another six or seven while his friend passed him cameras. And all of that, Hughes explains, was just the start of another surge of the overproduction from which it was intended to bring relief. 'Because of the window's proximity to his new darkroom and workspace, Gene was able to produce workprints fairly quickly, pinning them up to create a constantly changing panoply on the 4x8 panels that slowly but surely began to divide the loft into a maze of interior streets and alleys.' The photographer didn't want to go into the streets; instead, by dint of obsessive Borgesian twists, the street moved into the home.

My car became my home.
Weegee

One way of combining the view from the window with the movement of the street is to drive. Throughout the 1930s photographers were motoring through America on FSA assignments, stopping whenever they came across something that caught their eye or complied with Stryker's edicts. Here, more specifically, I mean pictures actually taken from the car: the kind of photo that Evans took near New Orleans in 1935 as he sped past a group of Negroes sitting out on the grass, one of them playing the guitar, watching the car blur past. Evans liked the almost-randomness of this, the way that you couldn't really know what you'd got. It was the same, a few years later, when he'd take pictures surreptitiously on the New York subway.

When Evans became a kind of mentor to Robert Frank, the men went on road trips together. In the early 1950s, Evans would ask Frank to stop the car, walk to a spot a hundred yards away, come back and say that tomorrow the sun would be in the right place at a certain time and they should return then. Frank stayed in the car.

The Guggenheim Frank had applied for with Evans's encouragement enabled him to travel through America and take photographs of 'the kind of civilization born here and spreading everywhere'. Accompanied by his wife and two kids, Frank set off in 1955, photographing – as Jack Kerouac wrote in the introduction to the book that resulted from this trip – in 'practically forty-eight states in an old used car'. As on those earlier jaunts with Evans he sometimes stayed in the car – even while he was photographing. And he didn't bother to wait until tomorrow, when the sun would be in the right place.

'I love to watch the most banal things,' Frank has said, 'things that move.' Many of the pictures – even those taken from a stable, fixed spot – look like they were taken on the move too. America was becoming a place to be seen from a car, a country that could be seen without stopping. As a result it is as if the camera only just succeeded in stopping time. And even then we are always being urged on. The pictures are apparently so casual as to seem hardly worth dwelling on. If we do choose to linger it is often to try to work out why Frank took a particular picture (what's so special about this?). A neon arrow on the side of a building directs us beyond the edge of the page to the next photo. The purpose of the photograph made from a hotel window in Butte, Montana, is to confirm that the view, partly hindered by net curtains, does not merit a second glance (as such the photograph demands that we return to it again and again). An elevator door is about to close, like a shutter that will open again, for a moment, not on another floor but in another building or another city (though which one – and why – is anybody's guess).

The sense of being constantly in motion contributes to what has often been remarked on: the grim, bleak quality of Frank's pictures. According to another European observer of America, Jean Baudrillard,

part of the pleasure of travel is 'to dive into places where others are compelled to live and come out unscathed, full of the malicious pleasure of abandoning them to their fate. Even their local happiness seems tuned to a secret resignation.' That is the mood one encounters again and again in Frank's pictures. But what is going on in them is more complicated than that. There is also a snatched, self-cancelling lyricism, a grainy yearning that never quite has the opportunity to manifest itself fully. The fact that someone is passing through makes those who are staying put conscious of their fate so that their resignation becomes disturbed and unsettled by the possibility – even if it will never be acted upon – of moving on. In turn moving on acquires a taint of desperation: the fear of being one of the abandoned, one of those doomed to stay put.

Perhaps this is why John Cheever felt that 'this nomadic, roadside civilization is the creation of the loneliest travellers the world has ever seen.' Unlike Kerouac – who considered Frank's view of urinals 'the loneliest picture ever made' – Cheever did not have Frank or any other photographer in mind when he wrote this, but his 'vision of the waywardness of man and the blessings of velocity' serves as a sidelong commentary on a world first glimpsed in *The Americans*.

Despite the enthusiastic support of Evans, Frank's perceived indifference to traditional ideas of visual composition was so challenging that at first he could not find an American publisher for the book. It was only after its successful publication in France in 1958 that *The Americans* came out in the States the following year. The year after that, Ornette Coleman released an album that boldly announced *The Shape of Jazz to Come*. Though occurring independently of each other these defining moments in music and photography are mutually illuminating.

The history of jazz is the history of listeners growing used to what at first sounds alien, unassimilable. Frank's pictures share with Coleman's music the need to explore formal boundaries by doing away with them. The objections to the free jazz ushered in by Coleman can easily be carried over to Frank, whose work was judged, by traditional

standards, to be unframed, uncomposed. In the late 1950s Coleman's music was revolutionary, unprecedented. Listening to it now we can hear, quite clearly, that it is drenched in the blues that the saxophonist had heard growing up in Fort Worth, Texas. It's the same with Frank. Since his pictures have themselves become part of a tradition we can see how they have come directly out of an earlier phase of that tradition. However unprecedented there is usually something familiar about Frank's pictures, some vestige of an earlier, safer pictorial logic whose packaging has been deliberately discarded. What makes Frank unique, according to Wim Wenders, is an ability 'to take pictures out of the corners of his eyes'. The results of this skill are never going to be easy on the viewer's eye but, having learned to feel at ease with this uneasiness, we can see how much of the earlier visual blues of Lange and Evans is there in Frank. On US 91, the road out of Blackfoot, Idaho, he photographs a pair of people in their car, in profile, staring through the windshield, driving into the future with all the fixed determination of purpose that was memorialized by Lange.

The influence of innovators like Frank and Coleman extends in both directions. Obviously they have a massive impact on the work that is made after them. But once it becomes clear that they are rooted in a tradition which they seemed, initially, to flout, challenge or overthrow, they change our perceptions of the work that has gone before. Just as the new appears traditional so the traditional comes to seem newer. Duke Ellington, it turns out, sits surprisingly comfortably alongside Charles Mingus and Max Roach or John Coltrane. In the same way, if Frank had stopped off at a *Café near Pinole, California* he might have photographed the guy in the cowboy hat, sitting at a bar at the edge of the frame, smoking, while the cigarette machine and phone go about their lack of business behind his back [52]. Maybe the juke is playing an Elvis song; more probably it's not playing anything so all you hear is the whirr of the fan and the metal coat hanger which shakes every time it turns that way. Were it not for the fact that it was actually taken by Lange this picture could have easily found a place in *The Americans*.

Frank's consciousness of treading, both thematically and geo-

52. Dorothea Lange: *Café near Pinole, California*, c.1956

© the Dorothea Lange Collection, Oakland Museum of California, City of Oakland.
Gift of Paul S. Taylor

graphically, in the footsteps of his predecessors is highly developed. The idea was not to passively record how America had changed in the twenty years since Evans and Lange documented it in the 1930s but, more actively and challengingly, to see how photography might be changed for the next twenty or thirty years – maybe more.

It was this – the fear of the visual deluge that might come in his wake – as much as what Frank actually did that troubled people. It was wholly appropriate for Kerouac to write the introduction to *The Americans*, for the questions the Beats prompted a horrified Gore Vidal to ask himself were exactly those posed by Frank. 'Was this what writing was destined to be – an endless report on what one had done the night before while listing the names of the all-alike towns that one sped through on the ever-same road?' Kerouac had already worked out his own answer. Having dismissed the material of F. Scott Fitzgerald as 'sweetly unnecessary', he went on to inform Neal Cassady that it 'is the exact stuff upon which American Lit is still to be founded'. That was in 1950. Frank's own answer – visual rather than verbal – was that, in some respects, he was travelling down the ever-same road as Lange and Evans. As it happens this can be illustrated quite literally.

*

In 1938 Lange took a picture of *The Road West, New Mexico* [53]. The top third of the photo is a band of blank sky; the bottom two thirds a barren landscape, dominated by the highway pouring towards the horizon. You could stand here for hours waiting for a car to come by and then stand for another two hours after it passed waiting for another, hoping this time it might stop. Nothing is coming the other way. There's no turning back. All you can do is keep heading west. The distance swallows you up. The distinguishing feature of this road is that it has no distinguishing features. But knowing what we do of Lange and the Depression, this road features vividly in our sense of American history. A current edition of Lange's work makes this explicit by placing the picture next to a quotation from one of the people she met on the road: 'Do you reckon I'd be out on the highway if I had it good at home?' In *An American Exodus* (1939) the picture on the facing page was of a family of homeless tenant farmers, taking to a similar road like refugees. In cinematic terms, *The Road West* is like their 'point-of-view' shot.

Lange shares this point-of-view. She stands there like Tom Joad, 'silent, looking into the distance ahead, along the road, along the white road that waved gently, like a ground swell'. Her picture is of a long road to some kind of economic salvation. Its colossal emptiness could

53. Dorothea Lange: *The Road West, New Mexico,* 1938

© the Dorothea Lange Collection, Oakland Museum of California, City of Oakland.
Gift of Paul S. Taylor

be a sign of infinite promise but it also suggests a chronic scarcity of resources, an undeviating absence that will persist to the horizon or the grave. Since we know that Lange was a photographer dedicated to depicting the lives of migrants, Okies and sharecroppers we know – even though, strictly speaking, *we cannot know it from the picture* – that the road ahead is not an expression of her journey but of the road taken by those whose lives she was documenting.

The contrast with a strikingly similar picture taken by Frank could hardly be greater. Like Lange's, Frank's photo of *US 285*, also taken in New Mexico, shows a road heading to the horizon [54]. Still some way off, a car is coming the other way, offering the option of return. The scene is scarcely less desolate than Lange's but it has a different kind of sadness, the sadness of the night, the Kerouac-sadness that stood for the promise and romance of new adventures and, in Frank's case, new photographs. (Kerouac riffed on this picture in his introduction: 'Long shot of night road arrowing forlorn into immensities and flat of impossible-to-believe America in New Mexico under the prisoner's moon.') The slight white shine on the road imparts a feeling of motion, movement, speed. Lange's picture is about distance, remoteness; Frank's is about covering ground. What was a symbol of the harsh reality of economic necessity is here the begetter of artistic possibilities and imminent encounters. Just what these encounters will be is anybody's guess. There is no telling, as we turn the pages of *The Americans*, where this road might lead. Lange documented a desperate search for work; here the search is not for work but for works of art, for images. The subject of the photographs has become the photographer's own vision and journey. This road is a picture of Frank's trip or at least one segment of it. Lange's families of migrants have been replaced by the photographer's own family, featured in the book's closing sequence of pictures: Frank's wife and their two children, in the car, at a truck stop in Texas.

Two pictures of a road heading west: more vivid illustrations of the shift Szarkowski described – from documentary photography 'in the service of a social cause . . . towards more personal ends' – are hard to conceive.

*

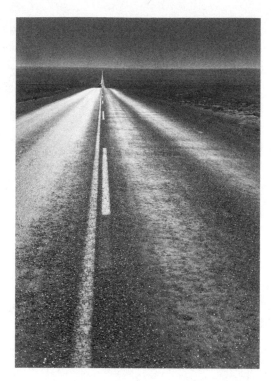

54. Robert Frank: *US 285, New Mexico*, 1955–56, from *The Americans*

© Pace/MacGill Gallery, New York

In the course of *his* Guggenheim-funded romp through America in 1964, Garry Winogrand pushed things a stage further, combining Frank's ad hoc aesthetic with a pictorial appetite so voracious it bordered on the indiscriminate. In Frank's pictures motion is implied; Winogrand's are taken on the move, from the left-hand seat, while he's actually driving, enhancing the feeling of the snatched moment, of near-randomness. Kerouac was amazed by Frank's ability to snap 'something that's on the move in front of him, and through an unwashed windshield at that', but as far as I can tell none of these pictures found their way into the final selection of *The Americans* (though there are several shots taken through the open side windows). For Winogrand the hood of the car and the streaks and smudges on the windshield become part of the picture; the dark interior roof of the car

and the dashboard create a frame within the frame. Winogrand takes the idea of the view from the artist's window and gives it wheels.

Several of Winogrand's shots are similar to Frank's and Lange's pictures of the open road, but that vastness is rendered manageable by the interior framing of the car. The knowledge that we are behind the wheel of the car shrinks the distance, making it familiar – homely even. You can see it in another of these land-sky-and-highway pictures, taken *Near El Paso*, of a home being towed along the highway: not a mobile home as such but a home that is temporarily mobile [55]. In another picture, *Near Dallas*, an interminable freight train is on a bridge crossing the highway, extending from one side of the picture frame to the other. The distant horizon has been blotted out: instead of a destination there is simply another means of transport. And still there is a vestige of the kind of yearning glimpsed in Frank, reduced by now to a simple reluctance to stop, a frazzled insistence on heading somewhere else. 'And so,' writes Cheever, 'one sees this great, nomadic nation on roads built by blackmailing unions and the lobbies of contractors, manufacturers, truck-fleet owners, and politicians of all sorts. We see a great people turned nomadic in their passionate search for love.'

A quick glance in the rear-view: Lange takes a picture of the open road; Frank takes an almost identical picture at night; Winogrand takes several through the windshield of his car . . . In an undated photograph, Ormerod peers at the road through a rain-spotted windshield in twilight [56]. A white truck, lights blurring through the rain, is coming the other way. A grey sag of cloud weighs down on everything. At any moment the wipers are either going to clear the picture or smear it across the windshield.

A basic drive in the development of all arts is to advance formally, the corollary of which is the Flaubertian urge to do away with content, to get to the point where 'the subject would be almost invisible'. Obviously, this is a far more radical step in the visual arts than in literature. I looked back through *The Americans* to see if any of Frank's pictures were as blurred and dimly focused as this one by Ormerod.

55. Garry Winogrand: *Near El Paso,* 1964

© the Estate of Garry Winogrand, courtesy the Fraenkel Gallery, San Francisco

No, they weren't; nor were any of Winogrand's. Ormerod, if you like, has overtaken Frank and Winogrand.

This is not the only picture that Ormerod took through the windscreen of his car. In another he gazes out at a prairie expanse of grass where a horseless cowboy is making some rudimentary alteration to a fence, the whole scene surveyed by a bunch of cows chewing the cud, staring back in their cow-trance [57]. The sky is streaked with clouds and the windscreen is streaked with stuff too, grey mud or the bug-splat of insects who didn't know what hit them (it's like the sky suddenly turned solid). The hood of the car – borrowed, as it were, from Winogrand – is visible in the bottom part of the frame but something is missing. Namely the *road.* It makes you wonder what Ormerod is doing here and why, in this of all pictures, he's in his car. As always, the picture contains the answers to the question it poses. There's no road because this is the end of the road in the sense that the car is not simply a thing that enables one to get around but a way – even in the absence of a road – of seeing, a mode

56. Michael Ormerod: *Untitled*, undated

© Michael Ormerod/Millennium Images

57. Michael Ormerod: *Untitled*, undated

© Michael Ormerod/Millennium Images/Picture Arts

of perception that is more or less assumed; literally, a world-view.*
The American windshield has been thoroughly Anglicized and turned
into a windscreen.†

Some photographers become synonymous with a single image. Such
has been the fate of O. Winston Link whose picture *Hotshot Eastbound,
Iager, West Virginia* (1956) is dominated by a view of cars pulled up in
front of a drive-in movie screen. Near the top of the frame a steam train
hurtles by, billowing smoke. On the movie screen is a military jet.
Floating in the indeterminate space between actual motion (the train)
and stillness (the cars) the plane has 'the air of being twice as quiet that
mobile things have when they are not moving'. In a few moments the
train and the plane will be gone – and with them the fleeting sense of
densely concentrated time.

Link's photo is as carefully contrived and lit as a movie set. Frank's
picture of a drive-in movie in Detroit displays his characteristic appar-
ent randomness [58]: cars are faithfully parked up before an American
Mecca; there is still some light in the sky. Apart from that nothing is
about to happen or not happen. Frank could have taken the picture ten
minutes later or ten minutes earlier; he could have taken it a few feet
nearer or a few feet further away. All that would have changed is the
image on screen. Even this indifference, though, helps lock the picture
historically in that period when people would turn up at any point in a
film, confident in the knowledge that as soon as it finished they could
watch it all over again, from the beginning. What is happening onscreen
is irrelevant: what matters is going to the movies, eating popcorn,

* How appropriate, then, that Andrew Cross, a contemporary British photographer as
obsessed as Ormerod by the American landscape, feels that 'in a sense my destinations [lie]
beyond the end of the road'.
† Martha Rosler uses this dual idea of the screen to deliberately cinematic effect in the
series *Rights of Passage*. Her wide-angle, through-the-windshield shots of the traffic on
Pulaski Bridge, Queensbound (1994) or *Routes 1 and 9, New Jersey* (1995), for example,
duplicate in miniature (36.4x99.5 cm) the elongated format of the film screen.
Substantiating the claim made by J. B. Jackson – 'roads no longer merely lead to places;
they are places' – the road movie gives way to the road still.

58. Robert Frank: *Drive-in Movie – Detroit*, 1955–6, from *The Americans*

© Pace/MacGill Gallery, New York

making out. Edward Hopper's painting *New York Movie* reminded the writer Leonard Michaels that the habit of arriving in the middle of a picture 'led to an expression we no longer hear, "This is where I came in."'* Frank's picture shows where he came in, where he *happened* to come in.

Coincidentally – since Frank's photo was taken before *On the Road* made its author famous – one of the two men on screen, the one on the left wearing a check shirt, looks like Jack Kerouac, who would later introduce and celebrate 'the EVERYTHINGNESS and American-ness' of pictures like this. Frank, as Wenders reminds us, was a 'European photographer who loved America'. And since, to

* Reflecting on his cinema-going youth in the 1930s Italo Calvino – in a passage not without relevance to the present work – takes the Italian habit of arriving in the middle of the film as 'looking forward to the more sophisticated techniques of contemporary cinema, breaking up the temporal thread of the narrative and transforming it into a puzzle to be put back together piece by piece or accepted in the form of a fragmentary body'.

foreign eyes, there is nothing more American than a drive-in, it comes as no surprise that some of the best pictures of them should have been taken by another European besotted by the American-ness of photographs of America.

Michael Ormerod was drawn like a pilgrim to the screens of American drive-ins. In one of his pictures the scene is viewed from a distance with cars, quiet as cattle, herded up before the screen. Obviously, for my purposes it would be perfect if there were a picture of a drive-in screen seen through the windscreen of a car but, as far as I know, Ormerod didn't take such a picture. He did, however, do the next best thing: a view down a country road at night, to the right of which is a drive-in screen filled with the projected, hovering image of an automobile [59]. The picture contains a picture, quotes an image.*

Unlike Frank, Ormerod picked the moment of quotation carefully, deliberately. Lee Friedlander did the same thing to more sensational effect at Monsey, New York, in 1963. But while Ormerod chose an on-screen image that was floating free of history, Friedlander preserves a moment that is – both on-screen and off – as historically specific as Paul Fusco's views from a train. The light is fading. The sky is not dark, not quite. On the drive-in screen is a close-up of President Kennedy, grinning in his convertible as the motorcade makes its fateful way through Dallas, heading to Zapruder's super-8 camera.

In the mid to late 1950s Diane Arbus took a number of photos of people in movie theatres, often silhouetted and framed by the action on screen. This was before she had found what became her distinctive style and subjects. Then, in 1971, the year of her death, she returned to a movie theatre and photographed it while the seats were empty

* The first drive-in opened in 1933; by 1958 there were 4,000 in the US; by the mid-1990s less than 900 were still in operation. Hence while Frank photographed its booming heyday, Ormerod observed its nostalgia-brightened twilight.

59. Michael Ormerod: *Untitled*, undated

© Michael Ormerod/Millennium Images/Picture Arts

and the screen blank. It is strange and haunting, this view of empty seats lined up and staring patiently at the empty screen, especially when set alongside a statement Arbus made about photographs in March of that year: 'They are the proof that something was there and no longer is. Like a stain. And the stillness of them is boggling. You can turn away but when you come back they'll still be there looking at you.' The photo of the blank screen proves this by showing how, in the case of the moving image, the opposite is true: you turn from the screen and when you look back at it the faces that were there – larger than life, mythic, ageless – have vanished. The images that moved and moved us have been replaced by a vacant stillness. There's just a blank rectangle.

What Arbus glimpsed in her photograph, Hiroshi Sugimoto has turned into an extended meditation. The empty movie palaces and drive-ins that he began photographing in the late 1970s are dominated, inevitably, by the radiant white of the screen. Using an exposure time equal to the duration of the film, Sugimoto reduces the entire contents

of whatever is on screen – car chases, murders, slapstick, betrayals, romance – to a single moment of absolute whiteness. In this way 'time passes through [his] camera'. The white screen of *Union City Drive-in, Union City* (1993) is framed not by a theatre but by the night sky [60]. Because of the long exposure time the tracks of planes and stars are pale scratches on the darkness. On screen, meanwhile, the stars – whether long dead or in their ascendancy – have become pure projections of unmoving light.

The screen in Arbus's picture of the empty cinema is simply blank – it has not become a source of light. That is to say it has not, by the definition quoted earlier, become visionary. Ironically, however, Sugimoto's pictures bring us right back to Arbus, to her love of what she 'can't see in a photograph'. Arbus had in mind darkness – the nights of Brandt and Brassaï – but with Sugimoto we end up with the opposite idea of what can't be seen: absolute lightness. Perhaps

60. Hiroshi Sugimoto: *Union City Drive-in,* Union City, 1993
Courtesy of Sonnabend Gallery

there is a philosophical thing going on here: something to do with an Eastern idea of enlightenment (the experience of being in-light) as the flow of images dissolves, transcends itself, leaving behind this white glow. In the 'Preamble' to *Let Us Now Praise Famous Men* James Agee commented on the efforts of his friend Walker Evans to perceive 'the cruel radiance of what is'. Sugimoto perceives the soothing radiance of what is not. At the risk of over-romanticizing, life has given way to that which – according to Shelley – it 'stains': 'the white radiance of eternity'.

> *I'd have to be really quick*
> *to describe clouds –*
> *a split second's enough*
> *for them to start being something else.*
> Wisława Szymborska

In the early 1850s there was no sky and there were no clouds, just an expanse of whitishness. Or so it appears in photographs from the time. The problem was in calibrating the different exposure times required by land and sky. If the darker features of the land were to be correctly exposed then the sky was rendered uniformly featureless through over-exposure. In the late 1850s Gustave Le Gray pioneered a way of solving this problem by combining two negatives to create a print that showed a magical combination of sea or land and sky that had, in fact, never existed. The technique became sufficiently widespread that, by the end of the century, people complained about composite landscapes 'with clouds hung low above still water in which they had no reflections, and over which they cast no shadows'. The debate was rehearsed late in the twentieth century when David Hockney took exception to Brandt's spectacular photograph of clouds scudding over the bleak moorland of *Top Withens* (1945). Aiming not to record an actual scene but to evoke the visceral emotion of Emily Brontë's *Wuthering Heights*, Brandt made a collage of two negatives. For Hockney, willed deception

like this amounted to a form of 'Stalinist photography'. Brandt's biographer, Paul Delany, on the other hand, finds justification for the practice in lines of Wordsworth which the photographer 'probably knew':

Ah! *then*, if mine had been the Painter's hand,
To express what then I saw; and add the gleam,
The light that never was, on sea or land,
The consecration, and the Poet's dream.

Not that Wordsworth's dream of painterly liberty would have cut any ice with Paul Strand. He took exception to this kind of thing even in painting. There were, he claimed, 'plenty of skies in art where the sky has no relation to the land – some of the Impressionists, like Pissarro, made that mistake'. To avoid repeating this mistake, Strand pursued his own policy of contrivance by rigorous selection. The louring, storm-laden clouds that he deemed appropriate to the character of the American South-West appear in many of his pictures of the area. By contrast, fluffy 'Johnson & Johnson clouds', as he termed them, have no place in Strand's meteorological scheme of things. (Rejected by Strand, one of these clouds wandered off on its own and drifted to New York. In 1937 Kertész eagerly snapped this *Lost Cloud* as it was confronted with the vertiginous fact of a skyscraper: a gentle representative of his own sense of being disorientated and out of place.)

If they were conscious of the error diagnosed by Strand, Weston and Stieglitz responded by removing the sky from the land. Other than 'matter-of-fact records', the first negatives Weston made after moving to Mexico City in 1923 were of a 'quite marvellous cloud form': 'a sunlit cloud which rose from the bay to become a towering white column'. A month later the clouds still held him in their thrall: 'they alone are sufficient to work with for many months and never tire.' In July the following year he found clouds were 'tempting' him again. 'Next to the recording of a fugitive expression, or revealing the pathology of some human being, is there anything more elusive to capture than cloud forms!' The techni-

cal challenge of capturing clouds was matched by Weston's interest in the sculptural quality of light and form; as such the cloud pictures were like ethereal forerunners of studies he would later make of fruit and vegetables. One of his most famous pictures of the sky in Mexico shows a horizontal length of cloud stretched as luxuriously across the picture frame as the torso and hip of a nude woman he photographed a year later, in 1925. Essentially, there was no difference between photographing a cloud and a human body.

Like Weston, Stieglitz was fascinated by the technical difficulties of photographing clouds. He'd made his first attempts in Switzerland in 1897 and often thought of following up these early experiments. The incentive finally came, in 1922, in the form of a suggestion by Waldo Frank that the effectiveness of Stieglitz's pictures 'was due to the power of hypnotism'. The very same day – 'out of the clear sky' – his brother-in-law also irked Stieglitz by asking why he had given up playing the piano. Irritated, Stieglitz resolved to answer them both by doing something he'd had in mind for years: 'a series of cloud pictures'. He explained exactly what he intended to O'Keeffe. 'I wanted to photograph clouds to find out what I had learned in forty years about photography. Through clouds to put down my philosophy of life – to show that my photographs were not due to subject matter.' Stieglitz became steadily more absorbed by what he called 'his great sky stories – or songs'. Some of the earlier pictures show sky and clouds over the land and trees of Lake George. Gradually, though, the pictures became increasingly abstract, detached from and independent of the land beneath them – 'way off the earth', as O'Keeffe put it. The first series of photographs was called *Music – A Sequence of Ten Cloud Photographs*; the second, from 1923, *Songs of the Sky*. By 1925 Stieglitz had abandoned the evocative musical associations and had taken to calling them *Equivalents*. 'I have a vision of life and I try to find equivalents for it sometimes in the form of photographs', he explained. The cloud pictures were '*equivalents* of my most profound life experiences'.

Reporting on reactions to these pictures, Stieglitz informed Hart Crane that 'several people feel I have photographed God'. Crane's friend Walker Evans was certainly not one of these. Stieglitz's airy aestheticism

elicited an increasingly hostile reaction from Evans as he grew older. The *Equivalents* were, for him, an extreme manifestation of the tendency in Stieglitz's work he most deplored: 'Oh my God,' he sighed. 'Clouds?'*

In this book certain photographs serve as nodes, places where subjects initially considered distinct converge and merge. These pictures are not necessarily better than the rest, but a number of tendencies and themes can be seen to culminate and converge in them. The threads of hats, backs and steps, for example, are woven perfectly together in Eudora Welty's modest view of three men, backs to the camera, sitting on the courthouse steps in Fayette in the 1930s. I've not mentioned it before for the simple reason that, aside from pointing out its importance within the structural logic of this book, I don't have anything to say about it – except, of course, that I love it.

The two 'traditions' or threads of photographing clouds and of photographing film screens – especially drive-ins – become definitively tied together in a picture by Diane Arbus of a movie screen in New Jersey in 1960. The picture is dense with darkness. The watching cars are discernible only by a few reflective gleams of light. While the sky in Sugimoto's picture of a drive-in at Union City is star-streaked, in Arbus's it is a heavy mottled grey framing a rectangular screen on which is projected an image of sky, clouds. There is something inevitable about this (as there is, in retrospect, about most coincidences). It provides documentary evidence to support John Berger's suggestion that the movie screen *is* a kind of sky: 'A sky filled with

* The sky in Evans's own work is almost incidental. It just happens to be there. His interest is always in human activity, even if it is represented only as a trace: a fading advertisement, say, or a hand-written sign. Hence the peculiar fascination of a picture that is at once completely anomalous and absolutely characteristic. Taken in Santa Monica in 1947, it shows the top corner of a hotel, the neon sign on its roof – HOTEL WINDERMERE – and a palm tree, all of which are framed by an expanse of Californian sky in which the white residue of sky writing can be seen. The letters appear to be ST PP, though what I take to be the 'T' is partially obscured by the palm tree (similarly, the assumed 'IN' of Windermere is hidden by the corner of the hotel). It would have been perfect if the first 'P' had been an 'O'. As it is I have no idea what, if anything, these fast-fading letters stand for.

events and people. From where else would film stars come if not from a film sky?'

Stieglitz's clouds pictures were, as the photographer himself put it, manifestations of 'something already taking form within me'. Intended neither as meteorological records nor as 'documents of the sky on a particular day', they are 'totally artificial constructions which mirror, not the passage of real time, but the change and flux of Stieglitz's subjective state'. Sarah Greenough's summary of Stieglitz's aims doubles as an explanation of Evans's curt rejection of them. More recently, Richard Misrach has offered a rejoinder in the form of a creative homage. 'Clouds', Canto XII of his ongoing series of *Desert Cantos*, is sub-subtitled 'Non-Equivalents'. Like Cantos XVIII ('Skies')* and XXII ('Night Clouds'), it's a conscious attempt to photograph the sky not in order to discover allegories or metaphors of human moods or feelings but to create an irreducible, infinitely varied set of site-specific records. Canto XVIII consists entirely of fields of pure and vibrant colour, but these ostensibly non-representational images are evidence of, for example, the way the sky appeared above Pyramid Lake, Nevada, at 6.57 a.m. on 28 June 1994. Isolate and abstract though they are, Misrach's photos re-anchor the sky in the realm of documentary fact from which it had been poetically sundered by Stieglitz. They are proof, also, that the blue or purple or orange – and the sky are one thing.

> . . . *I am thinking of*
> *a colour: orange.*
> Frank O'Hara

Dorothea Lange remembered being told by her grandmother 'that of all the things that were beautiful in the world there was nothing finer

* In Misrach's *The Sky Book* 'Skies' is mistakenly identified as 'Canto XV'.

than an orange. She said this to me as a child, and I knew what she meant, perfectly'.

Lange photographed a pile of oranges in a market in Saigon in 1958 – or tried to. You can't be absolutely sure they're oranges for the simple reason that the picture is in black-and-white. It's a major photo-philosophical question, this: can you photograph an orange in black-and-white? Doesn't the thing that makes an orange an orange demand that it is photographed in colour?

In the late nineteenth century colour was a black-and-white problem in the sense that, since photographic chemicals were not sufficiently sensitive to the colours of the spectrum, certain shades of red and blue came out as the same dark black. By 1900 the difficulties had been largely overcome: the full range of colours could be distinguished by increasingly subtle tonal variations of black and white. (Though not subtle enough – even by 1929 – to satisfy the red-bearded D. H. Lawrence: 'Look at this passport photograph I had taken two days ago,' he grumbled, 'some sweet fellow with a black beard I haven't got.') Alternatively, the limitations of tonality could be turned to advantage. When Strand was experimenting with crockery and fruit at Twin Lakes in the summer of 1916 he found that the Orthochromatic film he was using registered anything with a hint of red as black. Since he was seeking to render ordinary things as abstract shapes, this helped him to defamiliarize them, forcing the viewer to concentrate on the patterns and forms created rather than on what they were created *by*. An orange, in these circumstances, was defined by anything but its orangeness. In one of Strand's still lives an orange is exactly the same 'colour' – a dense black – as a banana.

Multiple ironies and an unflinching logic become deeply entangled here. The following year Strand would declare that the defining characteristic of photography was its 'absolute unqualified objectivity'. He arrived at this certainty through rigorous experimentation with the medium. This single-mindedness was a direct result of his study of painting, particularly of Cézanne who had achieved what Rilke termed 'a limitless objectivity' by representing 'oranges purely by means of colour'. By contrast, Strand's unqualified objectivity

took advantage of a technical *in*ability to distinguish between colours.

By the time he was making these experiments a number of colour processes had come and gone on the market. In 1890 Stieglitz had begun working for Heliochrome, a firm pioneering a process for printing photographs in colour. When the company went bankrupt it promptly sprang back to life as Photochrome, only to lose the race to print colour reproductions. That potentially lucrative honour went to William Kurtz who, in January 1893, included a full-colour picture in the magazine *Photographische Mittheilungen*. The photograph, naturally, was of fruit on a table.

Photochrome duly patented their own, slightly different process, but the real breakthrough came in Paris in 1907 when the Lumière Brothers, already famous for their motion pictures, demonstrated Autochrome plates for colour photography. Steichen and Stieglitz were both in Paris at the time but the latter was ill and could not attend. Steichen, though, was sufficiently impressed to buy a supply of plates and Stieglitz was soon echoing his enthusiasm. The process would, he was sure, rank in the history of photography alongside the invention of the 'startling and wonderful' Daguerreotype. In expressing his approval in these terms, however, Stieglitz also revealed the shortcoming of the process, namely that each Autochrome plate was, like the Daguerreotype, a unique positive image. Nevertheless, in September of that year he announced his own demonstration of Autochromes at 291 with characteristic bravura. 'Colour photography,' he declared, 'is now an established fact.' And so it was – briefly. Stieglitz, Steichen, A. L. Coburn and Frank Eugene were among those in the grips of 'colour fever'. Three of Steichen's Autochromes were published in the April 1908 issue of *Camera Work* before Stieglitz lost interest in the whole idea. Other photographers, European and American, continued to use Autochrome and other processes – Dioptichrome, Dufaytacolour – until the 1930s. In 1936 the best-known colour transparency film, Kodachrome, came on the market but this enormous investment of scientific ingenuity and investigation did nothing to shake the hold that black-and-white had on the serious practice of photography as art.

*

Strand voiced his objection to colour with characteristic severity. 'It's a dye. It has no body or texture or density, as paint does. So far, it doesn't do anything but add an uncontrollable element to a medium that's hard enough to control anyway.' By 1961 the technical limitations had been comprehensively overcome but this served only to intensify the conviction, best expressed by Robert Frank, that 'Black and white are the colours of photography. To me, they symbolize the alternatives of hope and despair to which mankind is subjected'. For the master of serendipitous composition, Henri Cartier-Bresson, organizing the chaos of reality was complicated enough – 'imagine having to think about colour on top of all this'. In 1969 Walker Evans made his famous statement that 'Colour tends to corrupt photography and absolute colour corrupts absolutely . . . There are four simple words for the matter which must be whispered: colour photography is vulgar.' Within a few years Evans had acquired a Polaroid camera and would spend the rest of his life exploring its creative potential with unfettered relish. 'Paradox is a habit of mine,' he said. 'Now I am going to devote myself with great care to my work in colour.'

By then a number of American photographers were not just working in colour but using it to reconceive the idea of what a photograph might look like. What Walter Benjamin said of the origins of photography – that 'the time was ripe for the invention, and was sensed by more than one – by men who strove independently for the same objective' – also applies to the rise of colour photography in the early 1970s. One of these men, Joel Sternfeld, refers to this time as 'the early Christian era of colour photography', when small groups of converts would gather together and discuss their new-found subversive faith. This faith gained official acceptance in May 1976 with an exhibition at the Museum of Modern Art in New York of photographs by William Eggleston.

Lange had conceded that 'the tropics, and it may be Asia, cannot be photographed on black-and-white film.' America would continue to be photographed in black-and-white but, from this moment on, the States – especially the southern ones with their blazing sun and drenching rains – acquired an almost tropical brightness. The 'bebop

of electric blues, furious reds, and poison greens' that Evans had railed against became a defining part of the palette of American photography. Eggleston sign-posted both his debt to photographic tradition (especially Evans) and his power of innovation early on with a photo from the cache made between 1966 and 1974 that came to be known as *Los Alamos*. A scrawled menu of sodas or shakes available from a roadside café is seen in extreme close-up. The list of flavours doubles as a colour chart, a caption for a taxonomy of American colours:

<div align="center">

STARWBERY

BLUEBERY GRAPE

CHOCLATE SPEARMINT

NECTAR

ORANGE

WILD CHERRY . . .

</div>

The final item on the list becomes almost a manifesto of intent:

<div align="center">

RAINBOW

</div>

If there is a poetry in illiteracy ('starwbery', 'choclate') there is also a beauty in vulgarity. Evans himself knew this. His famous denunciation of colour actually continues with lines that are quoted less often: 'When the point of a picture subject is precisely the vulgarity . . . then only colour film can be used validly.' Eggleston's 1976 exhibition demonstrated, to put it crudely, that vulgarity, if approached with sufficient technical and aesthetic refinement, could be beautiful. Vulgarity, like beauty, was in the eye of the beholder.

Not everyone was convinced. Eggleston's work was dismissed by the influential critic Hilton Kramer ('the banal leading the banal'), who failed to see that its subtle proximity to banality was crucial both to its disconcerting, enigmatic power and – as Kerouac had said of Frank – to its 'American-ness'. Since then Eggleston's influence has extended beyond the realm of still photography: David Lynch's *Blue*

Velvet and Gus Van Sant's *Elephant* are, among other things, cinematic tributes to Eggleston's aesthetic slant on the spectrum of Americana.

Whatever his influence, Eggleston, it must not be forgotten, was himself the beneficiary of a liberating moment in the development of American photography. He was born in Memphis in 1939, and by the time he became interested in taking pictures black-and-white photography had been raised to the highest level of documentary and artistic sophistication by Evans. His successors – Frank, Friedlander and Winogrand – variously disturbed this classical poise with challenges to an idea of pictorial form that also represented its logical extension. Arbus had noticed 'a kind of hollowness' in Frank's work. 'I don't mean hollow like meaningless. I mean his pictures always involve a kind of nondrama . . . a drama in which the center is removed. There's a kind of question mark at the hollow center of the sort of storm of them, a curious existential kind of awe, it hit a whole generation of photographers terribly hard, like they'd never seen that before.' Eggleston realized that if this hollow centre was filled by colour the existential kind of awe would, if anything, be enhanced. By throwing colour into the mix Eggleston both added a complicating variable *and* came up with a simplifying solution. What in black-and-white looked like a nothing picture could in colour become something extraordinary.

While Eggleston's photos were visibly faithful to life's banal certainties, they also solved a problem that had long preoccupied photographers. Edward Weston expressed this, with great prescience, near the end of his working life, in 1946, when he was persuaded to take some Kodachromes of Point Lobos. Weston, initially, was wary. Although he knew Point Lobos 'better than any man alive', he 'didn't know colour'. His reservations were not principled; far from dismissing colour he took against the habit of aversion to it: 'The prejudice against colour comes from not thinking of *colour as form*. You can say things with colour that can't be said in black and white.' Weston duly made some prints and responded to the results 'like an amateur looking at his first drugstore print – "Gee, they came out!"' From that moment on Weston decided he 'liked color'. More than any photographer

Weston knew that oranges were not the only fruit, but he was also acutely aware of the peculiar problems they – i.e. colour – posed. 'Those of us who began photographing in monochrome spent years trying to *avoid* subject matter exciting *because* of its colour; in this new medium, we must now *seek* subject matter *because* of its colour. We must see colour as *form*, avoiding subjects which are only "coloured" black-and-whites.'

Another of the pioneers of colour photography, Joel Meyerowitz, explored this issue of the difference between colour and coloured black-and-whites in pictures made with a large format camera at a beach-front cottage in Provincetown, Cape Cod. Two photographs from the resulting book, *Cape Light* (1978), are particularly relevant in this context. The first is of a white picket-fence, surmounted by blue sky and sagging clouds [Pl. 3]. Part of the fence is glowing in the sun, most is dulled by shadow. The picture can be seen as an attempt to re-photograph Strand's canonical black-and-white image in colour without, in Strand's phrase, *dyeing* it. Through the fence posts can be glimpsed the parched grass and green trees of the world beyond the fence, beyond, that is to say, the compositional demands of black-and-white. By photographing the fence from behind – from the opposite side of the fence to Strand – Meyerowitz declares that there is now another way of looking at what makes a photograph.

This is made still more explicit in a picture added to a later, enlarged edition of the book, of a still life of sunset-coloured peaches spread out on a folded copy of the *New York Times* [Pl. 4]. The paper is resting on a table on the porch of, presumably, Meyerowitz's cottage. As in the early abstractions Strand made of crockery and fruit on the porch at Twin Lakes in 1916, the grain of the table is crossed by sharp angles of shadows. The newspaper features a reproduction – i.e. a black-and-white *photograph* – of a Cézanne painting of a bowl of fruit.

Meyerowitz had been shooting in colour since 1962. His street photography of the early 1970s was marked by a Winogrand-like energy and 'thrust', but the pictures made in Cape Cod – 'a one-story place' – are slow, formal. His fascination is with what Stephen Shore, another of the apostles of colour, called 'the colour of light'. For

Szarkowski, the importance of Eggleston (whose decision to 'convert' from black-and-white was influenced by Meyerowitz's work) in this collective interrogation of the varied potential of colour, was the way that form was reconciled with experience. In the introduction to the book that accompanied the 1976 exhibition, Szarkowski situated Eggleston among a number of photographers

> . . . working not as though colour were a separate issue, a problem to be solved in isolation (not thinking of color as photographers seventy years ago thought of composition), but rather as though the world itself existed in colour, as though the blue and the sky were one thing. The best of Eliot Porter's landscapes, like the best of the colour street pictures of Helen Levitt, Joel Meyerowitz, Stephen Shore, and others, accept colour as existential and descriptive; these pictures are not photographs of colour, any more than they are photographs of shapes, textures, objects, symbols, or events, but rather photographs of experience, as it has been ordered and clarified within the structures imposed by the camera.

As far as Weston was concerned, the orange should be sought out because of its orangeness (just as, in his black-and-white photographs, the pepper was sought out because of its pepperness). If Eggleston photographs an orange, however, it is because the orange is part of the world and the world – as Szarkowski reminds us – is in colour. It might as well be a bottle of ketchup or a bar of soap. Effectively, the whole world is an orange. The *orangeness* of the orange is only an issue in a black-and-white world. Once Eggleston had 'really learned to see in colour', the orange lost its special status. It became just another fruit. What Eggleston was looking for could be found anywhere, was never more particularized than when manufactured en masse. In a series of photos taken in the Transvaal in 1989 Eggleston showed oranges bobbing through a sorting plant in uncountable numbers, pouring like prints from the film processing machinery in a store window. In keeping with the quality of defamiliarized strangeness

that is often there in his work many of these under-ripe 'oranges' are actually green.

Eggleston's photographs look like they were taken by a Martian who lost the ticket for his flight home and ended up working at a gun shop in a small town near Memphis. On the weekends he searches for that lost ticket – it must be somewhere – with a haphazard thoroughness that confounds established methods of investigation. It could be under a bed among a bunch of down-at-heel shoes; or in the Thanksgiving turkey that seems, somehow, to be 69ing itself; in the dusty forecourt of Roy's Motel; in the spiky ears of a Minnie Mouse cactus; in a micro-scopic tangle of grass and weed; under the seat of a kid's looming tricycle – in fact, it could be anywhere. In the course of his search he interviews odd people – odd in the Arbus sense – who, though polite, look at him askance. He suspects that some of them (especially the fellow sitting on a bed in what looks like the Motel Solaris) might once have been in a predicament similar to his own but have since put down roots. Not so the guy standing naked in the red haze of a graffiti-scrawled room: he's gonna find that thing if it kills him. Trouble is, he can't remember *what* that thing is. Couldn't be an *orange*, could it?

The tacit psychological dimension in Eggleston's work is due in part to his use of dye-transfer printing. As Eggleston himself has expressed it, dye-transfer meant that he could manipulate individual colours to the extent that the finished result 'doesn't look at all like the scene, which in some cases is what you want'. On the one hand his pictures are as local and intimate as snaps in a family album; on the other they look like noth-ing you've ever seen before (even when you're seeing them for the fifth or sixth time). This defamiliarizing of the familiar – the greening of the orange, as it were – became more marked after 1976, as Eggleston chose, on occasions, to abandon the camera's viewfinder. No longer glued to the photographer's eye, the camera gained a measure of inde-pendence and began to reveal the world as it might appear to an insect, a child – or, for that matter, a Martian. While most photographers squint through the viewfinder as if down the sights of a rifle, Eggleston prefers the 'shotgun pictures' that result from shooting from the hip in this way.

In keeping with this metaphor, a potential for violence is often latent in his photographs. An axe lying on a barbecue has what it takes to become a murder weapon; guns are frequently close to hand. Even harmless objects – like the abandoned suitcase that once had hopes of being stuffed with dollar bills – look like leftovers from a thriller that never got made.

Eggleston himself has said that he thinks of his photos 'as parts of a novel [he's] doing'. With its skewed angles and strategically manipulated colours, this ongoing novel has its own peculiar psychological tint and tilt. Since it is also drenched in a sense of place comparisons are often, and rightly, made with writers such as Eudora Welty and William Faulkner. (Welty wrote the introduction to Eggleston's *The Democratic Forest* (1989); Eggleston contributed photographs to the 1990 book *Faulkner's Mississippi*.)* The writer he most closely resembles, however, is Alabama-born Walker Percy. Eggleston actually worked with the video artist Richard Leacock on a never-completed film of Percy's 1961 novel *The Moviegoer*. Percy's narrator, naturally, spends a lot of time at the cinema – catching a glimpse of William Holden he is struck by the 'aura of heightened reality' the star exudes – but moviegoing, in the book, is part of a larger existential 'search'. What kind of search? 'The search is what anyone would undertake if he were not sunk in the every-dayness of his own life. This morning, for example, I felt as if I had come to myself on a strange island. And what does such a castaway do? Why, he pokes around the neighbourhood and he doesn't miss a trick.' Again and again Percy's narrator sees the world as if through Eggleston's camera. Getting dressed in the morning he becomes stranded in the mystery of the objects he is putting in his pockets:

> They looked both unfamiliar and at the same time full of clues. I stood in the centre of the room and gazed at the little pile on his bureau, sighting through a hole made by my thumb and forefinger. What was unfamiliar about them was that I could see them.

* The latter is one of the most explicit examples of a photographer following in the footsteps of Evans whose photographic survey of 'Faulkner's Mississippi' had been published in *Vogue* in 1948.

They might have belonged to someone else. A man can look at this little pile for thirty years and never once see it. It is as invisible as his own hand. Once I saw it, however, the search became possible.

In 1971 Eggleston made a colour photograph of a corrugated roof and blue sky, separated by two faded signs: one for Coca-Cola and one – in peach-coloured letters – for PEACHES! In 1981 Eggleston's fellow southerner Jack Leigh made a black-and-white photograph of a truck stop. There are various signs including one for Coca-Cola and, on the back of a pick-up, one for PEACHES. A few years earlier he had taken a picture of a bowl of fruit on a table. I had been fascinated by Leigh's work for a long while but it was only when I came across these two pictures that I was able to articulate one of the reasons for that fascination. At the risk of oversimplifying: in the work for which they are best known Strand, Evans, Frank, Cartier-Bresson, Lange and Weston saw and photographed the world in black-and-white. In their different ways each took a dim view of photographers who saw the world in black and white but photographed it in colour (in Strand's terms, dyed it). Then came people like Eggleston, Meyerowitz and Shore who saw the world *and* photographed it in colour. Leigh, on the other hand, is that rare phenomenon: a photographer who sees the world in colour but records his vision in black-and-white. It is as if the exposures have actually been made with colour film and then printed in monochrome. But always when this is done (as it often is in newspapers and magazines), there is an evident sense of loss, of approximation, as if we are seeing an inferior copy. Whereas in Leigh's pictures – whose subjects cry out 'Look at the colours!' – there is no sense of diminution. If, as Szarkowski claims, Eggleston proceeds as if 'the blue and the sky were one thing', Leigh seems determined to show that the grey and the sky can also be one thing. This is most marked in his 1993 picture *Hammock* [61]. From a pale blue sky the sun angles over turquoise sea, casting shadows on the gold strips of wood. All of this is seen in black-and-white. There are no people around – indeed it is hard to imagine

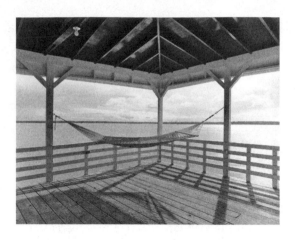

61. Jack Leigh: *Hammock*, 1993
© Jack Leigh

anyone ever lying in the hammock. Apart from the colours there's nothing to look at – and there *are* no colours. The powerful sense of absence derives, obviously, from the empty hammock – but that is the symbol, really, of a less tangible absence: the absence of colours which are all the more vividly felt for being in black-and-white. Perhaps this is why it is an image, simultaneously, of contentment and yearning.

I'm not really interested in gas stations or anything
about gas stations. This happens to be an excuse for seeing.

Joel Meyerowitz

Eggleston and Leigh meet again when they pull up – photographically, at least – at a gas station sometime in the early 1970s. To understand the significance of this encounter we need to go back to 1940, to Edward Hopper's iconic painting of a lonely gas station in the evening. The word 'lonely' is perhaps superfluous: this is a Hopper painting, how could it not be lonely? A dusk-coloured road curves into dark woods. There's just a solitary guy there, doing something to one of three red pumps. He looks as if he's about to close everything down for

the night – it doesn't seem likely that anyone will come by at this hour. But something, surely, has just happened or is about to happen. That's the thing about Hopper: anything can happen, especially nothing. A car could have pulled in, filled up and driven off just minutes ago (perhaps that's why the guy is out there) and already it would seem as if it had never happened. Five minutes ago is the same as never. They have no memories, Hopper's pictures. That's why they generate such intense curiosity about what is happening either side of the moment depicted. It's not surprising, in these circumstances, that people have often been tempted to formulate answers to the questions posed by Hopper in the form of imagined or possible movies. 'An Edward Hopper painting is like the opening paragraph of a story', reckons Wim Wenders. 'A car will drive up to a filling station, and the driver will have a bullet in his belly. They are like the beginning of American films.'

The Norwalk Gas Station – photographed by Lange at about the same time that Hopper made his painting – also encourages thoughts of film, something like a remake of Arthur Penn's *Bonnie and Clyde*, but in black-and-white, without the colour and violence and with no script or actors, just people going about their business, observing the speed limits and noticing the signs: NORWALK, 7-Up, Coca-Cola [62]. The

62. Dorothea Lange: *Norwalk Gas Station*, c.1940

© the Dorothea Lange Collection, Oakland Museum of California, City of Oakland.
Gift of Paul S. Taylor

signs are all new — NEW! NEW! NEW! — but the newest thing of all is the gas pump itself which looks like a prototype of something designed with Mars in mind. This was in the days before credit cards. All payments were in cash and any notes you got handed back were well used – 'oil-soaked, oil-permeated', as Elizabeth Bishop recalls in her poem 'Filling Station'. Maybe it's the fact of there being cash on the premises that makes one think of crime, of robbery. The guy running the place has the shape, the distinctive frozen gait of the Hopper figure, stranded between moments. The shadows are long but the sky – birdless, cloudless – has so many hours to go before it even has to think about getting dark it might as well be morning, and quite possibly is, especially with everything looking so new.

In October 1970 Winogrand was at the Rochester Institute of Technology, New York, showing slides, taking questions from the audience. Someone asked him about Frank's photos of the American flag. Winogrand said that they didn't interest him much. He preferred to talk about the picture of the gas station that Frank had photographed near Santa Fe, New Mexico. It's a picture of five 'Shamrock' gas pumps against a nondescript landscape. Looming over the pumps is a sign with the letters S A V E illuminated and the intervening ones – G A S – barely visible. That's all there is, but, for Winogrand, the fact that it's 'a photograph of nothing', that 'the subject has no dramatic ability of its own whatsoever', makes it 'one of the most important pictures in the book'. What amazed Winogrand was that Frank could even 'conceive of that being a photograph in the first place'. Quizzed by his audience Winogrand rambled on about other things but then came back to 'that gasoline picture'. The important thing is

> the photographer's understanding of *possibilities* . . . When he took that photograph, he couldn't possibly know – he just could not know that it would work, that it would be a photograph. He knew he probably had a chance. In other words, he cannot know what that's going to look like as a *photograph*. I mean, understanding fully that he's going to render what he sees, he still does

not know what it's going to look like as a photograph. Something, the fact of photographing something changes . . .'

Winogrand lost his way again but then came back with an irrefutable declaration of intent: 'I photograph to find out what something will look like photographed. Basically, that's why I photograph, in the simplest language.'

That's what this book is trying to do also, to: find out what certain things look like when they've been photographed and how having been photographed changes them. Often it turns out that when things have been photographed they look like other photographs, either ones that have already been taken or ones that are waiting to be taken.

In his picture Frank removed the gas pumps completely from the suggestions of human activity that hover insistently around Hopper or Lange. There's actually no sign of life: no houses, no windows, no cars. Even the road is quite hard to see. There's a hint of the sunflower or parade ground (eyes *right!*) about the way the pumps are loosely regimented but this exacerbates their independence from the people they are designed to serve. In Hopper and Lange the point-of-view is that of the arriving car or driver. In terms of the way the pumps are arranged Frank's picture could, compositionally, have been taken by one of their number. For Winogrand, the remarkable thing was that Frank could even have conceived of this as a photo, there was so little going on in it. It is perhaps the most extreme example of the hollowness or non-drama – 'a drama in which the center is removed' – that Arbus noticed in his work. In the picture of the gas pumps this centre extends to the very edges of the frame. Hopper shows the petrol pump attendant suspended tantalizingly before or after the moments that will place his actions in some kind of narrative context. If the picture frame extended a little to the left or right – that is, if it extended slightly beyond the moment depicted – the scene would comprehensively explain itself. Frank shared Hopper's fondness for what he called 'in-between moments'. In this instance, though, the inbetween-ness has been extended, like the road in the middle distance, indefinitely.

*

In a picture from the *Los Alamos* series Eggleston shows time raining down on a disused gas station [Pl. 5]. When Eggleston took this photograph it happened to be pouring, and this contributes to two mutually confirming impressions. Either it was done with an unbelievably long exposure time (forty years or thereabouts), or it has been raining solidly for forty years. The photo is as saturated by time as the place it depicts. The Gulf Coast pumps (red as the Mobil pumps in Hopper) are now red with southern rust. What's happened? Simple: they ran out of gas.

Time, in Eggleston's picture, is corrosive; in Leigh's photo of Felix C. House's store and gas station it is cumulative [63]. Leigh shows time working on the place, but there are enough signs of life – TUBELESS TIRES REPAIRED, STANDARD OIL DEALER – to suggest that it is still working, still in business. Time is both passing and staying put. I suspect this impression is especially acute just now. Leigh took this picture thirty years ago, in 1971, a little over thirty years after Lange and Hopper made theirs. This affects the way we see it. At present the picture serves as a fulcrum between then and now. Felix C. House looks pretty

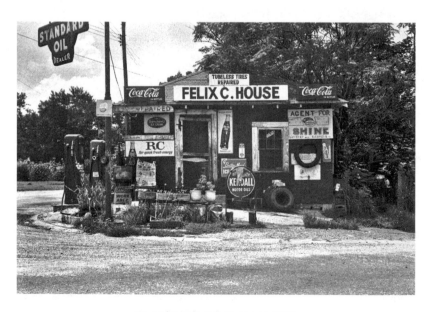

63. Jack Leigh: *Felix C. House*, 1971

© Jack Leigh

much the same age in Leigh's picture as Lange's Gas station did in 1940. But while the Norwalk sign proudly announced NEW NEW NEW, the patchwork of signage now conveys OLD OLD OLD. The picture, for the moment, is exactly in the middle of the two, the old and the new.

In the years since Leigh's photograph was taken, gleaming, self-serve gas stations have spread across the continent. Stephen Shore photographed one of these on the corner of La Brea Avenue and Beverly Boulevard in Los Angeles [Pl. 6]. A sky of ozone-depleted blue frames a Chevron sign. To the right of the frame are the pumps and the forecourt. In the middle distance is a TEXACO sign. If you moved a hundred yards down the road there would be another instance of pretty much the same kind of thing, endlessly repli-cated. Shore actually took his picture in 1975, just a few years after Leigh, but at some point America went from looking like that (unchanged, in many ways, since Lange) to looking like this. Shore shows what America still looks like now. It is impossible to imagine a time when *this* will look like the past, partly because what it incar-nates and enables is an *instant* civilization (fast food, self-service) predicated entirely on speed of transaction and immediate gratifi-cation. In their different ways the images by Frank and Hopper both presented 'in-between moments'. Shore, partly due to the view camera's capacity to render stillness, shows a world in which there is nothing but the moment, a moment 'like a drugstore stretching to infinity'.

The world depicted by Shore will continue to sprawl until it engulfs Norwalk and Felix C. House. This has, of course, proceeded in tandem with the spread of the way of seeing and recording the world developed by Shore. In a picture from Peter Brown's book *On the Plains* we can see how, by 1986, it has extended as far as Duncan, Oklahoma [Pl. 7]. The signs might be for CONOCO and BELL rather than Texaco, but the view is pretty much the same. Since Los Angeles is often regarded as the paradigmatic city without a past, this would seem to represent a complete break with any idea of pastness. As such this is a cause for considerable regret.

Except, it turns out, the scene pictured by Shore does have its

past.* Since Shore made a conscious decision to 'apprentice [him]self to a tradition' it comes as no surprise to discover that his view of an Avenue and Boulevard has recognizable antecedents – in Walker Evans's *Roadside View, Alabama Coal Area Company Town* of 1936, for example. On closer inspection the unprecedented and new turn out to be of classic provenance. Like Shore's, Evans's picture is taken from the forecourt of a gas station. A road slopes diagonally off into the distance, lined by newish buildings. Scored by telephone wires the sky frames a sign for GAS. The essential sameness of the two views is brought out by Don DeLillo in *White Noise*:

> Traffic lights swayed on cables in a sudden gust. This was the city's main street, a series of discount stores, check-cashing places, wholesale outlets . . . Blank structures called the Terminal Building, the Packer Building, the Commerce Building. How close this was to a classic photography of regret.

What is the difference between a road and a street? It is not a question of size (some urban streets are wider than country roads). A road heads out of town while a street stays there, so you find roads in the country but not streets. If a street leads to a road you are heading out of town. If a road turns into a street you are heading into town. Keep on it long enough and a road will eventually turn into a street but not, necessarily, vice versa (a street can be an end in itself). Streets must have houses on either side of them to be streets. The best streets urge you to stay; the road is an endless incentive to leave.

In the 'Negro Quarter' of Savannah in 1935, Evans took a picture of the strangely ambiguous moment when a street turns into a road

* Also, the older, Langean America turns out to be surprisingly resilient. In the same year that Brown found 'Shore's' LA in Oklahoma in Lone Oak, Texas, he also happened upon blue Exxon pumps in the forecourt of Darrow's General Store, looking just as rickety, time-worn and – as Bishop claims at the end of her poem – 'loved' as the Norwalk Gas Station.

[64]. One street recedes into the centre of the picture; the other moves off to the left, beyond the edge of the frame. Stretching into the middle distance, the street has all the features one would expect: parked cars, people standing or lounging, watching the picture being taken. It doesn't look cold but most of the people are well wrapped up. There are faint shadows. A breeze moves the white skirt of the woman standing off to the left, talking to two fellows sitting on the stoop. Evans is photographing from a road in the sense that he is passing through, heading somewhere else. The people in the picture are staying put; as far as they're concerned it's just a street. Perhaps that's why, to us, it has 'the sadness of all roads leading out of town, a blues-song street'.

Charles Clifford's photograph of an old house in the Alhambra elicited a simple and heartfelt response from Roland Barthes: 'I want to live there . . .' Evans's 1931 view of *Main Street, Saratoga Springs* provokes a similar reaction from me: 'I want to walk down it'. The remarkable thing about the picture is not just that it provokes such a desire but that, in doing so, it simultaneously satisfies it. To look at this photograph is to walk down the street shown in it [65].

64. Walker Evans: *Savannah Negro Quarter,* 1935
© Library of Congress, Prints and Photographs Division, LC–USZC4–5637

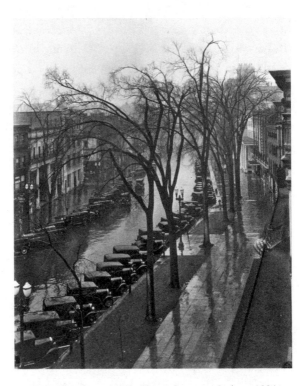

65. Walker Evans: *Main Street, Saratoga Springs*, 1931

© The Walker Evans Archive, The Metropolitan Museum of Art, New York, 1994 (1994.256.137)

And yet, the more I look at this photo the stranger it seems, for the street looks like it might not be a street and could actually pass for a canal or river. Asked, rhetorically, what he most loves Joseph Brodsky replies, unhesitatingly, 'Rivers and streets – the long things of life'. Evans's photo is the representation of this longed-for elision. Not so much parked as moored, the cars seem oddly amphibious. The trees have something of the watery melancholy of weeping willows. There is a touch of Venice or Amsterdam about the scene. You feel that if you wanted to cross this wet road a bridge would come in handy. The impression of street as waterway is enhanced by the way it kinks, bends, before dissolving not into countryside or suburbs but into a damp mist that might be the sea. The carefully incremented details – cars, trees, buildings – fade and recede into an unfathomable, indistinct mass of grey. That's when you realize that although it may be a picture

of a street that looks like a river, its real subject is *time*. And it was not quite right to say that 'to look at this photograph is to walk down the street shown in it'. More accurately — and even more remarkably — it is *to have walked down it*, before returning to one's room at the United States Hotel and looking down at the rain-slick street.

Main Street, Saratoga Springs is a quietly audible photograph, preserving not just the view of the street but its sounds: the swish of an occasional car, the slow drip of rain from trees. What you hear most clearly, though, is a sound from earlier in the day: the bell — the memory of the bell — as you entered the barber shop, alerting him to your arrival. He was tipped back in the customers' chair, comfy as a sheriff, reading a paper that he began folding away, taking in the unfamiliar face (in need of a shave) at the door, glad of the custom, confident in the knowledge that if it was a haircut you wanted you had come to the right place. And all of this — probably because of the multiple reflections of the mirrors — seemingly happened at the very moment that the bell began the chime that lingers, even now.

> *A haircut has what. Associations. Calendar on the wall.*
> *Mirrors everywhere.*
> Don DeLillo

Barber shops are pretty much the same the world over. The bustling *barbiere* photographed by William Klein in Rome in 1956 is, to all intents and purposes, the same as the one photographed by Evans in Havana in 1933 [66]. A barber's is a place where you can get a haircut. That's the defining quality of the establishment but certain other elements are also essential: the availability of conversation (if required), reading matter and a task-specific seat (midway between the regular chairs provided for waiting customers and the frightening specialism of a dentist's chair). You can get your hair cut anywhere but not everywhere is a barber's. Few pictures are as suggestive of the subsistence and resilience of rural life in the Depression as Russell Lee's photo of

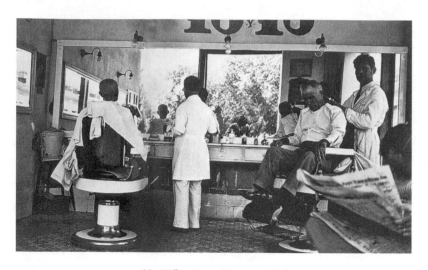

66. Walker Evans: *Havana*, 1933

© The Walker Evans Archive, The Metropolitan Museum of Art, New York, 1994 (1994.251.699)

a *Farmer Cutting his Brother's Hair, near Caruthersville, Missouri* in 1938. They're out on the stoop, watched by a younger brother or son. Going to the barber's seems, in this context, a luxury, practically a vacation.

Evans's 1933 picture lovingly itemizes this day-to-day abundance of activity and resources: the barbers, the customers, the waiting, the swivelling chairs and the mirrors – in one of which we see the 'penitent spy' himself, camera in hand. The only person in the picture who is not in the room, he is also the only person in the picture who is not involved, either as customer or barber, in the business of getting a haircut. He is also, understandably, the only person in the picture to be wearing a hat. In Stieglitz's *Steerage* and Hine's picture of the blind beggar in the Italian market there was a man in a hat surveying the scene: a detached projection and representative of the photographer. This time the photographer himself is there, looking down into his view camera, identified by the hat (which also renders him anonymous).

That same hat – or one very like it – is there in a picture Evans made three years later of a barber shop in Atlanta [67]. This time the place is completely empty. Towels are stacked up on shelves and folded over the arms and backs of the empty chairs. The shelves are lined with old news-

67. Walker Evans: *Negro Barber Shop, Interior, Atlanta*, 1936

© The Walker Evans Archive, The Metropolitan Museum of Art, New York, 1994 (1994.258.353)

papers. Mirrors look on vacantly. Evans said he liked to 'suggest people sometimes by their absence'.* Few things are more suggestive of absence than empty chairs – and no picture is more suggestive of human activity than this empty barber shop. 'All rooms are waiting rooms,' writes Martin Amis. He means rooms in which *we* wait – 'you are waiting, I am waiting' – but some *rooms* wait too. They wait for us to keep them company, to bring them back to life. This is partly because the barber shop is so much more than just a place to get your hair cut.

> Mankind has always taken great delight in knowing and descant-
> ing on the actions of others. Hence there have been, in all ages

* Robert Frost uses the same device to emphatic effect in 'The Census-Taker':
 They were not on the table with their elbows.
 They were not sleeping in the shelves of bunks.

and nations, certain places set apart for public rendezvous where the curious might meet and satisfy their mutual curiosity. Among these, the barber shops have justly borne the pre-eminence.

To photographers this is a source of their attraction — which is why Gedney copied out this passage from *Tom Jones* when he was photographing in India.*

In the vacant meantime, the chairs wait. Despite being old and worn they have almost no memory, these chairs. Their attention is fixed entirely on who will sit in them next. And that hat — propped casually on a shelving unit, right in the centre of the picture — adds an urgency to their waiting. Everything else is in its place, the hat has just been put there temporarily, possibly (irrespective of whether it is really his) by Evans himself. The hat is like a guarantee that someone — barber, customers or, at the very least, the person who left it — will return. The striking thing about the picture, however, and of Evans's work generally, is that he does not disturb the emptiness of the place. It is unoccupied even while he is there photographing it. We will return to this. In the circumstances, how could we not?

Frank returned there — not to this exact shop but to another empty barber shop in McCellanville, South Carolina — in the course of his Guggenheim road-trip of 1955–6. He photographed it through the screen door and the picture is smudged with tree-filtered light and the partial reflection of a house across the street. I could be wrong but it looks as if the chair itself is surrounded by the blurred reflection of the photographer's own face (I think you can see the camera strap wrapped around his wrist). Interior and exterior merge; the blur of ambiguity makes it seem as though this is as much a picture of a memory of a barber shop as it is of an actual place. And so it is, for Frank is not simply photographing a barber shop but coming up with his own version of Evans's picture. When the barber has finished cutting your hair

* Not all photographers feel so fondly about barbers. In 1929 Weston complained: 'I always feel denuded coming from the barber shop — quite immodest: and seated in the chair I feel helpless — anything may happen.'

he holds a mirror behind your head so that you can see, in a double reflection, the way it looks from the back. Frank, if you like, is holding his own highly subjective, heavily distorted mirror up to Evans's picture. His photograph is a way of reflecting on it: a mirror image, so to speak, of Evans's.*

Perhaps, in this light, the hat in the Negro barber's could be seen to serve as a symbolic marker of photographic territory. The hat – which, to repeat, is remarkably similar to the one Evans was wearing when he photographed the barber shop in Havana – does not lay claim to the barber shop as Evans's photographic property in the way that a nation lays claim to a piece of land (by planting a flag there). Unlike the signs Evans was fond of photographing – and stealing – it does not say 'Keep Out' or 'No Trespassing'; more democratically it lays claim to the barber shop in the name of any and all photographers who come after him. From this moment on the barber shop has been definitively added to the repertoire of subjects. You cannot photograph a scene like this, says the hat, without paying some kind of tribute to Evans. It has, if you like, been photographically tagged.

Frank explicitly, if serendipitously, acknowledges this in one of his photographs. Evans's picture is not just of a barber shop; it is also a photograph of empty chairs. In a bank in Houston, Texas, Frank photographed a line of five well-appointed but empty chairs slaloming up to a vacant desk. The picture works like a composite image showing how, over time, a chair gradually made its way from the back of the room where an employee talks on the phone – to a position of unavoidable prominence. To put it slightly differently, the picture shows the tradition of the empty chair making its way from the past to the immediate present. But that is not the only way in which the photograph contains its novel consciousness of historical precedents. On the desk midway

* On the subject of returns: in 1958, on the way to Florida, Frank took Kerouac to see the barber shop he had photographed several years previously. The shop was unchanged – 'even the bottles on the shelf are all the same and apparently haven't been moved' – but this time the barber himself was there. He made them coffee and insisted on giving both of them haircuts.

between the blurred desk top that dominates the bottom half of the frame and the one right at the back is perched a hat. It has been placed there as casually and deliberately as the one in Evans's barber shop. I'm reluctant to use a word like 'symbol' too often. Let's say instead that this unexpected little detail – I'm even more reluctant to use Barthes's term 'punctum' – is at the very least a nod to Evans. Frank touches his hat in the direction of his mentor. What was a reliable gauge of the experience and fortunes of the people in photographs of the 1930s becomes, like the road glimpsed first from the side of Lange's car and then from the side of Frank's, an indicator of the photographer's own project.

Arbus brought her own skewed vision to bear on the exclusively male preserve of the barber shop. In a picture of a barber's in New York city from 1963 there are two chairs, one occupied and one empty. As in the pictures by Evans, Klein and Frank, the shop is, among other things, an endless source of image-generation, the mirrors on the walls cloning barbers and customers who cannot be seen in the actual room. The walls are adorned with pin-ups of women but the mirrors paste reflections of the men up there with them. Photographs of women and reflections of men end up collaged together on the wall. There is something strange, almost unsettling about this picture. Then it occurs to you that perhaps this photograph – made by a woman – reflects what these women, pinned like butterflies to the wall, see day after day. As Arbus said of her time at a nudist camp, 'It's like walking into an hallucination without being quite sure whose it is.'

If what I have said about Ormerod is true – that he consciously and deliberately set about making a photographic catalogue of the tradition of American photographs – then it was inevitable that he would take a photo of an American barber shop. He does not disappoint but the picture offers a stranger take on this tradition than might have been expected. Like the place that Frank happened upon in McCellanville, the one photographed by Ormerod – Sal's Barber Shop – is shut [Pl. 8]. (If the sign in the window is to be relied on this means that the picture was taken on either a Sunday or a Wednesday or before 7 a.m.) Not

only is it shut but the curtains are closed: all that can be seen is the red, white and blue pole and, bizarrely, the stuffed heads of deer. Nothing of the interior – chairs, mirrors – can be seen. What we can see – as in Berenice Abbott's picture of August Pingpank's barber shop at 413 Bleecker Street – is a reflection, in the storefront glass, of a tall building across the street, behind the photographer's back. It's a sad and strange picture, as if this particular strain of Americana is not available for Ormerod's inspection. A curtain has been drawn across it. It's become a site of abandoned meaning.

But Ormerod would not have left it at that, would not have chosen to photograph it on such stingy terms.

Another way of looking at it would be that Ormerod sought out this barber shop as a way of having the last word. The picture says: the barber shop photograph is over with. It's been done. Now it's closed. One can see this tendency at work in several of Ormerod's pictures. As well as photographing movie screens a number of photographers – among them, Friedlander, Arbus, Frank and Shore – took pictures of TV screens. Naturally Ormerod did this too. One of these pictures – in colour, very Egglestonian – shows a TV lying in the street with the screen smashed in. This could be read – as it is by Jan Morris in her introduction to *States of America* – as a symptom of the way the country has become 'a listless, mean and littered place' but Ormerod's work tends to offer a commentary on photography rather than on society. Having smashed the mini-tradition of photos of the TV and – most daringly and symbolically of all – broken the white fence, he now closes down the barber shop, puts it out of business.

Neither explanation quite does justice to what we are actually seeing within the frame. Neither the place nor the photographer has the last word – or rather, they both do. The place (and the picture) contains its (and Ormerod's) own appeal and lament. The appeal is in the form of a sign, and the picture – like many of Evans's – turns out to be self-captioning:

WANTED

RESPONSIBLE

Within the context of the picture the sign, effectively, implores 'Wanted: Responsible Photographer'. Ormerod duly obliges, thereby bringing the vacancy to the attention of those who will come after him.

One of whom is Peter Brown. In 1994, three years after Ormerod's death, Brown took a picture of a barber shop in Brownfield, Texas [Pl. 9]. The barber shop's iconic place in American photography is flagged by the correspondence between the red, white and blue of the barber's pole and the red, white and blue of the American flag, dangling, windless, from its pole. The shop is closed and, as in pictures by Evans and Frank, the photographer himself is reflected in the window. Frank was using a little Leica; Evans was looking down into a Rolleiflex. Brown, however, is using a Deardorff view camera. You could be forgiven for thinking that the figure standing next to the silhouetted tripod reflected in the storefront window was the reincarnation of Atget himself. In a way this is a mirror-image of one of the pictures in which Atget's camera, tripod or focusing cloth are reflected in the window of the shop he was photographing. The best-known example is a photograph made in Palais Royal in about 1926, of a store specializing in toupees.

> *There are things known and things unknown,*
> *and in between are . . . the Doors!*
>
> Jim Morrison

Perhaps it is only a self-fulfilling quirk of this book's aleatory approach and structure but, increasingly, the history of photography seems to consist of photographers doing personalized versions of a repertoire of scenes, tropes, subjects or motifs. This repertoire is constantly expanding and evolving rather than fixed, but a surprising number of its components were established at the outset by Henry Fox Talbot in the 1840s.

Some of these pictures of Talbot's had been derived, in turn, from earlier templates found in painting. Talbot himself rightly believed *The Open Door*, arguably his most famous photograph, to be an example 'of the early beginnings of a new art', which would be brought to maturity in the near future. (He was wrong in claiming, with the presumption of his age, that it would be brought to maturity by 'British talent'.) Consciously adapted from 'the Dutch school of art', the first version of the photograph had been made by Talbot on 21 January 1841. When his mother, Lady Fielding, saw the picture she called it *The Soliloquy of the Broom* (which, in this version, is propped against the right-hand side of the doorway). In *The Photographic Art of William Henry Fox Talbot* Larry J. Schaaf observes that although the diagonal of the broom 'acts as a barrier across the doorway, the light (and its shadow) invites the viewer into the room. The symbolic tradition of the doorway is as the boundary between life and death. The door ajar represents hope.'

Two years later Talbot returned to the scene and made a similar image but it was not until April 1844 that he succeeded in capturing it definitively [68]. In this version the broom is bigger and is propped against the wall to the left of the door (the side, that is, to which the door is fixed). The alteration of mood hinges on this change for once the broom has moved aside there is no obstacle between us and the interior – but this interior now exists as a solid, uninviting mass of shadow, softened only slightly by the light entering through a lattice window at the back. The boundary symbolically interpreted by Schaaf is both subtler and more stark. The very simplicity of the composition generates its sense of mystery and suspended possibilities – possibilities to be explored by subsequent photographers. 'You press the button,' wrote Jean Rhys. 'The door opens.'

In 1974 Paul Strand was asked how he chose the things he photographed. 'I don't,' he replied. 'They choose me.* All my life, for

* Cartier-Bresson said much the same thing ('It is the photo that takes you; one must not take photos'); so did Arbus: 'I don't press the shutter. The image does.'

68. William Henry Fox Talbot: *The Open Door,* 1844
© Science and Society Picture Library

example, I've been photographing windows and doors. Why? Because they fascinate me. Somehow they take on the character of human living.' This can be seen happening in a 1946 photograph of a side porch, taken as part of the series of pictures that would be published as *Time in New England* (1950). The picture shows an open door leading to an interior, to the right of which is another open door affording a glimpse of a garden [69]. On the weather- and time-warped porch itself is a chair. Hanging from a nail, between the chair and the doorway, is a broom.

I don't know if Strand was aware of Talbot's picture but, on the evidence of this photograph, it is hard to believe that he was not. The open door and the broom on the wall would seem to allude to Talbot as surely as Talbot did to 'the Dutch school of art'. Expressed like this, though, we are in danger of contradicting Strand's own explanation of why he was drawn to certain subjects or, to put it in terms compatible with his explanation, why certain subjects drew him to them. One answer works both ways: in some measure doors drew him to them

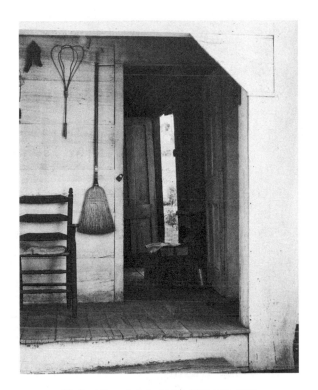

69. Paul Strand: *Side Porch, Vermont,* 1946

because of a power they had acquired as a result of having been photographed by Talbot. In this way, an indirect connection is established between the descriptive rigour of Strand's photograph and the larger symbolic history suggested by Schaaf. It is as if through the door photographed by Strand another door can be glimpsed – which is exactly what we do see.

In Talbot's picture there is simply a door and an interior. In Strand's the open door leads to an interior through which can be seen another door leading once again to the exterior. The picture suggests, in diagrammatic form, that whatever photography's capacity for psychological penetration, it will always necessarily come back to depicting the external world.

*

Lange is pre-eminently a photographer of people. But in a body of work so densely populated the pictures I am most drawn to – that most strongly draw me to them – are the ones with no people in them, the ones, in fact, that do not look like they are by Lange. In Lange even the loners – especially the loners – crowd you with meaning; by virtue of the silent, unstoppable testimony of their faces they jostle and petition. It is a relief to get away from them, to turn to her picture of a door with the sign DAY SLEEPER pinned on it [70]. The door is number 1D, but it could as easily be read as ID, as if the identity of the occupant of 1D rests entirely on the fact of their sleeping habits. But how much information is conveyed or suggested by that unambiguous message. DAY SLEEPER serves as an instruction ('Do Not Disturb') and, implicitly, suggests something about their employment (works nights). It seems, at first, as if the only round things are the door knob, the lock and the convex curve of the D; everything else consists of sharp angles and wide-awake lines (diagonal, vertical, horizontal). But then your eye returns to the weathered sign itself which is starting to bend, heeding its own message, curling up to sleep.

To sleep and to dream . . .

70. Dorothea Lange: *El Cerrito Trailer Camp (Day Sleeper)*, c.1943
© the Dorothea Lange Collection, Oakland Museum of California, City of Oakland.
Gift of Paul S. Taylor

In Francesca Woodman's photographs, the empty door frames are just as substantial as the walls, the walls through which her naked figure is constantly on the brink of emerging or disappearing. The walls them-selves become doors. To look at the pictures she made in Providence, Rhode Island, in the mid-1970s is to pass through a doorway into another world, a world of Woodman's dreams. Often she appears from behind the peeling wallpaper, as if she had somehow ended up between the paper and the brickwork and got caught there for about fifty years. It's as if, when scraping away at the walls you exhume each of the pre-vious occupants – except there's only one and it's always her. Everyone who has ever lived in this house has been reincarnated as a teenage girl. A girl who can pass through walls. You pass through a door which might as well be a mirror because the room you end up in is exactly the same as the one you've left behind. There's no telling whether the house in Rhode Island is undergoing extensive renovation or falling into terminal decay. There is no difference between a builder and an archae-ologist or, for that matter, between a door and a mirror. The door leaves its post and floats into the middle of the room. There are things known and things unknown and beyond both there is a door.

One thing we do know is that a few years after making these pic-tures Woodman killed herself by jumping out of the window of an apartment in the Lower East Side of Manhattan. She was twenty-two. The photographed house is haunted by the ghost of her brief future. You can't see her fate in her face but you can, perhaps, in the house, in its walls and through its doors.

Atget's pictures of Paris are also haunted, by people who step through walls and dissolve before our eyes. There is a simple technical explan-ation for this: long exposure times caused any swiftly moving objects or people to disappear completely. This is why, in old photographs, even densely populated cities such as London or Paris appear almost entirely deserted. Soon after the invention of photography – and directly after mentioning the Daguerreotype – the English Opium Eater, Thomas De Quincey, wrote of being 'haunted' by the 'ghostly beings moving amongst us'. They are still there, in photos from the early twentieth

century: people moving so slightly or slowly that they become blurred, incorporeal, insubstantial. Anything that does not get 'disappeared', though, is granted a permanence that is palpable, utterly intransigent. This is why the closed doors photographed by Atget look like they can withstand the siege of centuries while open ones look like they will never shut.

Hence, I suspect, the peculiar power of Atget's photo of the *Hôtel des Archevêques de Lyon, rue Saint-André-des-Arts* (1900). It is a frontal view of one of those immense and impregnable doors that fill the entrances to Parisian courtyards [71]. A smaller 'pedestrian' door within the door is wide open, as if a bright rectangle had been permanently cut out of the larger entrance-way. This rectangle frames a view of a bright courtyard, at the back of which is another open doorway. It is as if two

71. Eugène Atget: *Hôtel des Archevêques de Lyon, rue Saint-André-des-Arts*, 1900

© E:6652.MOMA I.69.221

fundamentally contradictory experiences of time coexist within the same picture.

Making his living by providing 'documents for artists', Atget built up a huge photographic inventory of the doors of Paris, open and closed. Neither predominate. Closed doors convey the medium's commitment to the surface, to the exterior; open doors convey its potential for interior or psychological investigation of unseen recesses. Atget's photographs rewrite the lines of William Blake which Aldous Huxley used for the title of his book on psychedelics (and which Morrison and friends, in turn, plundered for the name of their band): 'If the doors of perception were cleansed, everything will appear to man as it is, infinite.' Affirming the empirical rather than the visionary, Atget insists on photographic perception as, precisely, an art of the finite. And yet, through the doorways there are always glimpses of other doorways, of other photographs, of infinite possibilities. Garry Winogrand might have been looking at — and through – this door when he said, 'There is nothing as mysterious as a fact clearly described.'*

Generally speaking, when Walker Evans photographed exteriors the doors remained shut. In his pictures of buildings, usually taken from directly in front, doors provide only notional access to the interior. The best way to demonstrate this claim is by looking at a series of pictures, made late in his career, which appear to refute it. In 1971 Evans visited Robert Frank at his home in Nova Scotia where, as well as a portrait of his friend, he took a number of photographs of a barn. As arranged in *The Unknown Walker Evans*, he begins with a shot of the barn in its natural setting of hills and sky. Then he moves in closer until we can see, quite clearly, the open door, so open, in fact, that the inside of the door – patched and insulated, in a way that always appealed to Evans, with the packaging from old cartons of Scotian Gold – faces out. The interior has effectively become the exterior. The actual interior is jet

* In her biography of Arbus, Patricia Bosworth quotes Lisette Model as saying almost exactly the same thing: 'The most mysterious thing is a fact clearly stated.'

black, a monolith of impenetrable black. In the penultimate picture of the sequence the framing is tighter still, just the open door and the interior, as black as the screens in Sugimoto's pictures of cinemas are white [72]. The final picture of the series focuses on the knotted, worn and grainy wood of the exterior, so close up that it has become almost an abstraction of texture. It's an explicit statement: there is no getting beyond the surface. The interior is denied, closed off as firmly as if the door were bolted shut.

Once Evans finds himself inside a house, however, the situation changes dramatically. Then, looking into one room, we often see doors leading into other rooms. The eye is always faced with the possibility of further revelation, of deeper levels of initiation and access. A picture from 1962 gazes into a room in Walpole, Maine [73]. On the right-hand side there is a white chair and desk. In the centre there is an open door. Through this we can glimpse another room or hall, beyond which is another door, another room and another chair. Perhaps the most revealing picture of all is an interior made during the trip to Nova Scotia in 1971. The view, through a door frame, is of bare floor boards leading into another room, at the side of which is an open door, illuminated by bright sun [74]. A glimpse of the outside seen from within,

72. Walker Evans: *Barn, Nova Scotia,* 1971

© The Walker Evans Archive, The Metropolitan Museum of Art, New York, 1994 (1994.252.123.3)

it is like a mirror image of the pictures of the barn. Its effect on the viewer, though, is stronger and stranger than this suggests. Looking at it is like stepping inside an Evans photograph.

73. Walker Evans: *White Chair and Open Door, Walpole, Maine*, 1962

© The Walker Evans Archive, The Metropolitan Museum of Art, New York, 1994 (1994.252.113.1)

74. Walker Evans: *Door, Nova Scotia*, 1971

© The Walker Evans Archive, The Metropolitan Museum of Art, New York, 1994 (1994.252.119.93)

Lately I've become interested in the passage of time within a photograph.
Richard Avedon

Evans had his first museum exhibition in November 1933. This was in the architecture galleries of the Museum of Modern Art in New York where, coincidentally, a retrospective of Edward Hopper's paintings was also on show. In an essay written to accompany Evans's exhibition, his friend Lincoln Kirstein remarked on the 'airless nostalgia for the past' in the work of both artists. If the young Evans found the comparison elevating or flattering, it was one he grew to resent, claiming later that he 'didn't know Hopper or what he was doing'. This seems hard to believe for Hopper could, with some justification, claim to be the most influential American photographer of the twentieth century – even though he didn't take any photographs. There is no getting away from or avoiding him. To see his pictures is to begin to inhabit them. You see them everywhere even when you are not looking at them. 'Hopper' has come to evoke a real place that *looks like* a Hopper as often as it refers to an actual painting. And to preserve our memory of that place a photograph serves as a more reliable record than a painting. (Wim Wenders cleverly exploits this in a panoramic image which, though it depicts an empty *Street Front in Butte, Montana, 2000* is really a photographic rendering of Hopper's *Early Sunday Morning* of 1930.) In memory, then, Hopper's pictures tend not to be paintings at all; they are photographs in waiting. They are not only in waiting, they are also *of* waiting, and it is this quality that they share most obviously with Evans's photographs.

Even if we take Evans's word that Hopper was not an influence the fact that the two of them were, as he conceded, 'doing very similar things' suggests that the work of the painter might shed valuable light on that of the photographer. I mean that as literally as possible.

The poet Mark Strand has pointed out that 'Hopper's use of light is almost always descriptive of time.' His ability 'to use space convincingly as a metaphor for time is extraordinary. It demonstrates the ratio between stillness and emptiness, so that we are able to experience the emptiness of moments, hours, a whole lifetime.' Strand might just as

well have been describing Evans's photographs of Victorian buildings. The 'airless atmosphere' noticed by Kirstein was the result of Evans shooting in bright sunlight, often in cold weather with the sun low in the sky, throwing shadows across the buildings as if hours had passed in the split-second the shutter was open. This is seen most clearly in his pictures of ruined plantation houses, places where history has moved on, leaving time to do whatever work remains. The mock-classical or Greek Revival style of Doric and Ionic columns creates the impression that a far greater span of years – stretching back to Mediterranean antiquity – has been compressed into the picture. We talk about things being as old as the hills but the great ruins of Greek and Roman antiquity look as old as the sky. A Louisiana plantation house pictured in 1935 looks as if it has been around longer than the surrounding trees, one of which has itself fallen into ruin.

Even buildings in perfect condition – those that have not yet fallen into ruin – are deserted, devoid of people, as if they are inhabited only by time. The period when they were occupied by a particular owner or tenant is almost insignificant compared with time as experienced by the buildings themselves. Not that we are seeing things that exist in the elemental timelessness of Yosemite or the great deserts of the West. Relative to places like these, the houses are as transient as their occupiers. Apparently sharing Cartier-Bresson's opinion that 'landscapes represent eternity', Evans avoided them photographically. What attracted him was the slow manifestation of time, not its absence. Even when there are no people around their traces are everywhere. You sense something similar in French or Italian villages in the early afternoon when all activity is temporarily but absolutely suspended. James Agee remarked on exactly this when, in the course of the work that would culminate in *Let Us Now Praise Famous Men*, he and Evans arrived in Greensboro, Alabama, in 1936: 'All the porches were empty, beyond any idea of emptiness. Their empty rockers stood in them; their empty hammocks hung in them.' It was as if they had turned up on the set of an Evans photograph – or a Hopper painting where, in Mark Strand's words, 'it is always just after and just before . . . just after the train has passed, just before the train will arrive.'

Evans tried repeatedly to articulate his fascination with time in photographs. In 1931 he commented on how 'the element of time entering into a photograph provides a departure for as much speculation as an observer can make.' Thirty years later, in a self-interview, he explained that he 'was, and is, interested in what any present time will look like as the past'. Or, to put it another way, what new buildings will look like when they are tinged with ruination, like old plantation houses. In its way, this impulse is as prophetic as it is backward-looking. The distinctive temporal concentration of Evans's photographs – their sense of being able to contain the time when they are being looked at, when what they depict has become a part of the past – had a remarkably speedy capacity to generate nostalgia. Looking at Evans's 1936 picture of a railroad in Edwards, Mississippi, Roy Stryker found himself succumbing to just this kind of reverie. Again, the emphasis is on absence, emptiness and suspended activity:

> The empty station platform, the station thermometer, the idle baggage carts, the quiet stores, the people talking together, and beyond them, the weather-beaten houses where they lived, all this reminded me of the town where I had grown up. I would look at pictures like that and long for a time when the world was safer and more peaceful. I'd think back to the days before radio and television when all there was to do was to go down to the tracks and watch the flyer go through.

The railroad, as Evans well understood, had an inbuilt tendency to shunt people back into their pasts. In photographic terms the rails lead to a point distant in years as well as miles. The track recedes in time as well as into space. Evans was as acutely sensitive as Hopper to the ways the temporal could be visually suggested by the spatial. Crucial to this understanding was his discovery, through Berenice Abbott, of the work of Atget in 1929 or 1930. In later life Evans said that he had arrived at his own style independently of Atget's – a claim motivated in part by the way that 'such magnificent strength and style', if it 'happens to border on yours . . . makes you wonder how original you are'.

Atget spent his working life recording a Paris that had become abruptly old in the wake of Hausmannization. His pictures are of places but they are all *about* time. No other photographer so comprehensively embodies Barthes's suggestion that cameras, originally, were 'clocks for seeing'. Atget's steps rise out of or take us down into the past. Alleys become conduits for the narrow passage of time. Doorways afford glimpses of almost forgotten memories. Through all of this runs the Seine, the dark river of the unconscious in whose depths the city's memories are preserved perfectly precisely because they are inaccessible. The city is inhabited by ghosts, by figures dissolving into its walls and stones, preserved in the act of passing, forever fading.

A key element in Atget's temporal geometry was the receding vista: a street or alley stretching or curving its way to the past. The *New*

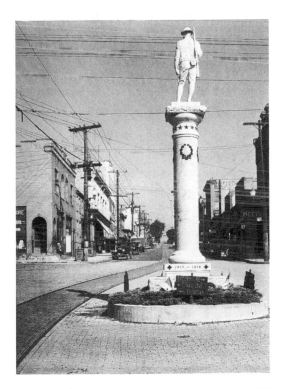

75. Walker Evans: *Main Street, Pennsylvania Town*, 1936

Yorker writer Anthony Lane succinctly sums up the way that Atget uses this to create the 'sensation that perspective is a matter not only of space but of time: in front of your eyes it is high noon, but day seems to be breaking at the end of every street'.

Evans repeatedly used perspectival recession of this kind to indicate not so much the passage of time as its *direction*. In 1936, in a Pennsylvania town, tramlines follow the main street into the distance [75]. Except for parked cars the street is devoid of life; other than the ghostly smear of someone mounting the sidewalk, it is devoid of movement. Dominating the photograph is the statue of an unknown soldier, casually surveying the empty street, guarding against a non-existent threat. The whole scene is viewed, in fact, as if from the point of view of this memorial. But this statue – erected, presumably in the 1920s, years before the picture was taken – refers back to and is determined by a time before it was even conceived, to the dates inscribed on the base of the column: '1917–1918'. In every way, then, we are drawn back to the past – an impression heightened by the way that the picture has itself grown old.

Like Atget, Evans also deployed the receding vista internally, using floors and windows to suggest that the corridor led back down the years. In Saratoga Springs in 1931 he took a photograph that is like an interior companion piece to the exterior shot of the town's memory-drenched Main Street [65] [75]. In a pair of ornate mirrors is reflected a corridor, illuminated by windows, receding into the past like an endless arcade [76]. It is not simply that the picture is able to contain time, it also suggests that places have their own inbuilt capacity for memory. Connie, in D. H. Lawrence's *Lady Chatterley's Lover*, senses this on a walk through her husband's ancestral home. 'The place remembered,' she exclaims, 'still remembered'.

Evans believed these memories could be coaxed out and distilled by the camera. He could show memory in the process of formation and, by so doing, make it part of *our* memory. In this way we get a sense not just of the chronological passage of years but of psychological time. This does not feel like a psychological projection on the part of the viewer but of a receptiveness to something abiding in the place itself.

76. Walker Evans: *Saratoga Springs*, 1931

© The Walker Evans Archive, The Metropolitan Museum of Art, New York, 1994 (1994.256.388)

The passage from Whitman used as an epigraph to the catalogue of the 1971 retrospective could not have been more apt:

> I do not doubt interiors have their interiors, and exteriors have their exteriors, and that the eyesight has another eyesight . . .

We sense this most powerfully in Evans's 1935 picture of *The Breakfast Room of Belle Grove Plantation, Louisiana* [77].* The room is quite empty, as if the picture had been taken with an exposure so long that everything except the building itself – not just people, but chairs,

* Evans's biographer James Mellow points out that the photo has been mislabelled; it is actually the drawing-room.

77. Walker Evans: *The Breakfast Room, Belle Grove Plantation,*
White Chapel, Louisiana, 1935

© The Walker Evans Archive, The Metropolitan Museum of Art, New York, 1994 (1994.258.421)

furnishing, carpets – has been disappeared. What was said of Sugimoto also holds good for Evans: time passes *through* his camera. This is why it seems almost inconceivable that a picture like this could ever be taken with a digital camera. The house took a long time to get into this state and, as far as possible, a photograph of it needs to partake of a similar process and duration. To look at the picture is to share the viewpoint of the photographer who saw it come gradually into view in the developing tray. So closely does Evans achieve this identification and merging of image and subject that damage to the room – the damp stain above the door – looks, at first, like damage to the print. (It is not the first occasion that 'DAMAGE' catches Evans's eye; this time he does not spell it out.) That stain and the more severe water damage to the ceiling mark the points where the outside is starting to get inside. It's also coming in at the door: a bright T of light pressing through the shutters as Evans presses his shutter. It is only a matter of time before the inside becomes the outside, before things get turned around, reversed. The ceiling will be first to go, followed, eventually, by the doors, then the walls. The Corinthian columns and pilasters – which one associates with the open-air ruins of classical antiquity – make the room seem

predisposed to such an eventuality. As things stand, though, the room is still managing to hold its own: to enclose time within its walls (as Evans encloses it within the picture frame) and keep it at bay.*

Evans also made a large number of exterior pictures of the Belle Grove. My favourite among these plantation views, though, is of the Woodlawn Plantation a few miles away.

In the course of this book I have come, increasingly, to like pictures which look like they were taken by someone else – the Shahn of a 'Lange' back, say. My favourite pictures by Brassaï are the ones done in daylight, especially ones that look like they were taken by Lartigue. It's quite possible that some of my favourite Shores were taken by Eggleston, and vice versa. Perhaps it's not such a surprise, then, that my favourite Walker Evans (WE) photo was taken by Edward Weston (EW).

Whatever their importance in the history of photography, I can't muster up much enthusiasm for Weston's endless grocery store of forms: the Lisa Lyon pepper, the brain-stem cabbage, the earth-from-outer-space onion, the cock-and-balls gourd. The twisted abstracts of kelp don't do it for me, nor do the shrouded rock forms, the vulva shells and all the Brancusi-in-the-raw stuff that Weston prided himself on finding. This leaves the portraits of Lawrence, the nudes – and the work he did after being awarded a Guggenheim.

Convinced it was the right thing to do, Weston had filled in a terse, proudly defiant application. To the question asking about learned societies he'd belonged to Weston replied 'None. I avoided them.' Education? 'Self-taught'. Positions held? 'With the exception of a few months' Federal work I have worked for myself for over 25 years.' The more Weston thought about this the more worked up he became, as if the only way of bearing the indignity of asking for money was to ensure that he would not get any. He heard subsequently that although the Guggenheim Foundation wished to award the grant to a photographer they would be hard pressed to give it to someone ready to bite the hand

* Stephen Shore describes Evans's photos as formulating 'closed little worlds'.

before it had even fed him. Coaxed by Charis, he redrafted his application and, in March 1937, was informed that he had been awarded the grant.

He and Charis bought a car. They nicknamed it Heimy, loaded it up with provisions and equipment and hit the road. Between April 1937 and March 1939 they made trips to Arizona, Washington, Oregon and New Mexico as well as travelling all over California. Charis drove, Weston took pictures. Wherever they went he saw the shadows and the light arranging themselves, the endless and shifting geometries of pattern and form that he had spent years learning to photograph. Death Valley blew his mind. According to Charis, 'Edward was so shaky with excitement he could hardly set up his camera, and all we could say for some time was, "My God! It can't be"'. Essentially, this meant taking a tried and tested way of isolating the defining characteristics of an object and transferring it – with the attendant massive increase in scale – from a thing to a place. In the course of their travels, however, the skills Weston had acquired in all the years of doing fruit, veg and rocks found a context in which history – what Strand, back in 1915, had called 'the human element' – entered the frame.

The relevance of Strand's idea is particularly apposite if we look at a picture taken in 1937, in Marin County, of a child's grave [78]. Commentators have often remarked on the way that, towards the end of his working life, Weston was increasingly drawn to photographing cemeteries and graveyards. The significance of this elegiac note is appropriate and obvious. What is so striking about this picture, though, is the way the grave is surrounded by a fence that gives it the poignancy of a mournful play-pen. But this is not just any fence: this is *Strand's* white picket fence. Weston's view of the grave is determined and framed by Strand.

Weston had been conscious for a while of the way that their careers had in some ways run parallel, 'he on the Atlantic coast, I on the Pacific, using same material'. This had prompted Weston 'to ponder' further, in April 1929, on a competitiveness in his own nature. He remembered how, 'months ago', he had declared that 'it was immaterial whether one man was greater than another: the important thing

78. Edward Weston: *Child's Grave, Marin County*, 1937

being a matter of personal growth.'* And yet, Weston reflected, only a few weeks previously he had happily transcribed the opinion of an artist who had judged that 'my work was more important than Strand's'. Weston concluded these reflections by admonishing himself. 'I need to grow, – beyond personalities.' Made eight years later, this picture of a child's grave shows how Weston had largely succeeded. With this photograph he lays to rest his childish rivalry with Strand. It is the first in a number of images in which Weston, whether through accident or design, enters into a dialogue with other photographers.

Weston may have baulked at the term but his work began to approach the main thrust of documentary photography from which he had remained grandly and geographically distant.† He photographed signs, twisted bits of man-made Americana to which he had previously

* Weston was probably – and revealingly – remembering an entry from August 1928 occasioned by his learning of Stieglitz's low opinion of his work: 'it has come to me of late that comparing one man's work to another's, naming one greater or lesser, is a wrong approach. The important and only vital question is, how much greater, finer, am I than I was yesterday? Have I fulfilled my possibilities, made the most of my potentialities?'
† Weston believed, not entirely accurately, that 'the term "documentary photography" ha[d] come to refer exclusively to photography dealing with social welfare or social problems'.

paid no attention. Admitting to a fascination with 'abandoned service stations', he did his version of a subject that, from Evans and Lange through to Cartier-Bresson and Ormerod, would become *de rigueur* for observers of the American scene: the burned-out wreck of an automobile. In the same year, 1937, he took the picture which, in some ways, represents the terminus of documentary photography in the Depression years.

Lange and others had photographed people at the limits of endurance, about to drop dead from exhaustion, so weary they were ready to fall asleep anywhere. Weston went one better, photographing a corpse that he and Charis chanced upon in the Colorado Desert [79]. Charis had never seen a dead person before and expected it to be more dramatic. As she looked at the unmoving man he looked so peaceful 'it was hard to believe he was really dead.' In the picture that Weston took he looks, in fact, exactly like the Stalker in Andrei Tarkovsky's great film, napping on his journey through the Zone. These similarities lend a reassuring quality to the mundane fact of his death – hatless, naturally – in the parched wilderness. Charis found a note in his pocket – he was from Tennessee – and she wondered what California symbolized

79. Edward Weston: *Dead Man, Colorado Desert*, 1937

to him. Maybe he still 'held the vision of better things to come, even as he wrote: "Please tell my people . . ."' Charis does not tell us what it was he wanted told. The only message we have is the photograph ('*the utmost that we know . . .*'): this was a man who ran out of life-fuel, who couldn't take another step, or knew that even if he took one more he certainly couldn't take three or four or a hundred more, and unless he was able to take at least four or five thousand more there was no sense taking even one. And at that point, as he sat down for the last time, he must have felt as peaceful as Charis believed him to be. The only thing he wished was that he still had a hat to keep the sun from squinting in his eyes. Other than that, where he was was as good as anywhere he was ever going to get. Once you've come to that conclusion the only pillow you need is the hard earth itself. So he just lay there, the sun boring into his eyes, the sound of insects in his ears and the tickle of a fly on his face, until there was not even that, just the stubble on his chin that didn't have the sense to know when it was beat.*

In 1938 Weston took a picture which is, in many ways, an extension of Evans's vision into more elemental terrain. Typically, the ruins photographed by Evans were not that ruined. An exception is his 1936 picture of the crumbling tabby walls — made of lime, sand, saltwater and oyster shells — at St. Mary's, Georgia. Through a vacant doorway can be seen another doorway, beyond which is twisted and broken woodland. Far exceeding anything seen elsewhere in Evans's work, the degree of ruination approaches that observed by Weston at the Harmony Borax works in Death Valley [80]. All that remains are broken walls and the vacant shapes of windows. Nothing is left of the idea of the inside. The roof is just sky. The interior has become the

* *Dead Man* is not only one of Weston's most widely reproduced pictures, the story of how he came to take it was also one of his most widely reproduced anecdotes. Charis recalls coming down from her shower to join her husband and some friends: 'I still enjoyed listening to Edward, even though his talk never varied from one such occasion to the next. "Charis has heard this already," he began with a nod in my direction as he held up a print of the dead man at Carrizo Springs. "We'd been driving all day through sand and heat on the old Butterfield Stage Route across the Colorado Desert . . ."'

80. Edward Weston: *Harmony Borax Works, Death Valley*, 1938

exterior. Weston photographed these vertical remains in the way that Evans favoured, from directly in front. The rear wall can be seen through the empty window of the nearest wall, and through the window of the far wall is the desolate emptiness beyond. Evans, as we have seen, became adept at using the receding vista – whether of roads, hallways or mirrors – to represent the passage of time. Weston does the same thing in his picture; the difference is that here the visual telescoping extends beyond the recesses of historical time – beyond even the decaying trees glimpsed in that exceptional photo of St. Mary's – and into the vastness of geology, into prehistory. In Evans, the ruined walls are still sufficiently substantial to fill the picture frame; in Weston they are surrounded by emptiness. The effect is the one noticed by Wenders whereby 'the sudden appearance of the relics and remnants of civilization' makes 'the surrounding desert all the emptier'.

Weston's movement towards the mainstream of American documentary photography was consolidated in 1941 when he accepted a commission from George Macy, director of the Limited Editions Club, to provide photographs for an illustrated edition of Whitman's *Leaves of Grass*. Confident that this project would enable him to produce 'the best

work of [his] life', Weston spent nine months driving – or, more accurately, being driven by Charis – across America in a new car, this one nicknamed 'Walt, the Good Gray Bard'. From their home in Carmel the couple headed east, moved through the South, and roamed the middle Atlantic States and New England. In total they racked up twenty thousand miles and twenty-four States in the course of the Whitman trip.

Weston rejected the idea of producing pictures 'tied into any specific lines' in favour of a 'broad, inclusive summation of contemporary America that Whitman himself gave'. Macy worried that the photographer wasn't tied in enough, was straying too far from his source. His fears were confirmed when Weston wrote to him from New Orleans, rejecting the shooting script proposed by 'a poem like "Our Old Feuillage" in which are catalogued more than a hundred specific scenes, places, people, and things that could be photographed'. For Weston the challenge was to come up with photographs that would 'really "get" America'. By contrast, 'to make a list out of Whitman's catalogues (1 Louisiana live oak, 1 California redwood, 1 tired oxen in barn, 1 knife grinder, 1 lilac bush in dooryard etc.) and make pictures to fit is not even properly a job for a photographer.'

There is a poetic irony in this. On his original Guggenheim application Weston had taken a resentful pride in the way that he had not been involved with the FSA or other federally funded photographic projects. In the course of the Whitman trip, however, especially as his relationship with Macy became strained, Weston's experience began to resemble that of photographers like Evans and Lange who had simultaneously enjoyed the opportunities and been frustrated by the demands of the FSA. Evans regarded his employment by the FSA as a form of 'subsidised freedom'. Finally enjoying the benefits of sponsorship Weston, who had looked forward to the 'great freedom' afforded by the commission, found himself resenting the kind of impositions that were all too familiar to photographers working for Stryker. The difference was that on this occasion the 'shooting scripts' were dictated by Walt ('In these *Leaves* every thing is literally photographed') Whitman himself!

Not that this was going to dissuade Weston from doing as he wished. 'Edward didn't give a hoot about *Leaves of Grass* — he was having the time of his life,' Charis recalls: driving round the US with his beautiful young wife, photographing whatever took his fancy. And his hunch had been right: he did produce some of the greatest work of his life as the obligations and opportunities of the trip brought about a series of remarkable meetings — in the form of photographs — with the other great photographers of his time. Weston had said that the pictures would be a vision of 'my America'; the fact that parts of this vision closely resemble other photographers' America enhances its interest.

Evans had headed south and west from the East Coast; Weston headed east from the Pacific. An encounter of sorts had occurred a few years earlier when Weston photographed an old building with the words 'Photo Studio' painted on its faded frontage. As if that weren't enough of a coincidence or tacit salute the picture happens to be captioned 'Judge *Walker's* Gallery, Elk, 1939' (my italics).

The definitive meeting took place in Louisiana where Weston photographed the Belle Grove Plantation house that Evans had photographed six years earlier. Evans considered it to be 'the most sophisticated example of [a] classic revival dwelling in the country', and Weston evidently shared his enthusiasm. They each made repeat visits to photograph there, Evans in March 1935, Weston in August 1941.

Evans, thirty-one at the time, had come here with a woman he had only recently met: Jane Smith, a twenty-two-year-old painter, married to Paul Ninas (also an artist). While they were at Belle Grove, Evans took a snap of her sitting by a large stone column. 'By the time he made this picture', writes Belinda Rathbone, 'he was in love with Jane.' They became lovers and, following Jane's divorce, were married in 1941, the year that Charis and Weston turned up at Belle Grove. The irony is twofold. While Evans was there he had found himself in the classic Weston situation: photographing and falling for a beautiful woman almost ten years his junior. Shortly before *they* arrived there the Westons — who had by now been together for seven years — had a brief but explosive quarrel. They made up soon enough; it was only later that Charis would understand 'how great a chasm had opened between us'

at that point. The Evanses' marriage lasted until 1955, until Jane came to what might be termed the Larkin verdict on her husband: namely that he was 'too selfish, withdrawn, / And easily bored to love'.

I have compressed the story of these two relationships down to their bare essentials, reducing several years into a few sentences. The justification is that, from the perspective of the Belle Grove, a decade might just as well be a matter of minutes. Devoid of its human dramas, six years, the difference between 1935 and 1941, between the happy inception of a relationship and the beginning of its slow deterioration, is practically nothing. In these terms Evans was inside photographing 'the breakfast room' while Weston was outside, photographing the exterior. The same question keeps coming up: how long does a coincidence last?

When I think of that exterior view the picture that comes to mind is actually of another plantation house that Weston photographed earlier in the day of his first visit to Belle Grove. This was at Woodlawn. And it was here that Weston took the best of his 'Evans' photographs [81]. The house has a facade of classical columns but has obviously fallen into ruin (one part of it seems to have been turned into a barn).

81. Edward Weston: *Woodlawn Plantation, Louisiana*, 1941

To the left a tree reaches almost to the top of the frame: nature continuing to flourish after the man-made building has become a relic of its own former splendour. The buildings slope away diagonally. A car is pulled up between two columns, right up to the front door, giving the place the look of an utterly dilapidated but still grand garage. (When I think of Weston photographing the exterior of Belle Grove this is the picture that first comes to mind and – applying the principle of temporal compression encouraged by ruins – I often find myself believing that the car is Evans's, left there like the hat that Frank saw in the bank at Houston.) The house could be in Greece or Tuscany. Only the car makes it identifiably American. It also creates the impression – and this is something that differentiates Weston's picture from Evans's – that some kind of life is still going on here, that even if the house is unoccupied a prospective buyer has perhaps arrived. Weston captures what J. B. Jackson, in his influential essay 'The Necessity for Ruins', calls the 'interval of neglect' that is an 'artistically essential' incentive (often in the form of a photograph) to eventual restoration. Wordsworth expressed his own ambitions in similar terms in the penultimate book of *The Prelude*: 'I would enshrine the spirit of the past / For future restoration.' Evans was interested in what any present time will look like as past; Weston preserves time past as it awaits future renovation.

As Weston continues working his way east, the sense of an ongoing engagement or dialogue with American photographers becomes more and more acute. Sometimes he even has the opening line in this dialogue. The picture he takes in Pittsburgh of the bridge-spanned Ohio river, shrouded by industrial smoke, is like an establishing shot for Smith's later exhaustive survey of the city. In Burnet, Texas, he photographs an old couple, Mr and Mrs Fry, sitting on their stoop with all the reverence and dignity we associate with Lange's subjects. The picture of a Yaqui Indian in Tucson, white shirt and mahogany face framed by weathered wood, is exactly the kind of image familiar from Strand's portraiture of the early 1950s.

Most significant of all are two pictures Weston made in New York and Brooklyn after he and Charis arrived there in the fall. As Evans had

done in 1929, at the very start of his career, Weston photographed the Brooklyn Bridge [82]. But whereas Evans photographed it as an abstract meshing of geometric forms (saw it, in other words, as Weston might have done), Weston photographs it rising in the distance over a street busy with automobiles and dense with signs – Otto's Bar and Grill; Wines and Liquors – of human life (sees it, in other words, as Evans might have done).*

On 20 November Weston and Charis visited Stieglitz at An American Place. It was, as Charis says in her memoir, 'a retracing of Edward's 1922 pilgrimage', but the actual meeting failed to make much of an impression on her. The 'white-haired old man looked through Edward's prints, made occasional comments about their subject matter, but said nothing about the photography'. Later in the day, O'Keeffe joined them and repeated Stieglitz's comments, 'almost to the word'.

82. Edward Weston: *The Brooklyn Bridge*, 1941

* It is appropriate that these photographic meetings took place on Evans's territory, as it were. Writing to Beaumont Newhall in 1937 Weston declared that 'he is certainly one of our finest. When I see a photograph reproduced that I like, I usually find it is by Walker Evans.' His good opinion was not reciprocated; in a 1947 interview Evans lumped Weston in with 'Ansel Adams and Strand, none of whom I admire.'

Perhaps we should not be too disappointed by this. The 'real' meeting between these four people is less important than one which took place in the frame of Weston's camera. At some point during their stay in New York Weston made a view of Mid-town Manhattan facing southwest [83]. The view of the vaulting mass of skyscrapers – especially the recently completed Rockefeller Center – is strikingly similar to the ones Stieglitz had made from his window at the Shelton Hotel. The picture serves as spectacular proof that although visiting Stieglitz may have been a retracing of Weston's earlier pilgrimage, 'this time he wasn't a pilgrim.'

Weston and Charis returned to California in 1942. Their relationship had become increasingly strained in the course of their travels and in 1945 they separated. It was around this time that Weston experienced the first symptoms of Parkinson's, the disease which gradually incapacitated him. In the meantime, he did a number of 'Pussygraphs' – not what you think, unfortunately: they were pictures of cats. He also made a series of nudes of Charis wearing a gas mask, but the aim, as the title *Civilian Defence* suggests, was satirical rather than fetishistic. In 1945 Imogen Cunningham visited them at Point Lobos. She photographed

83. Edward Weston: *New York*, 1941

Weston sitting on a rock looking like a little troll, Charis and Edward together leaning back against a rock, Charis on her own playing a recorder. In turn Weston photographed Imogen photographing Charis, recognition of a kind that she was no longer his exclusive photographic property.

After 1945, as Weston's physical condition began to deteriorate, his productivity declined. He made a number of pictures of bits and pieces – a dead bird, driftwood – washed up on the shore at Los Lobos, near his home in Carmel. His very last picture – one of only two he made in 1948 – shows eroded rocks scattered over the beach. In the context of this book, though, the most poignant picture from the final phase of his long career is one made in 1944 at Eliott Point. It could hardly be simpler: a frontal view of a broken bench [84].

Weston suffered a gradual falling away of the ability to compose material, to frame the world and turn it into photographs. Bit by bit the ability, in his terms, to transform looking into seeing deserted him.

In the case of Winogrand, the opposite occurred: he became seized by a mania for photographing so intense that it took the place of seeing

84. Edward Weston: *Bench, Eliott Point*, 1944

Perfectly adapted to – and a product of – his native New York, Winogrand's high-energy approach served him well beyond his Guggenheim-funded road trip of 1964. By the time he moved to Los Angeles in 1978, though, he was on the brink of becoming engulfed by his own relentless compulsion to photograph. Los Angeles is a city where you are obliged to drive and this, as Szarkowski drolly notes, proved fatal: 'As a pedestrian he had come to shoot at anything that moved, and from the car everything moved.'

Winogrand had always been a 'heavy shooter', but in Los Angeles his photographic insatiability began to surpass that of Smith's in Pittsburgh. 'It is difficult to say precisely how much Winogrand shot in California, but it is certain that the totals were prodigious,' writes Szarkowski. 'At the time of his death in 1984 more than 2,500 rolls of exposed film remained undeveloped, which seemed appalling, but the real situation was much worse. An additional 6,500 rolls had been developed but not proofed. Contact sheets (first proofs) had been made from some 3,000 additional rolls, but only a few of these bear the marks of even desultory editing.' It would seem, Szarkowski observes with a mixture of wonder and bafflement, 'that in his Los Angeles years he made more than a third of a million exposures that he never even looked at'. Unlike many photographers who are painstaking to the point of obsession about printing, Winogrand reckoned that 'anyone who can print can print my pictures.' Time spent in the darkroom was time spent not photographing. Processing the material had always counted for less than the urgent task of amassing it; in LA it no longer counted at all.

Surveying this 'gargantuan excess' in the catalogue accompanying the 1988 retrospective, Szarkowski concludes 'that he photographed whether or not he had anything to photograph, and that he photo-graphed most when he had no subject, in the hope that the act of photographing might lead him to one'. The technical decline of Winogrand's pictures was accelerated when, in 1982, he acquired an auto-wind which enabled him to take more photos with less and less thought as to what and how he was photographing. The curator Trudy Wilner Stack wrote of Winogrand that 'he believed the world stopped

when he stopped photographing it.' By the late 1970s this idea seems to have taken hold of him completely. When Frank first saw Evans's pictures he had 'thought of something Malraux wrote: "To transform destiny into awareness"'. It was Winogrand's destiny to turn awareness into a kind of oblivion.*

By the spring of 1973 Evans was in the deep twilight of his career. He was almost seventy and his status was assured. It wasn't simply that he was one of the great American photographers; his 1938 exhibition and book had, quite explicitly, defined what American photographs looked like. A retrospective at MoMA in 1971 consolidated his reputation while exacerbating Evans's gnawing sense that the achievements for which he was being lauded were firmly in the past. Also, despite the acclaim, Evans insisted he was 'still as poor as a church mouse'. While money was a perpetual source of anxiety – leading him, eventually, to rashly sell off almost his entire archive of negatives and prints – it had never been a primary motivation. All his life, Evans claimed, he had wanted 'nothing so much as leisure'. Since 1945 that had come in the form of a prestigiously cushy job at *Fortune* magazine from which he resigned when he was offered a position teaching photography at Yale in 1965. Had it not been for that it seems likely that he'd have fallen into something approaching terminal recline. He lounged his days away, cultivating what Belinda Rathbone calls 'an exaggerated sense of personal entitlement'. On occasions his second wife, Isabelle, entered his workroom to find her husband 'mesmerized by a pornographic magazine'. When she finally left him there seemed nothing to prevent Evans, whose drinking had contributed to the collapse of their marriage, lapsing into sodden befuddlement.

* In 1972 when Stephen Shore (then aged twenty-five) set out on the road-trip that would result in *American Surfaces* he found his Rollei 35 so easy to use that he also became snap-happy. 'I was photographing every meal I ate, every person I met, every waiter or waitress who served me, every bed I slept in, every toilet I used.' On subsequent trips Shore swapped to an 8x10 view camera in order, partly, to slow down both his methods and results (as seen in *Uncommon Places*). Joel Sternfeld made a similar move to the large format camera for the work eventually published in *American Prospects*.

Then, in July 1973, Evans obtained a Polaroid SX-70 camera. He began experimenting and playing with something he at first regarded as a 'toy'. Such was his fascination and satisfaction with the results that he felt 'quite rejuvenated' and ended up devoting the last fourteen months of his life almost exclusively to this new gadget.* Both a reprise of and addendum to everything he had done before, the Polaroids made between September 1973 and November 1974 constitute a final radiant and unexpected extension of his vision. Revisiting his favourite motifs in a series of pellucid dreams, the 2,600 Polaroids are like a condensation of and extended meditation on Winogrand's claim that Evans's 'photographs are about what is photographed, and how what is photographed is changed by being photographed, and how things exist in photographs'. His subjects remained the ones that had always dominated his work – empty buildings, discreet portraits, signs, found language – all strangely enhanced by the technical limitations of the camera.

He photographed a toilet seat and roll of paper (perhaps as an unconscious homage and rejoinder to Weston who had photographed the toilet in Mexico). He photographed a mirror propped on a floor; reflected in it is an empty chair. It is as if, from the mirror's point of view, the time an individual spends sitting in that chair is so small that he or she might as well never have been there. The emptiness in the Polaroids of houses, streets and railroad stations is absolute, as though the places had somehow succeeded in taking pictures of themselves.†
And this, of course, is one of the things that drew Evans to the SX-70. The role of the photographer was reduced to almost nothing. To so little, in fact, that, aside from holding the camera, he might as well not have been there at all. All he did was point.

Evans highlighted this by photographing arrows painted on a road,

* In 1978, when he was in his mid-80s, Kertész also embarked on an intense phase of photographing with a Polaroid camera.
† The historical novelty of this might be disputed by Henry Fox Talbot who took a number of pictures of his country house in 1835. A few years later Talbot wrote that he believed 'this building . . . to be the first that was ever yet known *to have drawn its own picture*'. [Italics in original]

pointing eerily one way and then the other. In a series of pictures these arrows are accompanied by the word 'ONLY' [Pl. 11]. Technically speaking, the medium required only that he was articulate in the language of sight. The only thing he said was 'Look' and he said this so quietly that it was almost inaudible, as if no one had said anything, as if there were no one around to say it or hear it said.

And yet these pictures – of buildings stranded, apparently, by the mere fact of their existence – are as evidently Evans's as any he made. Because they could, ostensibly, have been taken by anyone, the fact that they were taken by him becomes all-important. 'It's as though there's a wonderful secret in a certain place and I can capture it,' he said. 'Only I, at this moment, can capture it, and only this moment and only me.' Consistent with this, these pictures, so nearly anonymous, are intensely suggestive of the photographer's interior life. It is as if there is no distinction whatever between a room's sense of itself and Evans's sense of himself. He had become his subjects.

Evans took these pictures and watched the known world change, in his hands, to something unknowably strange [Pl. 10]. The weird colour saturation had an immediately oneiric quality. Walls became insubstantial. The sky became as turquoise as De Chirico's. These were colours that emptied the world, made it seem like a dream – not a human dream, but the dream a room or road might have of itself. In the late 1950s he had taken photos from the window of a moving train. Now he took photos of a signal box and station when the train had gone by, when the only sign of its having passed was the little box of flowers, nodding in its wake. Time, like the train, has moved on elsewhere. The documentary has become inseparable from the lyrical.

Once described by Evans himself as 'still photography of general sociological nature', his life's work had come to comprise an inventory of American memory. When he looked at stations and store fronts now, in his seventies, it was like he was seeing the external embodiment of a memory he had created. The present was turning to the past before his eyes. Everything he saw was like a memory of itself. Polaroids were the perfect way to preserve this. What are they, after all, but *instant* memories? Instant memories of other pictures.

One picture, taken in a coffee shop on Oberlin, Ohio, shows a hallway framed on each side by doors [Pl. 12]. An American flag is furled up in the corner. The walls are a pale turquoise, more or less the same colour as the sky in Evans's exteriors of the time. At the end of the hallway is another door, open this time and showing the basins of the bathroom. In explaining Talbot's picture of an open door, Schaaf invoked the idea of the doorway 'as the boundary between life and death. The door ajar represents hope.' The problem with this analysis is that its suggestiveness is at odds with what it seeks to describe, with what Adrienne Rich, in a phrase of photographic precision, calls 'the fact of a doorframe'. Evans, as always, shows how the two can be reconciled. He died in 1975, the year after taking this picture of an open door, leading to what a sign, shiny with the reflected glare of the flash, explains are REST ROOMS.

that rather terrible thing which is there in every photograph
Roland Barthes

A figure, familiar from Kertész's picture of the broken bench, stands with his back to the camera, wearing a black coat. We saw him walk out of shot in a 1961 photo by Schapiro but he turns up again, before the century's end, in a picture from Brcko, Bosnia. Stretched diagonally across the picture is the body of a dead Muslim fighter, killed by Serbs [85]. On one side of his body are steps leading up to the top of the picture frame. On the other, back to the camera, hands behind his back, holding an umbrella, dressed in black, is that figure – identified by all the things that render him anonymous – of the Kertészian solitary. There are stains on the ground; the fact that it is impossible to say what has caused them is one of the rhetorical advantages of black and white: all stains assume the look of blood.

The picture is by James Nachtwey who, in a sense that I suspect he would not be displeased with, is not a photographer so much as a destiny or destination. He is the place to which he goes on assignment: a

85. James Nachtwey: *Mourner holds umbrella at funeral of Bosnian Moslem soldier killed by Serbs in battle outside Brcko, Bosnia and Herzegovina*, January 1994

By kind permission of VII Photos, Paris

place characterized by hardship, pain, injury, mutilation, starvation, atrocities, death. It is the place depicted in Auden's 1938 sonnet sequence *In Time of War*:

> A land laid waste, with all its young men slain,
> The women weeping, and the towns in terror.

Nachtwey's photographs are a kind of destiny for the medium as a whole, a place where photography has always had the potential to end up. Many of the details or tropes or categories – call them what you will – encountered in the course of this book end up in Nachtwey's blood-soaked inferno. The hat that lived through the Depression and the dust bowl comes to grief here, on a blood-stained apartment floor after the battle for Knin, Croatia [86]. In Chechnya, the view through a car windscreen is almost obscured by mud thrown up by the wrecked landscape and smeared by the wipers into two grimy rainbows through

which can be seen the figure of a Muslim praying [87]. The slow work of time and rain, turning mansions into the ruins photographed by Evans and Weston, is replaced by the instant and absolute devastation of bombs.

86. James Nachtwey: *A hat and a pool of blood lie on the floor. They are of a civilian killed during fighting between Croats and Serbs in the city of Knin in the Krajina region. Bosnia and Herzegovina*, March 1993.
By kind permission of VII Photos, Paris

87. James Nachtwey: *A Moslem Chechen stops his car at a dangerous place on the road to observe noon prayers. Grozny, Chechnya*, January 1996.
By kind permission of VII Photos, Paris

We have seen a figure photographed by Lange on the White Angel Bread Line reappear in a photo by DeCarava. Another of Lange's iconic figures, the Migrant Mother, reappears in a photo of ethnic Albanians fleeing ethnic cleansing in Kosovo, the anxious gesture – right hand raised to her mouth – unchanged after sixty years [88 and 89]. Recorded with such fascination by Kertész, Smith, Stieglitz and others, the view from the window – the view that enlivens the life of the solitary man – becomes that of a Croatian militiaman firing on his Muslim neighbours. The faces glimpsed through the windows of a bus are impoverished Russian mothers who had come to Grozny to search for their missing sons. 'They carry terror with them like a purse,' wrote Auden. 'They are and suffer; that is all they do.'

In Pittsburgh Eugene Smith photographed a young boy making palm prints on a wall. In Pec, Kosovo, Nachtwey finds the wall of a

88. James Nachtwey: *Albanian Kosovar women refugees on the back of a truck. They crossed the border between Yugoslavia and Albania, during a violent campaign of ethnic cleansing, deportation, pillage, murder and rape carried out by Serbian military forces under the orders of Slobodan Milosevic. Kosovo,* August 1999.
By kind permission of VII Photos, Paris

89. Dorothea Lange: *Migrant Mother, Nipomo, California*, 1936.
Courtesy the Dorothea Lange Collection, Oakland Museum of California

family's living room covered in bloody hand prints and graffiti (also drawn with blood). Some of these atrocious handprints look like rabbits with long floppy ears [90]. They resemble some of the earliest marks made in caves by humans who wished to leave behind a sign that they existed.

That same urge led eventually to the camera's invention. People had dreamed for years of finding a way of fixing an image before Daguerre, Niépce and Talbot were able, in their different ways, to turn this wish into a reality. On occasions, though, the earth itself can become a print or photograph. Tony Harrison wrote a film-poem, *The Shadow of Hiroshima* (1995), about one such occasion, when the burnt outline of a man was printed on stone by the force of 'the A-bomb blast'. Nachtwey records how something similar can be achieved with-

out the immense technological complexity of nuclear physics. In Meja, Kosovo, he photographed the floor of a house stained with the imprint of a man who had been killed by Serbs [91]. It is reminiscent both of

90. James Nachtwey: *Handprints and graffiti traced with blood cover the walls of the living room, Pec*, August 1999.
By kind permission of VII Photos, Paris

91. James Nachtwey: *The ground bears the imprint of the body of a dead man, killed by the Serbians. Meja, Kosovo, Yugoslavia*, August 1999.
By kind permission of VII Photos, Paris

those simple prehistoric figures carved in the earth's surface, visible from space, and of some crude forerunner of the photographic process. Technologically this process culminates with pictures made in space that can be beamed back to earth. One of the most famous of these images is of Buzz Aldrin's bootprint in the dust after the first moon landing in 1969. As Smith's photo of handprints in Pittsburgh has become twinned with Nachtwey's in Pec, so this one has become paired with a picture showing bloody bootprints in the snow of Grozny, Chechnya.

This photograph is not by Nachtwey – it was taken by Paul Lowe in 1995 – but the point still stands. As Susan Sontag points out, 'the very success of photojournalism lies in the difficulty of distinguishing one superior photographer's work from another, except insofar as he or she has monopolized a particular subject.' Writing in 2002 about the exhibition and book *Here is New York*, she went further, pointing out that, as the subtitle *A Democracy of Photographs* suggested, 'there was work by amateurs as good as the work of seasoned professionals.' Unattributed and uncaptioned, all of the pictures in the show, whether by 'a James Nachtwey or . . . a retired school teacher', were taken during or after the attack on the World Trade Center on 11 September 2001. If Nachtwey is a destination or place as much as a photographer, then that place can be New York as well as Grozny.

As one would expect, many of the motifs that we have observed throughout this book crop up here too: a man, caked in dust, sitting stunned on a bench; a woman sitting out on the stoop, scarf wrapped around her face as a makeshift mask; a man looking out of the window of his apartment as the second plane streaks towards the tower; bowls of fruit so caked in dust the colours are barely visible; a barber shop, unchanged since the 1930s were it not for the photo taped to the door of a skull shaved except for the bristling outline of the twin towers and the flag – UNITED WE STAND [92]; the jumble of dust-smeared street signs; signs with Polaroids of the missing; messages scrawled on the windows of cars (WELCOME TO HELL), taped to store windows (NUKE THEM ALL), or stencilled on walls (WANTED DEAD NOT ALIVE: BIN LADEN). In these circumstances the mere fact that a pizza place is OPEN

92. Laura Mozes: *Barber Shop, New York*, 2001.
By kind permission of Laura Mozes

FOR BUSINESS becomes an expression of endurance, defiance, determination. The words 'Merrill Lynch' and the address – 2 World Financial Centre, 5th floor, New York, New York 10080 – on an empty business envelope become a memorial. The words, the signs, are often pretty much the same as those depicted by Evans and Friedlander but, in this context, they become records of history captioning itself.

Amid all the written admonitions to exact revenge there are numerous voices urging us to 'Amplify Love, Dissipate Hate'. The many variants of 'Our Grief is not a Cry for Revenge' are necessary reminders that Nachtwey's inferno is only one of several possible destinations for photography. Of all the messages photographed in the wake of 9/11 none is as poignant and simple – so simple as to be self-evident – as one scrawled in felt-tip on the wall of a building. The picture is slightly blurred, the message difficult to read.

Photography's unique capacity to preserve or bring back the dead has often been remarked on. For Barthes this – 'the return of the dead' – is the terrible thing that we see in all photographs. This

photograph affirms the opposite point of view, conveys the simple message that is also there in all photographs: 'You are alive'.

The strangest photo in *Here is New York* takes us right back to where we started. Like Paul Strand's *Blind* this picture, of a person in the street holding a take-away cup of coffee, is self-labelling. His shirt tells us that he is called 'Monty' – or it could be 'Marty' – and he works for 'Reliance Machining Inc'. Unlike Strand's this photo did not have to be taken surreptitiously. Cameras are now so common and small, have become so integral to the experience of disaster, that no one pays any attention to them. Like one of Arbus's subjects Monty is happy to stop and pose [93]. He stares straight at the camera. We look at the huge sign hung around his neck, 'as if admonished from another world':

AFTER

DEATH

WHAT

??

"NOTHING"

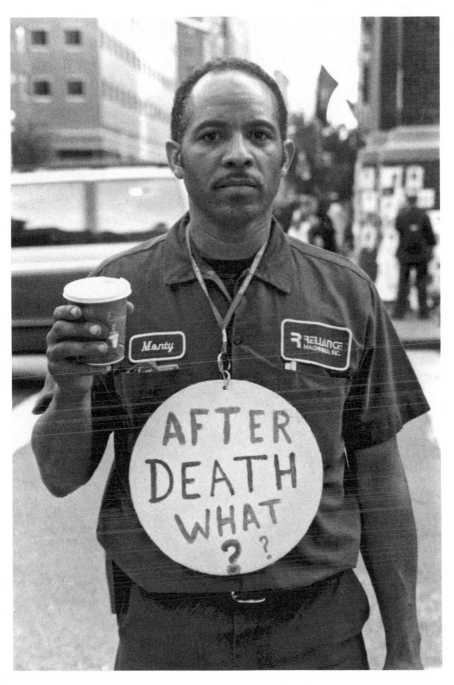

93. Regina Fleming: *After Death What??*, New York, 11 September 2001

By kind permission of Regina Fleming

Notes

p. 1 'certain Chinese encyclopaedia . . .': Jorge Luis Borges, 'John Wilkins' Analytical Language', in *Selected Non-Fictions* (edited by Eliot Weinberger), (New York, Viking), 1999, p. 231.

p. 1 'a pet subject . . .': quoted by Mellow, p. 401.

p. 1 'In these *Leaves* . . .': quoted by Davis S. Reynolds, *Walt Whitman's America* (New York, Knopf), 1995, p. 281.

p. 2 'See, in my . . .': Walt Whitman, 'Starting from Paumanok', in *The Complete Poems* (Harmondsworth, Penguin), 1975, p. 62.

p. 2 'People, all classes . . .': *Walker Evans at Work*, p. 98.

p. 2 'only seasoned with . . .': *Reading American Photographs*, p. 244.

p. 3 (footnote) 'House-building, measuring . . .': *The Complete Poems*, p. 244.

p. 4 'Crowded cars going . . .': quoted by Lesy, pp. 228–9.

p. 4 'Where are the elm . . .': ibid, p. 325.

p. 5 'a small town . . .': ibid, p 323.

p. 5 'Raking and burning . . .': ibid, p. 325.

p. 5 'a town at . . .': quoted in Rathbone, p. 234.

p. 5 'symbols, cars, cities . . .': quoted by Westerbeck and Meyerowitz, p. 356.

p. 5 'the project I . . .': quoted in *Moving Out*, p. 110.

p. 6 'to know ahead . . .': quoted in Meltzer, p. 140.

p. 6 'laughter that shattered . . .': Michel Foucault, *The Order of Things* (London, Tavistock), 1970, p. xv.

p. 6 (footnote) 'identified negatives alphabetically . . .': Wilson, p. 138.

p. 7 'that much unseen . . .': Walt Whitman, 'Song of the Open Road', *The Complete Poems*, p. 179.

p. 7 'a way of . . .': quoted in Montier, p. 210.

p. 7 'were not illustrations . . .': *Figments from the Real World*, p. 40.

p. 8 'the *idea* photography': *Photographs and Writings*, p. 13.

p. 9 'I have some . . .': *Diane Arbus*, p. 15.

p. 9 'the camera is . . .': *Photographs of a Lifetime*, p. 7.

p. 11 '*the inevitable familiar* . . .': *Walker Evans at Work*, p. 161.

p. 11 'I remember going . . .': interview with Leslie Katz, in Goldberg (ed), p. 367.

p. 11 'striking right across . . .': William Wordsworth, *The Prelude: A Parallel Text* (Harmondsworth, Penguin), 1971, p. 258.

p. 11 '. . . smitten with the . . .': *The Prelude*, pp. 286–8.

p. 12 'people in the . . .', 'Although *Blind Woman* . . .': *Sixty Years of Photography*, pp. 144–5.

p. 12 'was blind, not . . .': quoted by Maria Morris Hambourg in *Paul Strand, Circa 1916*, p. 37.

p. 13 'I felt that . . .': ibid, p. 35.

p. 13 'Lo! He dons . . .': *The Prelude*, p. 267.

p. 13 'in the last . . .': quoted by Alan Trachtenberg, 'Lewis Hine: The World of his Art', in Goldberg (ed), p. 242.

p. 15 'to work in . . .': quoted in *The Man in the Crowd*, p. 157.

p. 15 'who, walking the . . .': 'Street Musicians', *Selected Poems* (Manchester, Carcanet), 1986, p. 215.

p. 15 '1200 ASA jitteriness': Colin Westerbeck, *Bystander*, p. 377.

p. 16 'cloak of invisibility': *Photographs of a Lifetime*, p. 10.

p. 16 'He was a . . .': *Arrivals and Departures*, p. 14.

p. 17 'kept running into . . .': *Cape Light* [no pagination].

p. 19 'had come along . . .': *The Hungry Eye*, p. 220.

p. 19 'The guard is . . .': *Walker Evans at Work*, p. 152.

p. 20 'The face of . . .': *The Prelude*, p. 286.

p. 20 'every step / might . . .': Jorges Luis Borges (edited by Alexander Coleman), *Selected Poems* (New York, Viking), 1999, p. 311.

p. 21 'like the photographer': Colin Westerbeck, *Bystander*, p. 187.

p. 22 'dangerous at any . . .': Bruce Davidson, *Subway*, p. 112.

p. 22 'seemed weighed down . . .': *Bruce Davidson* [no pagination].

p. 22 'a penitent spy . . .': *Walker Evans at Work*, p. 160.

p. 22 'a pervert, voyeur . . .': *Subway*, p. 117.

p. 22 'uncover a beauty . . .': ibid, p. 113.

p. 22 'with wrinkled bags . . .': ibid, p. 117.

p. 23 'Look, Ben, there's . . .': quoted in Rathbone, p. 87.

p. 23 'a periscope on . . .': ibid, p. 87.

p. 23 'more like a . . .': quoted in Mellor, p. 113.

p. 23 'a bit too . . .': ibid.

p. 25 'The accordionist is . . .': George Szirtes, *Blind Field* (Oxford, Oxford University Press), 1994, p. 11.

p. 28 'saying too much': quoted by Borhan in *André Kertész: His Life and Work*, p. 26.

p. 28 'tricks & "effects"': *Photographs and Writings*, p. 218.

p. 28 'an absolute tragedy': quoted by Borhan, p. 24.

p. 28 'I am dead . . .': ibid, p. 31.

p. 28 'My secretary looked . . .': interview with Nicole Krauss, *Modern Painters*, Spring 2004, p. 60.

p. 29 'with tears in . . .': Borhan, p. 11.

p. 29 (footnote) 'with my whole . . .': *Camera Lucida*, p. 48.

p. 30 'We are the . . .': Szirtes, p. 11.

p. 31 'My God! What . . .': quoted in Loengard, p. 73.

p. 32 'a young Negro . . .': *Mythologies*, p. 116.

p. 33 'how their lives . . .': Philip Larkin, *Collected Poems* (London, Faber), 1988, p. 116.

p. 33 '*So what one* . . .': John Cheever, *The Journals* (London, Cape), 1991, p. 354.

p. 34 'to this view . . .': Paul Farley, 'From a Weekend First', *The Ice Age* (London, Picador), 2002, p. 3.

p. 34 'the rich pastime . . .': quoted in Mellow, p. 518.

p. 34 'torn, in a . . .': Fernando Pessoa, *The Book of Disquiet* (London, Quartet), 1991, p. 142.

p. 34 'the artistic element . . .': *The Hungry Eye*, p. 290.

p. 35 'He who travels . . .': quoted in Rathbone, p. 8.

p. 35 '*this world dense* . . .': Italo Calvino, *If on a Winter's Night a Traveller* (London, Secker & Warburg), 1981, p. 43.

p. 35 'carved the murderer's . . .': *The Prelude*, p. 480.

p. 36 'the photographs are . . .': *American Photographs*, p. 198.

p. 37 'like a title . . .': *The Prelude*, p. 260.

p. 38 'rather than a . . .': *Sixty Years of Photography*, p. 173.

p. 39 'quite rejuvenated': *Walker Evans at Work*, p. 235.

p. 40 'represent none other . . .': quoted in Montier, p. 40.

p. 40 (footnote) 'ancient Egyptian hieroglyphics': *Subway*, p. 111.

p. 41 'to photograph blind . . .': Bosworth, p. 275.

p. 42 'totally violates human . . .': *Photographs*, p. xix.

p. 42 'He lives in . . .': *Revelations*, p. 58.

p. 42 'had seen that . . .': Jorge Luis Borges, *Collected Fictions* (New York, Viking), p. 284

p. 43 'I photograph what . . .': *Portraits* [no pagination].

p. 43 'not sage but . . .': *Evidence*, p. 113.

p. 44 'because they can't . . .': quoted in Bosworth, p. 164.

p. 44 'to be king . . .': Anne Wilkes Tucker, quoted in Davis, p. 307.

p. 45 'Everybody has that . . .': *Diane Arbus*, p. 1.

p. 45 'she'd creep in . . .': quoted in Bosworth, p. 163.

p. 45 'to figure myself . . .': ibid, p. 248.

p. 45 'My only advantage . . .': Joan Didion, *Slouching Towards Bethlehem* (New York, Dell), 1968, p. xiv.

p. 46 'the poor girls . . .': *Revelations*, p. 153.

p. 46 'rare species of . . .': Gedney, p. 178.

p. 47 'I put the . . .': *Revelations*, p. 194.

p. 47 'What if I . . .': ibid, p. 212.

p. 47 'What I'm trying . . .': *Diane Arbus*, p. 2.

p. 47 'Every Difference is . . .': *Revelations*, p. 67.

p. 47 'people who appear . . .': ibid, p. 50.

p. 47 'undergoing some subterranean . . .': ibid, p. 192.

p. 47 'the suicides on . . .': quoted in Bosworth, p. 220.

p. 47 'the photographer's aim . . .': quoted in Delany, p. 188.

p. 48 'things which no one . . .': ibid, p. 11.

p. 48 'instead of photographing': *The Photography of Bill Brandt*, p. 17.

p. 48 'He died six . . .': *Sixty Years of Photography*, p. 30.

p. 48 'how I really . . .': ibid, p. 63.

p. 48 *'And to think . . .'*: *Selected Poems*, p. 413.

p. 48 (footnote) 'the camera had . . .': quoted in Delany, p. 208.

p. 49 'I gave him . . .': quoted in *Brassaï: The Eye of Paris*, p. 25.

p. 49 'makes it possible . . .': *The Key Set*, p. 148.

p. 49 'always loved snow . . .': quoted in Westerbeck and Meyerowitz, p. 92.

p. 49 'achieve the softness . . .': ibid, p. 92.

p. 50 'the only birth . . .': *Brassaï: No Ordinary Eyes*, p. 157.

p. 50 'out of the . . .': ibid, p. 171.

p. 50 'the optical unconscious': 'A Small History of Photography', *One-Way Street*, p. 243.

p. 50 'More than a . . .': 'Night Light: Brassaï and Weegee' in Goldberg (ed.), p. 412.

p. 50 'Walking in the . . .': Jean Rhys, *Good Morning, Midnight* (Harmondsworth, Penguin), 1969 (first published 1939), p. 28.

p. 51 'Well, well . . .': ibid, p. 142.

p. 52 'lost groping in . . .': Gedney, p. 176.

p. 52 'Photography is about . . .': quoted in Gedney, p. 176.

p. 52 'the slope of . . .': ibid, p. 157.

p. 52 *'Hands have a . . .'*: Rainer Maria Rilke, *Rodin and Other Prose Pieces* (London, Quartet), 1986, p. 19.

p. 52 'to imprint themselves . . .': *The Photographic Art of Henry Fox Talbot*, p. 13.

p. 53 'No human hand . . .' ibid, p. 15.

p. 53 'free of that . . .': quoted in Maddow, *Faces*, p. 191.

p. 53 'Love treasures hands . . .': John Berger, *Lilac and Flag* (New York, Pantheon), 1990, p. 144.

p. 53 'the quality of . . .': quoted in Malcolm, p. 117.

p. 54 'Every feeling waits . . .': Eudora Welty, *One Writer's Beginnings* (London, Faber), 1985, p. 85.

p. 54 'could just see . . .': Lange, quoted in Meltzer, p. 12.

p. 54 'elegance, control and . . .': *The Photographs of Dorothea Lange*, p. 116.

p. 55 'people who are . . .': *Photographs of a Lifetime*, p. 114.

p. 56 'All I have . . .': 'September 1, 1939', *The English Auden* (edited by Edward Mendelson) (London, Faber), 1977, p. 246.

p. 57 'could photograph thought': John Steinbeck, *Of Men and their Making: The Selected Non-Fiction of John Steinbeck* (London, Allen Lane), p. 217.

p. 57 'with scientific precision . . .': quoted in Rabb, p. 156.

p. 57 'an idea had . . .': quoted in Maddow, *Faces*, p. 343.

p. 58 'He sits silent . . .': *Rodin and Other Prose Pieces*, p. 24.

p. 59 'throughout the forties . . .': *Evidence*, p. 111.

p. 59 (footnote) 'general note is . . .': quoted in Rathbone, p. 70.

p. 59 (footnote) 'too clever, artificial': *Daybooks Vol. II*, p. 50.

p. 60 'Two workmen playing . . .': *Selected Poems*, p. 449.

p. 63 'at least for . . .': Gilbert Adair, *The Post-Modernist Always Rings Twice* (London, Fourth Estate), 1992, p. 36.

p. 63 'a man Edward . . .': (edited by James T. Boulton and Lindeth Vasey) *The Letters of D. H. Lawrence, Volume V, 1924–27* (Cambridge, Cambridge University Press), 1989, p. 176.

p. 64 'for either of . . .': *Daybooks, Vol. I*, p. 101.

p. 64 'not technically up . . .': ibid, p. 102.

p. 64 'the habit we . . .': D. H. Lawrence (edited by Edward D. McDonald), *Phoenix* (Harmondsworth, Penguin), 1978 (first published 1936), p. 522.

p. 65 'Photography's great difficulty . . .': *Daybooks, Vol. II*, p. 162.

p. 65 'not an interpretation . . .': ibid, p. 246.

p. 65 'keeping [him]self open . . .': ibid, p. 242.

p. 66 'photographs and things . . .': (edited by Keith Sagar and James T. Boulton) *The Letters of D. H. Lawrence, Volume VII, 1928–30* (Cambridge, Cambridge University Press), 1993, p. 189.

p. 66 'present the *significance* . . .': *Daybooks Vol. II*, p. 241.

p. 66 (footnote) 'exhibit an individuality . . .': *Diana & Nikon*, p. 53.

p. 67 'This place is . . .': quoted in *Paul Strand: Circa 1916*, p. 26.

p. 67 (footnote) 'a compact between . . .': *Evidence*, p. 114.

p. 67 (footnote) 'skin would be . . .': *Revelations*, p. 59.

p. 68 'to rip 291 . . .': Stieglitz to O'Keeffe, *Photographs and Writings*, p. 202.

p. 69 'whose duration is . . .': *Selected Essays*, p. 283.

p. 70 'a long discourse . . .': quoted in Whelan, p. 513.

p. 70 'was always there . . .': ibid, p. 260.

p. 70 (footnote) 'though they certainly . . .': Whelan, p. 510; see also Eisler, pp. 395–6.

p. 71 'walked out of . . .': quoted in Eisler, p. 429.

p. 73 'to be represented . . .': quoted in *Portraiture*, p. 13.

p. 73 'confirmed my ancient . . .': ibid, p. 21.

p. 73 'I never know . . .': ibid, p. 22.

p. 74 'that grim little . . .': quoted by Margery Mann in *Imogen Cunningham: Photographs* (Washington, University of Washington Press), 1970 [no pagination].

p. 74 'Nothing charms me . . .': quoted in Trachtenberg, p. 184.

p. 74 'I cried when . . .': quoted by Westerbeck in Goldberg (ed.), p. 414.

p. 74 (footnote) 'he was SO . . .': *Revelations*, p. 212.

p. 75 'It never rings': quoted in *Weegee's World*, p. 155.

p. 76 'worth the torture . . .': *Photographs and Writings*, p. 219.

p. 76 'an old man . . .': ibid, p. 218.

p. 77 '*By all means* . . .': quoted in Wilson, p. 346.

p. 77 'Quick as a . . .': *Daybooks Vol. I*, p. 4.

p. 78 'We'd make love . . .': quoted in Whelan, p. 403.

p. 78 'the general public . . .': ibid, p. 418.

p. 78 'gives the picture . . .': *Diana & Nikon*, p. 119.

p. 78 'should have had . . .': Norman Mailer, *The Time of Our Time* (London, Little, Brown), 1998, p. 1129.

p. 78 (footnote) 'My work is . . .': quoted in Mellow, p. 512.

p. 78 (footnote) 'sexual explorations of . . .': quoted in Whelan, pp. 184 and 188.

p. 80 'sullen with lust': Bernard McClaverty, *Cal* (London, Cape), 1983, p. 152.

p. 80 'O'Keeffe and I . . .': quoted in Whelan, p. 400.

p. 81 'really first class . . .': quoted in *The Key Set*, p. 446.

p. 81 'For an hour . . .': quoted in Whelan, p. 452.

p. 81 'Paul will be . . .': quoted in *The Key Set*, p. 447.

p. 82 'entirely different from . . .': ibid.

p. 82 'a messiness somewhere . . .': Whelan, p. 452.

p. 83 'could suggest something . . .': *The Photography of Bill Brandt*, p. 196.

p. 84 'afraid he could . . .': p. 53.

p. 84 'incapable of a . . .': quoted by Naomi Rosenblum in Stange (ed.), p. 48.

p. 84 'you had to . . .': quoted by Greenough in *The Key Set*, p. xxxviii.

p. 84 'astonishingly aggressive woman': Joan Didion, *The White Album* (London, Weidenfeld & Nicolson), 1979, p. 128.

p. 84 (footnote) 'Unless you can . . .': quoted in *Paul Strand: Sixty Years of Photography*, p. 154.

p. 84 (footnote) 'Aren't you absorbing . . .': quoted in Stange (ed.), p. 70.

p. 84 (footnote) 'found too much . . .': *Daybooks Vol. I*, p. 7.

p. 85 'a person with . . .': quoted in Eisler, p. 367.

p. 85 'I love you': quoted by Whelan, p. 530.

p. 85 'photographed God': *Photographs and Writings*, p. 208.

p. 85 'see Alfred as . . .': quoted in Whelan, p. 556.

p. 85 'put up with . . .': in *Georgia O'Keeffe: A Portrait by Alfred Stieglitz* [no pagination].

p. 86 'his whole philosophy . . .': quoted in Whelan, p. 272.

p. 86 'a Napoleon of . . .': *Daybooks Vol. II*, p. 70.

p. 86 'superb egoist': quoted in *Forms of Passion / Passion of Forms*, p. 64.

p. 86 'spoke with the . . .': *Daybooks Vol. I*, p. 4.

p. 86 'heavy tenets and . . .': quoted in Mellow, p. 87.

p. 86 'Alfred Stieglitz is . . .': *Daybooks Vol. I*, p. 72.

p. 86 'prints lacked life . . .': *Daybooks Vol. II*, p. 24.

p. 86 'all due credit . . .': ibid, p. 238.

p. 87 'avoided mentioning photographers': quoted by Weston, *Daybooks Vol. II*, p. 237.

p. 87 'fine a fellow . . .': quoted in Wilson, p. 94.

p. 87 (footnote) 'undoubtedly the most . . .': quoted in Mellow, p. 87.

p. 88 'this useful and . . .': *Daybooks Vol. I*, p. 132.

p. 88 'but coarse and . . .': Maddow, *Edward Weston: His Life*, p. 208.

p. 88 'fearing every moment . . .': *Daybooks Vol. I*, p. 135.

p. 88 'aesthetically stimulating form': ibid, p. 136.

p. 89 'a new love': *Daybooks Vol. II*, p. 63.

p. 89 'the figure is . . .': ibid, p. 111.

p. 89 'perhaps my only . . .': *Daybooks Vol. I*, p. 47.

p. 89 'kisses and embraces . . .': ibid, p. 196.

p. 90 (footnote) 'the result of . . .': *Photographs and Writings*, p. 184.

p. 90 'Why this tide . . .' *Daybooks Vol. II*, p. 4.

p. 90 'I never go . . .': ibid, p. 259.

p. 90 'go through life . . .': ibid, p. 93.

p. 90 'with pink point . . .': *Daybooks Vol. I*, p. 55.

p. 91 'She called me . . .': quoted in Maddow, *Edward Weston: His Life*, p. 104.

p. 92 'sexless and impersonal': *Diana & Nikon*, p. 22.

p. 92 'timid and repressed': ibid, p. 119.

p. 92 'in erotic terms': Wilson, p. 112.

p. 94 'knees akimbo, hands . . .': ibid, p. 144.

p. 95 'the brilliance and . . .': ibid, p. 9.

p. 95 'It was something': quoted in *The Key Set*, p. xxxviii.

p. 95 'the subject of . . .': *Diane Arbus*, p. 15.

p. 95 (footnote) 'Tina discovered in . . .': Patricia Albers, *Shadows, Fire, Snow: The Life of Tina Modotti* (Berkeley, University of California), 2002, p. 74.

p. 96 'Is what we . . .': Joel Sternfeld, *On This Site* (San Francisco, Chronicle Books), 1996 [no pagination].

p. 97 'a back may . . .': quoted in *The Waking Dream*, p. 48.

p. 97 'the camera should . . .': *Daybooks Vol. I*, p. 55.

p. 97 'with the immediate . . .': *Forms of Passion / Passion of Forms*, p. 17.

p. 97 'NO POLITICS whatever': *Walker Evans at Work*, p. 112.

p. 97 (footnote) 'The world is . . .': quoted in *Edward Weston: A Legacy*, p. 42.

p. 98 'a bad word': *The Photographs of Dorothea Lange*, p. 62.

p. 98 (footnote) 'when you're on . . .': in *Cape Light* [no pagination].

p. 99 'of prisoners of . . .'; Szarkowski, *Looking at Photographs*, p. 130.

p.104 'What you can . . .': *Evidence*, p. 112.

p.104 (footnote) 'a case could . . .': *Jacques Henri Lartigue*, p. x.

p.104 (footnote) 'a new idea . . .': quoted in Westerbeck and Meyerowitz, p. 146.

p.105 'you have an . . .': *The Photographs of Dorothea Lange*, p. 20.

p.107 'their roots were . . .': ibid, p. 49.

p.107 'squatting in the . . .': John Steinbeck, *The Grapes of Wrath* (Harmondsworth, Penguin), 1951 (first published 1939), p. 33.

p.108 'would have thought . . .': *The Photographs of Dorothea Lange*, p. 30

p.110 'In front of . . .': Steinbeck, p. 248.

p.114 'made their pictures , . .': quoted in Davis, p. 395.

p.114 'describes a hat . . .': George Steiner, *Language and Silence* (London, Faber), 1967, p. 362.

p.115 'There are only . . .': quoted in Montier, p. 8.

p.119 'peddling the same . . .': quoted by Westerbeck in Goldberg (ed.), p. 415.

p.119 'if we had . . .': *Of Men and their Making*, p. 25.

p.120 (footnote) 'dullness of vision . . .': *America in Passing*, p. 9.

p.121 'sedentary power': *Selected Essays*, p. 277.

p.123 'Indian streets serve . . .': Gedney, p. 184.

p. 123 'bodies of citizens . . .': ibid, p. 185.

p. 123 'I wander all . . .': *The Complete Poems*, p. 440.

p. 124 'the same thing . . .': *Atget*, p. 176.

p. 124 'how often, when . . .': *Memoirs of Hadrian* (Harmondsworth, Penguin), 1986 (first published 1954), p. 28.

p. 126 'in which all . . .': *Atget*, p. 80.

p. 126 'because he couldn't . . .': quoted in Susan Cheever, *Home Before Dark* (London, Weidenfeld & Nicolson), 1985, p. 23.

p. 126 'kept his white . . .': quoted in Rathbone, p. 114.

p. 126 (footnote) 'had an enormous . . .': *The Letters of John Cheever* (edited by Benjamin Cheever) (London, Cape), 1989, p. 304.

p. 126 (footnote) 'First I was . . .': *Revelations*, p. 216.

p. 127 'came all over . . .': *The Letters of John Cheever*, p. 304.

p. 129 '*I had a . . .*': Sven Birkerts, 'A Finer Accuracy', *The Threepenny Review*, Berkeley, Summer, 2004, p. 21.

p. 131 'One shouldn't be . . .': quoted in *Lartique: Album of a Century*, p. 138.

p. 133 'that Jacques Lartigue . . .': *Looking at Photographs*, p. 11.

p. 135 'Think of being . . .': 'Toads Revisited', *Collected Poems*, p. 146.

p. 140 'how you build . . .': *Paul Strand: Circa 1916*, p. 32.

p. 140 'broken by shacks . . .': ibid, p. 25.

p. 141 'Why did I . . .': *Paul Strand: Sixty Years of Photographs*, p. 34.

p. 141 'the basis for . . .': ibid, p. 145.

p. 141 '*locus classicus* for . . .': Samuel Green, quoted by Jonathan Green in Petruck (ed.), *The Camera Viewed, Vol. 1*, p. 19.

p. 141 'first view of . . .': quoted in *Cruel and Tender*, p. 267.

p. 142 'the moral quality . . .': *The Journals*, p. 284. See also p. 352 where Cheever writes of 'the moral beauty of light'.

p. 142 'The most wonderful . . .': ibid, p. 90.

p. 143 'perhaps Ormerod's own . . .': *States of America*, p. 111.

p. 143 'he has developed . . .': *The Journals*, p. 247.

p. 149 'An echo from . . .': C. P. Cavafy (translated by John Berger and Katya Berger Andreadakis), 'In the Evening': *Collected Poems*. For translation of the full poem see Edmund Keeley and Philip Sherrard (edited by George Savidis) (Princeton, Princeton University Press), 1992, p. 73.

p. 149 'looking over the . . .': quoted in Schloss, p. 108.

p. 150 'a figure who . . .': quoted in Meltzer, p. 335.

p: 150 (footnote) 'Sometimes when I'm . . .': quoted in *Lartigue: Album of a Century*, p. 374.

p. 153 'rushing to work': *Paul Strand: Sixty Years of Photographs*, p. 144.

p. 154 'helps keep you . . .': *Revelations*, p. 206.

p. 156 '*I remember well . . .*': *The Photographs of Dorothea Lange*, p. 18.

p. 157 'artists starve': *The Key Set*, p. xivii.

p. 158 'If what is . . .': quoted in Peter Conrad, *The Art of the City* (Oxford, Oxford University Press), 1984, p. 82.

p. 159 'We live high . . .': *Photographs and Writings*, p. 214.

p. 159 'A man nodding . . .': *The Complete Poems* (London, Faber), 1971, p. 232.

p. 162 'There must be . . .': Jane Jacobs, *The Death and Life of Great American Cities* (New York, Modern Library), 1993 (first published 1961), p. 45.

p. 162 'a window looking . . .': Franz Kafka, *The Collected Stories of Franz Kafka* (Harmondsworth, Penguin), 1988, p. 384; quoted in Gedney, p. 75.

p. 163 'the tremendous unity . . .': quoted by Sam Stephenson in *Dream Street*, p. 20.

p. 163 'a last ditch . . .': Hughes, p. 376.

p. 164 'Among the exceptions . . .': quoted in *André Kertész: His Life and Work*, p. 26.

p. 164 'My life has . . .': quoted in Hughes, p. 386.

p. 165 'where the observer . . .': *The Journals*, p. 354.

p. 165 'Because of the . . .': Hughes, p. 384.

p. 165 '*My car became* . . .': 'Weegee by Weegee' in Goldberg (ed.), p. 403.

p. 166 'the kind of . . .': quoted in Rathbone, p. 234.

p. 166 'practically forty-eight . . .' *The Americans*, p. 5.

p. 166 'I love to . . .': quoted in Rathbone, p. 219.

p. 167 'to dive into . . .': Jean Baudrillard, *Cool Memories II* (Oxford, Polity Press), 1996, p. 43.

p. 167 'this nomadic, roadside . . .': *The Journals,* pp. 345–6.

p. 167 'the loneliest picture . . .': *The Americans*, p. 8.

p. 168 'to take pictures . . .': quoted in Wim Wenders, *The Act of Seeing* (London, Faber), 1997, p. 135.

p. 169 'Was this what . . .': Gore Vidal, *Palimpsest* (London, André Deutsch), 1995, p. 410.

p. 169 'is the exact . . .': (edited by Ann Charters) *Selected Letters 1940–1956* (London, Viking), 1995, p. 242.

p. 170 'Do you reckon . . .': *The Photographs of Dorothea Lange*, p. 36.

p. 170 'silent, looking into . . .': *The Grapes of Wrath*, p. 12.

p. 171 'Long shot of . . .': *The Americans*, p. 6.

p. 171 'in the service . . .': quoted in Davis, p. 395.

p. 172 'something that's on . . .': quoted in *Moving Out*, p. 111.

p. 173 'And so one': *The Journals*, p. 346.

p. 173 'the subject would . . .': (edited by Francis Steegmuller) *The Letters of Gustave Flaubert 1830–1857* (Cambridge, Harvard University Press), 1980, p. 154.

p. 176 'the air of . . .': Julio Cortázar, *Blow-Up and Other Stories* (New York, Pantheon), 1985, p. 115.

p. 176 (footnote) 'in a sense . . .': Andrew Cross, *Along Some American Highways* (London, Black Dog Publishing), 2003 [no pagination].

p. 176 (footnote) 'roads no longer . . .': J. B. Jackson, *A Sense of Place, A Sense of Time* (New Haven, Yale), 1994, p. 190.

p. 177 'led to an . . .': 'The Nothing That is Not There', (edited by Julie Grau) *Edward Hopper and the American Imagination* (New York, Norton), 1995, p. 5.

p. 177 'the EVERYTHINGNESS and . . .': *The Americans*, p. 6.

p. 177 'European photographer who . . .': *The Act of Seeing*, p. 135.

p. 177 (footnote) 'looking forward to . . .': Italo Calvino, *The Road to San Giovanni* (New York, Pantheon), 1993, p. 40.

p. 179 'they are the . . .': *Revelations*, p. 226.

p. 180 'Time passes through . . .': Francesco Bonami in Sugimoto, *Architecture*, p. 9.

p. 181 'the cruel radiance . . .': *Let Us Now Praise Famous Men*, p. 9.

p. 181 'the white radiance . . .': 'Adonais' 1821, *Shelley* (edited by Kathleen Raine) (Harmondsworth, Penguin), 1973, p. 289.

p. 181 '*I'd have to . . .*': 'Clouds', Wisława Szymborska, *Poems New and Collected, 1957–1997* (London, Faber), 1999, p. 266.

p. 181 'with clouds hung . . .': quoted in Scharf, p. 114.

p. 182 'Stalinist photography': quoted in Delany, p. 281.

p. 182 'Ah! *then*, if . . .': 'Elegiac Stanzas', ibid.

p. 182 'plenty of skies . . .': *Paul Strand: Sixty Years of Photographs*, p. 24.

p. 182 'Johnson & Johnson . . .': ibid, p. 24.

p. 182 'quite marvellous cloud . . .': *Daybooks Vol. I*, p. 14.

p. 182 'they alone are . . .': ibid, p. 21.

p. 182 'Next to the . . .': ibid, p. 83.

p. 183 'was due to . . .': *Photographs and Writings*, pp. 206–7.

p. 183 'I wanted to . . .': ibid.

p. 183 'his great sky . . .': ibid, p. 208.

p. 183 'way off the . . .': quoted in *The Key Set*, p. xiiii.

p. 183 'I have a . . .': ibid, p. LIV.

p. 183 'several people feel . . .': *Photographs and Writings*, p. 208.

p. 184 'Oh my God . . .': quoted in Mellow, p. 91.

p. 184 'A sky filled . . .': *Selected Essays*, p. 475.

p. 185 'something already taking . . .': *Photographs and Writings*, p. 25.

p. 185 'documents of the sky . . .': ibid, p. 24.

p. 185 '. . . *I am thinking*': 'Why I Am Not a Painter', (edited by Donald Allen) *The Selected Poems of Frank O'Hara* (New York, Vintage), 1974, p. 112.

p. 185 'that of all . . .': *The Photographs of Dorothea Lange*, p. 118.

p. 186 'Look at this . . .': *Letters Vol. VII*, p. 189.

p. 186 'absolute unqualified objectivity': *Paul Strand: Sixty Years of Photographs*, p. 146.

p. 186 'a limitless objectivity': Rainer Maria Rilke, *Letters on Cézanne* (London, Cape), 1988, p. 65.

p. 187 'startling and wonderful': quoted in Whelan, p. 226.

p. 187 'Colour photography is': quoted in *Early Colour Photography* (New York, Pantheon), 1986 [no pagination].

p. 188 'It's a dye': *Paul Strand: Sixty Years of Photographs*, p. 16.

p. 188 'Black and white . . .': quoted in Davis, p. 295.

p. 188 'imagine having to . . .': quoted in Montier, p. 73.

p. 188 'Colour tends to . . .': *The Hungry Eye*, p. 336.

p. 188 'Paradox is a . . .': ibid.

p. 188 'the time was . . .': *One-Way Street*, p. 240.

p. 188 'the early Christian era . . .': quoted in *Sunday Telegraph Magazine*, 28 March 2004, p. 29.

p. 188 'the tropics, and . . .': quoted in Meltzer, pp. 321–2.

p. 188 'bebop of electric . . .': quoted in Marien, p. 361.

p. 189 'When the point . . .': *The Hungry Eye*, p. 336.

p. 189 'the banal leading . . .': quoted by Mark Holborn, *William Eggleston: Ancient and Modern*, p. 20.

p. 190 'a kind of . . .': *Revelations*, p. 342.

p. 190 'better than any . . .': quoted in Maddow, *Edward Weston: His Life*, p. 230.

p. 191 'Those of us . . .': ibid, p. 231.

p. 191 'a one-story . . .': *Cape Light* [no pagination].

p. 191 'the colour of . . .': Stephen Shore, *Uncommon Places* (original edition) (New York, Aperture), 1982, p. 63.

p. 192 'working not as . . .': *William Eggleston's Guide*, p. 9.

p. 192 'really learned to . . .': Szarkowski, quoted by Thomas Weski in *The Hasselblad Award 1998: William Eggleston*, p. 8.

p. 193 'doesn't look at . . .': *William Eggleston: Ancient and Modern*, p. 18.

p. 193 'shotgun pictures': ibid, p. 21.

p. 194 'as parts of . . .': quoted by Walter Hopps, *The Hasselblad Award 1998: William Eggleston*, p. 6.

p. 194 'aura of heightened . . .': Walker Percy, *The Moviegoer* (London, Methuen), 2003 (first published 1961), p. 16.

p. 194 'The search is . . .': ibid, p. 13.

p. 194 'They looked both . . .': ibid, p. 11.

p. 196 '*I'm not really* . . .': *Cape Light* [no pagination].

p. 197 'An Edward Hopper . . .': *The Act of Seeing*, p. 137.

p. 198 'oil-soaked, oil-permeated . . .': *The Complete Poems 1927–1979* (New York, Noonday), 1980, p. 127.

p. 198 'a photograph of . . .': 'Monkeys Make the Problem More Difficult: A Collective Interview with Garry Winogrand', transcribed by Dennis Longwell, in Petruck (ed.) *Vol. II*, pp. 125–7.

p. 199 'in-between moments': quoted in Sontag, *On Photography*, p. 121.

p. 201 'like a drugstore . . .': Don DeLillo, *Americana* (New York, Penguin), 1989 (first published 1971), p. 102.

p. 202 'apprentice [him]self to . . .': *Uncommon Places*, p. 177.

p. 202 'Traffic lights swayed . . .': Don DeLillo, *White Noise* (London, Viking), 1984, p. 89.

p. 203 'the sadness of . . .': Don DeLillo, *Americana*, p. 224.

p. 203 'I want to . . .': *Camera Lucida*, p. 39.

p. 204 'Rivers and streets . . .': Joseph Brodsky, *Collected Poems in English* (New York, Farrar, Straus and Giroux), 2000, p. 99.

p. 205 '*A haircut has* . . .': Don DeLillo, *Cosmopolis* (London, Picador), 2003, p. 15.

p. 207 'suggest people sometimes . . .': quoted in Rathbone, p. 252.

p. 207 'All rooms are . . .': Martin Amis, *Money* (London, Cape), 1984, p. 255.

p. 207 'Mankind has always . . .': quoted in Gedney, p. 184.

p. 207 (footnote) 'They were not . . .': Robert Frost, *Selected Poems* (Harmondsworth, Penguin), 1973, p. 108.

p. 208 (footnote) 'I always feel . . .': *Daybooks, Vol. II*, p. 129.

p. 209 (footnote) 'even the bottles . . .': Jack Kerouac, 'On the Road to Florida', in *New York to Nova Scotia*, p. 40.

p. 210 'It's like walking . . .': *Revelations*, p. 167.

p. 211 'a listless, mean . . .': *States of America*, p. 8.

p. 213 'of the early . . .': Schaaf, p. 196.

p. 213 'the Dutch school . . .': ibid.

p. 213 'acts as a . . .': ibid.

p. 213 'I don't . . .': *Paul Strand: Sixty Years of Photographs*, p. 34.

p. 213 (footnote) 'It is the . . .': quoted in Montier, p. 210.

p. 213 (footnote) 'I don't press . . .': *Revelations*, p. 147.

p. 217 'ghostly beings moving . . .': Thomas De Quincey 'Suspiria de Profundis' (1845) in *Confessions of an English Opium-Eater and Other Writings* (edited by Barry Milligan) (Harmondsworth, Penguin), 2003, p. 90.

p. 219 'If the doors . . .': Aldous Huxley quoted in *The Doors of Perception and Heaven and Hell* (London, Granada), 1977 (first published 1954), p. 6.

p. 219 'There is nothing . . .': quoted in *The Man in the Crowd*, p. 157.

p. 219 (footnote) 'The most mysterious . . .': quoted in *Diane Arbus: A Biography*, p. 187.

p. 222 '*Lately I've become . . .*': *Evidence*, p. 90.

p. 222 'airless nostalgia for . . .': quoted in Mellow, p. 216.

p. 222 'didn't know Hopper . . .': ibid, p. 217.

p. 222 'Hopper's use of . . .': 'Crossing the Tracks to Hopper's World', in J. D. McClatchy (ed.), *Poets on Painters* (Berkeley, University of California Press), 1988, p. 341.

p. 223 'landscapes represent eternity': quoted in Montier, p. 18.

p. 223 'All the porches . . .': quoted in Mellow, p. 318.

p. 223 'it is always . . .': *Poets on Painters*, p. 341.

p. 224 'the element of . . .': *The Hungry Eye*, p. 133.

p. 224 'was, and is . . .': *Walker Evans at Work*, p. 151.

p. 224 'The empty station . . .': *In This Proud Land: America, 1935–1943 as Seen in the FSA Photographs*, p. 7.

p. 224 'such magnificent strength . . .': quoted in Westerbeck and Meyerowitz, p. 275.

p. 225 'clocks for seeing . . .': *Camera Lucida*, p. 15.

p. 226 'sensation that perspective . . .': Anthony Lane, *Nobody's Perfect*, (New York, Knopf), 2002, p. 536.

p. 226 'The place remembered . . .': D. H. Lawrence, *Lady Chatterley's Lover* (Harmondsworth, Penguin), 1960 (first published 1928) p. 44.

p. 227 'I do not . . .': 'Assurances', *The Complete Poems*, p. 461.

p. 229 'None. I avoided . . .': quoted in Wilson, p. 98.

p. 229 (footnote) 'closed little worlds': quoted in *Uncommon Places*, p. 13.

p. 230 'Edward was so . . .': ibid, p. 123.

p. 230 'he on the . . .': *Daybooks Vol. II*, p. 119.

p. 231 'I need to . . .': ibid.

p. 231 (footnote) 'it has come . . .': ibid, p. 71.

p. 231 (footnote) 'the term "documentary . . .': *Edward Weston: A Legacy*, p. 43.

p. 232 'abandoned service stations': ibid, p. 23.

p. 232 'it was hard . . .': Wilson, p. 128.

p. 233 (footnote) 'I still enjoyed . . .': ibid, p. 218.

p. 234 'the sudden appearance . . .': Wim Wenders, *Pictures from the Surface of the Earth* (Munich, Schirmer), 2003, p. 9.

p. 234 'the best work . . .': *Passion of Forms / Forms of Passion*, p. 293.

p. 235 'Walt, the Good . . .': Wilson, p. 232.

p. 235 'tied into . . .': *Passion of Forms / Forms of Passion*, p. 291.

p. 235 'a poem like . . .': quoted in Wilson, pp. 261–2.

p. 235 'great freedom': *Passion of Forms / Forms of Passion*, p. 293.

p. 236 'Edward didn't give . . .': Wilson, p. 243.

p. 236 'the most sophisticated . . .': quoted in Mellow, p. 234.

p. 236 'By the time . . .': Rathbone, p. 98.

p. 236 'how great a . . .': Wilson, p. 255.

p. 237 'too selfish, withdrawn . . .': 'Wild Oats', *Collected Poems*, p. 143.

p. 238 'interval of neglect': J. B. Jackson, *The Necessity for Ruins* (Cambridge, MIT Press), 1980, p. 101.

p. 238 'I would enshrine . . .': *The Prelude*, p. 482.

p. 239 'a retracing of . . .': Wilson, p. 289.

p. 239 (footnote) 'he is certainly . . .': quoted in Rathbone, p. 166.

p. 239 (footnote) 'Ansel Adams and . . .': quoted in Mellow, p. 513.

p. 242 'As a pedestrian . . .': *Figments From the Real World*, p. 39.

p. 242 'heavy shooter': ibid, p. 18.

p. 242 'It is difficult . . .': ibid, pp. 35–6.

p. 242 'anyone who can . . .': quoted in *The Man in the Crowd*, p. 165.

p. 242 'he believed the . . .': *1964*, p. 277.

p. 243 'thought of something . . .': 'Statement', in Goldberg (ed.), p. 401.

p. 243 'still as poor . . .': quoted in Rathbone, p. 299.

p. 243 'nothing so much . . .': ibid, p. 211.

p. 243 'mesmerized by a . . .': ibid, p. 274.

p. 243 (footnote) 'I was photographing . . .': quoted in *Modern Painters*, Spring 2004, p. 76.

p. 244 'quite rejuvenated': *Walker Evans at Work*, p. 235.

p. 244 'photographs are about . . .': quoted in *The Hungry Eye*, p. 12.

p. 244 (footnote) 'this building . . . to . . .': 'Some Account of the Art of Photogenic Drawing' in Goldberg (ed.), p. 46.

p. 245 'It's as though . . .': interview with Leslie Katz, in Goldberg (ed.), p. 365.

p. 245 'still photography of . . .': *Walker Evans at Work*, p. 113.

p. 246 'that rather terrible . . .': *Camera Lucida*, p. 9.

p. 247 'A land laid . . .': *The English Auden*, p. 259.

p. 249 'They carry terror . . .': ibid, p. 258.

p. 249 'They are and . . .': ibid.

p. 250 'the A-bomb blast': Tony Harrison, *The Shadow of Hiroshima and Other Film/Poems* (London, Faber), 1995, p. 13.

p. 252 'the very success . . .': *On Photography*, p. 133.

p. 252 'there was work . . .': *Regarding the Pain of Others*, p. 28.

Select Bibliography

Books quoted in the text that have only an incidental connection with photography –
novels or collections of poetry, for example – are not listed here; nor are books
by or about photographers who are mentioned only in passing. Full publication
details for these titles can be found in the Notes section.

Books by or about Individual Photographers

(Where a book is intended primarily to showcase the work of a photographer the
name of the editor/curator is shown in brackets before the title.)

Merry Alpern, *Dirty Windows* (Zurich, Scalo), 1995.

Diane Arbus, *Diane Arbus* (New York, Aperture), 1972.
 Revelations (New York, Random House), 2003.
 Patricia Bosworth, *Diane Arbus: A Biography* (New York, Norton), 1984.

Eugène Atget (John Szarkowski), *Atget* (New York, Museum of Modern
 Art/Callaway), 2000.

Richard Avedon, *Evidence: 1944–1994* (London, National Portrait Gallery), 1994.
 Portraits (New York, Metropolitan Museum of Art/Abrams), 2002.

Bill Brandt, *The Photography of Bill Brandt* (London, Thames and Hudson), 1999.
 Paul Delany, *Bill Brandt: A Life* (London, Cape), 2004.

Brassaï (Anne Wilkes Tucker, with Richard Howard and Avis Berman), *Brassaï: The
 Eye of Paris* (Houston, Museum of Fine Arts/Abrams), 1999.
 (Alain Sayag and Annick Lionel-Marie) *Brassaï: No Ordinary Eyes* (London, Thames
 & Hudson), 2000.

Peter Brown, *On the Plains* (New York, Norton), 1999.

Robert Capa (Richard Whelan and Cornell Capa), *Photographs* (London, Faber), 1985.

Henri Cartier-Bresson, *Photographer* (London, Thames and Hudson), 1980.
America in Passing (London, Thames and Hudson), 1991.
Tête à Tête (London, Thames and Hudson), 1998.
The Man, the Image & the World: A Retrospective (London, Thames and Hudson), 2003.
Jean-Pierre Montier, *Henri Cartier-Bresson and the Artless Art* (London, Thames and Hudson), 1996.

Imogen Cunningham (Richard Lorenz), *Portraiture* (New York, Bulfinch), 1997.

Bruce Davidson, *Bruce Davidson* (New York, Pantheon), 1986.
(Expanded edition) *Subway* (Los Angeles, St. Ann's Press), 2003.

Roy DeCarava (Peter Galassi), *A Retrospective* (New York, Museum of Modern Art), 1996.

Philip-Lorca diCorcia (Peter Galassi), *Philip-Lorca diCorcia* (New York, Museum of Modern Art), 2003.

William Eggleston (John Szarkowski), *William Eggleston's Guide* (New York, Museum of Modern Art), 1976.
William Eggleston: Ancient and Modern (New York, Random House), 1992.
The Hasselblad Award 1998: William Eggleston (Goteborg, Hasselblad), 1999.
William Eggleston (London, Thames and Hudson), 2002.
Los Alamos (Zurich, Scalo), 2003.

Elliott Erwitt, *Handbook* (New York, Quantuck Lane Press), 2003.

Walker Evans, *American Photographs* (New York, Museum of Modern Art), 1988 (first published 1938).
(with James Agee) *Let Us Now Praise Famous Men* (Boston, Houghton Mifflin), 1941.
Many Are Called (New Haven, Yale/Metropolitan Museum of Art), 2004 (first published 1966).
Walker Evans at Work (London, Thames and Hudson), 1984.
The Hungry Eye (London, Thames and Hudson), 1993.
Signs (London, Thames and Hudson), 1998.
The Lost Work (Santa Fe, Arena), 2000.
(Jeff L. Rosenheim) *Polaroids* (Zurich, Scalo), 2002.
Belinda Rathbone, *Walker Evans: A Biography* (London, Thames and Hudson), 1995.

Jerry L. Thompson, *The Last Years of Walker Evans* (London, Thames and Hudson), 1997.

James R. Mellow, *Walker Evans* (New York, Basic Books), 1999.

Robert Frank, *The Americans* (New York, Grove Press), 1959.
(Anne Wilkes Tucker) *New York to Nova Scotia* (Houston, Museum of Fine Arts), 1986.
(Sarah Greenough and Philip Brookman) *Moving Out* (Washington, National Gallery of Art/ Scalo), 1994.

Lee Friedlander, *Letters from the People* (London, Cape), 1993.
Lee Friedlander (New York, Pantheon), 1988.

Paul Fusco, *RFK Funeral Train* (New York, Magnum), 2000.

William Gedney (Margaret Sartor), *What Was True* (New York, Norton), 2000.

Nan Goldin, *The Ballad of Sexual Dependency* (New York, Aperture), 1986.
I'll Be Your Mirror (New York, Whitney Museum of American Art/Scalo), 1996.

André Kertész, *The Manchester Collection* (Manchester), 1984.
(Pierre Borhan) *André Kertész: His Life and Work* (Bulfinch Press, New York), 1994.

Dorothea Lange, *Photographs of a Lifetime* (New York, Aperture), 1982.
Dorothea Lange (New York, Abrams), 1995.
Milton Meltzer, *Dorothea Lange: A Photographer's Life* (New York, Farrar Straus Giroux), 1978.

Jacques Henri Lartigue (Vicki Goldberg), *Photographer* (London, Thames and Hudson), 1998.
(Martine D'Astier, Quentin Bajac and Alain Sayag) *Lartigue, Album of a Century* (London, Hayward Gallery), 2004.

Jack Leigh, *The Land I'm Bound To* (New York, Norton), 2000.

Joel Meyerowitz (Expanded edition), *Cape Light* (New York, Bulfinch), 2002 (first published 1978).

Richard Misrach, *The Sky Book* (Santa Fe, Arena), 2000.

James Nachtwey, *Inferno* (London, Phaidon), 1999.

Michael Ormerod, *States of America* (Manchester, Cornerhouse), 1993.

Steve Schapiro, *American Edge* (Santa Fe, Arena), 2000.

Ben Shahn, *Ben Shahn's New York* (Cambridge, Yale University Press), 2000.

Stephen Shore, *American Surfaces* (Cologne, Photographische Sammlung/SK Stiftung Kultur), 1999.
Uncommon Places: The Complete Works (London, Thames and Hudson), 2004.

W. Eugene Smith (Gilles Mora/John T. Hill), *Photographs 1934–1975* (New York, Abrams), 1998.
(Sam Stephenson) *Dream Street: W. Eugene Smith's Pittsburgh Project* (New York, Norton), 2001.
Jim Hughes, *W. Eugene Smith: Shadow and Substance* (New York, McGraw Hill), 1989.

Paul Strand, *Sixty Years of Photography* (New York, Aperture), 1976.
(Maria Morris Hambourg) *Paul Strand: Circa 1916* (New York, Museum of Modern Art/Abrams), 1998.
Maren Stange (ed.), *Paul Strand: Essays on His Life and Work* (New York, Aperture), 1990.

Edward Steichen (Joel Smith), *The Early Years* (Princeton, Princeton University Press), 1999.
(Joanna Steichen) *Steichen's Legacy* (New York, Knopf), 2000.

Alfred Stieglitz (Sarah Greenough), *Photographs and Writings* (Washington, National Gallery of Art/Bulfinch), 1999.
(Sarah Greenough) *The Key Set* (two vols) (Washington, National Gallery of Art/Abrams), 2002.
Georgia O'Keeffe: A Portrait by Alfred Stieglitz (New York, Metropolitan Museum of Art), 1978.
Benita Eisler, *O'Keeffe and Stieglitz: An American Romance* (New York, Doubleday), 1991.
Dorothy Norman (Miles Barth), *Intimate Visions: The Photographs of Dorothy Norman* (San Francisco, Chronicle Books), 1993.
Richard Whelan, *Alfred Stieglitz: A Biography* (New York, Little, Brown), 1995.

Hiroshi Sugimoto, *Motion Pictures* (Milan, Skira Editore/SPSAS), 1995.
Architecture (Chicago, Museum of Contemporary Art, Chicago/Distributed Art Publishers), 2003.

William Henry Fox Talbot (Larry J. Schaaf), *The Photographic Art of William Henry Fox Talbot* (Princeton, Princeton University Press), 2000.

Weegee (Miles Barth), *Weegee's World* (New York, Bulfinch), 1997.

Eudora Welty, *Photographs* (Jackson, University of Mississippi), 1989.

Edward Weston (Nancy Newhall), *The Daybooks of Edward Weston* (two vols) (New York, Aperture), 1990.
(Gilles Mora) *Forms of Passion / Passion of Forms* (London, Thames and Hudson), 1995.
(Jennifer A. Watts) *A Legacy* (London, Merrell), 2003.
(Sarah M. Lowe) *Tina Modotti and Edward Weston: The Mexico Years* (London, Merrell), 2004.
Ben Maddow, *Edward Weston: His Life* (New York, Aperture), 1989.
Charis Wilson and Wendy Madar, *Through Another Lens: My Years with Edward Weston* (New York, North Point), 1998.

Garry Winogrand (John Szarkowski), *Figments from the Real World* (New York, Museum of Modern Art / Abrams), 1988.
The Man in the Crowd: The Uneasy Streets of Garry Winogrand (San Francisco, Fraenkel Gallery), 1999.
(Trudy Wilner Stack) *1964* (Santa Fe, Arena), 2002.
(Alex Harris and Lee Friedlander) *Arrivals and Departures: The Airport Pictures of Garry Winogrand* (New York, Distributed Art Publishers), 2004.

Francesca Woodman, *Francesca Woodman* (Zurich, Scalo), 1998.

General Surveys, Histories of Photography, Cultural Histories and Anthologies etc.

Roland Barthes, *Mythologies* (London, Cape), 1972.
Camera Lucida (New York, Hill and Wang), 1981.
The Responsibility of Forms (New York, Hill and Wang), 1985.
Walter Benjamin, 'A Small History of Photography', *One-Way Street and Other Writings* (London, New Left Books), 1979.
John Berger (with Jean Mohr), *Another Way of Telling* (London, Writers and Readers), 1982.
Selected Essays (New York, Pantheon), 2002.
Keith F. Davis, *An American Century of Photography*, 2nd Edition (New York, Abrams), 1999.
Emma Dexter and Thomas Weski (eds), *Cruel and Tender: The Real in Twentieth Century Photography* (London, Tate), 2003.
Vicki Goldberg (ed.), *Photography in Print* (Santa Fe, University of New Mexico Press), 1988 (first published 1981).
Maria Morris Hambourg (ed.), *The Waking Dream: Photography's First Century* (New York, The Metropolitan Museum of Art/Abrams), 1993.

Here is New York (Zurich, Scalo), 2002.

Michael Lesy, *Long Time Coming* (London, Norton), 2002.

John Loengard, *Life: Classic Photographs: A Personal Interpretation* (revised edition) (London, Thames and Hudson), 1996.

Ben Maddow, *Faces* (New York, New York Graphic Society/Little, Brown), 1977.

Janet Malcolm, *Diana & Nikon* (revised edition) (New York, Aperture), 1997.

Mary Warner Marien, *Photography: A Cultural History* (London, Laurence King), 2002.

Peninah R. Petruck (ed.), *The Camera Viewed: Writings on Twentieth Century Photography* (two vols) (New York, Dutton), 1979.

Jane M. Rabb (ed.), *Literature and Photography* (Albuquerque, University of New Mexico Press), 1995.

Martha Sandweiss (ed.), *Photography in Nineteenth Century America* (New York, Abrams), 1991.

Aaron Scharf, *Art and Photography* (revised edition) (Harmondsworth, Penguin), 1974.

Carol Schloss, *In Visible Light: Photography and the American Writer: 1840–1940* (New York, Oxford University Press), 1987.

Susan Sontag, *On Photography* (Harmondsworth, Allen Lane), 1979.

Regarding the Pain of Others (New York, Farrar, Straus and Giroux), 2003.

Roy Emerson Stryker and Nancy Wood, *In This Proud Land: America, 1935–1943 as Seen in the FSA Photographs* (Greenwich, New York Graphics Society), 1973.

John Szarkowski, *Looking at Photographs* (New York, Museum of Modern Art), 1973.

Alan Trachtenberg, *Reading American Photographs* (New York, Hill and Wang), 1989.

Colin Westerbeck and Joel Meyerowitz, *Bystander: A History of Street Photography* (London, Thames and Hudson), 1994.

Chronological list of photographers whose work is discussed in the text

William Henry Fox Talbot (1800–1877)
Eugène Atget (1857–1927)
Alfred Stieglitz (1864–1946)
Lewis Hine (1874–1940)
Edward Steichen (1879–1973)
Imogen Cunningham (1883–1976)
Edward Weston (1886–1958)
Paul Strand (1890–1976)
André Kertész (1894–1985)
Dorothea Lange (1895–1965)
Ben Shahn (1898–1969)
Brassaï (1899–1984)
Weegee (1899–1968)
Walker Evans (1903–1975)
Bill Brandt (1904–1983)
Eudora Welty (1909–2001)
Robert Capa (1913–1954)
O. Winston Link (1914–2001)
W. Eugene Smith (1918–1978)
Roy DeCarava (b. 1919)
Richard Avedon (1923–2004)
Diane Arbus (1924–1971)
Robert Frank (b. 1924)
Elliott Erwitt (b. 1928)
Garry Winogrand (1928–1984)

William Gedney (1932–1989)

Bruce Davidson (b. 1933)

Lee Friedlander (b. 1934)

Steve Schapiro (b. 1934)

Joel Meyerowitz (b. 1938)

William Eggleston (b. 1939)

Michael Ormerod (1947–1991)

Stephen Shore (b. 1947)

Peter Brown (b. 1948)

James Nachtwey (b. 1948)

Hiroshi Sugimoto (b. 1948)

Jack Leigh (1949–2004)

Richard Misrach (b. 1949)

Nan Goldin (b. 1953)

Philip-Lorca diCorcia (b. 1953)

Merry Alpern (b. 1955)

Francesca Woodman (1958–1981)

Acknowledgements

The lines from 'For André Kertész' by George Szirtes from *Blind Field* (Oxford) are reproduced by kind permission of the author.

The lines from 'A Weekend First' by Paul Farley from *The Ice Age* (Picador) are reproduced by kind permission of the author.

The lines from 'In Time of War' by W. H. Auden from *The English Auden* are reproduced by kind permission of Faber and Faber Ltd.

The lines from 'The Whitsun Weddings' and 'Toads Revisited' by Philip Larkin from *Collected Poems,* copyright © 1988, 2003 by the Estate of Philip Larkin, are reproduced by kind permission of Farrar, Straus and Giroux, LLC, and Faber and Faber Ltd.

The lines from 'Clouds' by Wisława Szymborska, English translation by Stanislaw Baranczak and Clare Cavanagh, from *Poems New and Collected, 1957–1997,* copyright © 1998 by Harcourt, Inc., are reproduced by kind permission of Harcourt, Inc., and Faber and Faber Ltd.

I finished writing this book in June 2004; little did I know that this meant that the drudgery, tedium and frustration of trying to find – and obtain permission to reproduce – photographs would now begin in earnest. I am especially grateful to Robert Gurbo at the André Kertész Archive and Anthony Montoya at the Paul Strand Archive, Marion Durand at VII Photos, Robert Byrd at the Special Collections Library of Duke University, Jason Shenai at Millennium Images and Dan Cheek

at the Fraenkel Gallery for making bits of the task a pleasure rather than the protracted pain in the arse that it proved to be overall. I am also grateful to the photographers Joel Meyerowitz, Steve Schapiro and Peter Brown for their help and to Michael Shulan and Mark Lubell for tracking down photographs from *Here in New York* for me. If this book comes close to the ideal I naively had in mind when I finished writing it, that is due in part to their understanding. For its failure to come closer to that ideal the frustrated reader can thank those responsible for the pictures — by Robert Frank, Roy DeCarava and Diane Arbus — most conspicuous by their absence.

I am grateful to Rahel Lerner at Pantheon in New York for overseeing the constantly changing list of images with such patience and good humour. Thanks also to Sarah Rustin (who copy-edited the manuscript) and Linda Silverman at Little, Brown in London.

As usual I am grateful to my agents Eric Simonoff (in New York) and Victoria Hobbs (in London) and my publishers Dan Frank (at Pantheon) and Richard Beswick (at Little, Brown).

I am deeply grateful to the Lannan Foundation in Santa Fe for the award of a Literary Fellowship. The final version of the manuscript was completed during an extremely happy residence at one of their safe houses in Marfa, Texas.

Margaret Sartor and Mark Haworth-Booth kindly took the time to read the manuscript and make many helpful suggestions and corrections. It goes without saying that any remaining mistakes are entirely their responsibility. My wife, Rebecca Wilson, was the first person to read each version of this book. Charmingly, she kept saying she wished there was more of me in it. The reader will, I suspect, be glad that for once I didn't follow her advice.

Index of Names

Page numbers in *italic* refer to the illustrations